THE SLEEP OF REASON

Frances S. Connelly

THE SLEEP OF REASON

Primitivism in
Modern European Art and Aesthetics,
1725–1907

The Pennsylvania State University Press
University Park, Pennsylvania

Library of Congress Cataloging-in-Publication Data

Connelly, Frances S., 1953–
 The sleep of reason : primitivism in modern European art and
aesthetics, 1725–1907 / Frances S. Connelly.
 p. cm.
 Includes bibliographical references and index.
 ISBN 0-271-01305-2 (cloth) ISBN 0-271-01827-5 (paper)
 1. Primitivism in art—Europe. 2. Art, European. 3. Art, Modern
—Europe. I. Title.
 N6754.C63 1995
 709'.03—dc20 93-27552
 CIP

First paperback edition 1999

Published by The Pennsylvania State University Press,
University Park, PA 16802-1003

It is the policy of The Pennsylvania State University Press to use acid-free paper for
the first printing of all clothbound books. Publications on uncoated stock satisfy the
minimum requirements of American National Standard for Information Sciences—
Permanence of Paper for Printed Library Materials, ANSI Z39.48–1984.

Contents

List of Illustrations

Preface

With a topic as multifaceted as that of primitivism, it is important to clarify not only the aspirations of this study but also its parameters. My intention is not to offer a survey or history of primitivism, which would be a project of encyclopedic scope. This study will reconstruct the framework of ideas through which Europeans of the eighteenth and nineteenth centuries understood those arts they described as "primitive." More specifically it will look closely at the process, which began in earnest during the Enlightenment, through which Europeans developed a nomenclature for "primitive" imagery. It was this cultural construction of the idea of "primitive" art, and not the discovery of a particular mask or borrowing from a specific pattern, that determined the shape of primitivism. This study endeavors to serve a reflexive function as well as a documentary one, since a deeper understanding of the development of a "primitive" aesthetic can only sharpen our awareness of the extent to which we still rely upon its framework.

The book's title comes, of course, from Goya's *Capricho*, "The Sleep of Reason Produces Monsters" (1796–98), which depicts an artist slumbering at his drawing table, while night-creatures hover closely over him. The subtitle of the etching as published reads: "Imagination abandoned by reason produces impossible monsters; united with her, she is the mother of the arts." The significance of this theme to the subject of this book will become clear as one reads on.

The research for *The Sleep of Reason* was largely supported by a Rockefeller Foundation Humanities Fellowship for a one-year residence at Johns Hopkins University in the Program for the History of Art and Anthropology. I was able to pursue specific aspects of this research through the support of a Faculty Research Grant from the University of Missouri–Kansas City and a grant from the Newberry Library in Chicago. The opportunity to participate in the 1989 NEH Summer Seminar, "Theory and Interpretation in the

Visual Arts," was a great help in clarifying the ideas presented here. This book builds upon the ideas formulated in my dissertation "The Origins and Development of Primitivism in Eighteenth- and Nineteenth-Century European Art and Aesthetics" (Pittsburgh, 1987) for which I received generous support through a Smithsonian Predoctoral Fellowship at the National Museum of African Art. Chapter 2 is an expanded version of an article published in the *Art Journal* (Summer 1993), and is reprinted by permission of the College Art Association.

I owe a debt of gratitude to Aaron Sheon, who encouraged me to pursue my interest in this topic, pointed me toward Meryon's work, and stuck by me through every draft of the manuscript. Many of the essential questions addressed here grew out of an all-too-brief period of study with David Summers. In addition, I had the benefit of discussing these ideas with Anne Weis and with Visiting Mellon Professors Gabriel Weisberg, Edward Fry, and Roy Sieber. I have enjoyed the support and encouragement of my colleagues at the University of Missouri–Kansas City, without whom I literally would not have been given the opportunity to write this book.

Finally, I am grateful to my family; my sisters, Becky, Beth, and Patty, and my parents, who always encouraged a love of learning. I dedicate this book to Mary, who has never wavered in her support and encouragement.

Introduction:
Framing the Question

In recent years the topic of primitivism has moved rapidly to the forefront of art-historical discussion. In part, this can be explained as response to both *"Primitivism" in Twentieth-Century Art* and *Magiciens de la terre*, the ambitious and controversial exhibitions organized by the Museum of Modern Art (1984) and the Centre Georges Pompidou (1989), respectively. However, a deeper motivation might lie in the increasing reflexivity of the discipline of art history itself. The reasons for reassessment are multifaceted, but they include the recognition that the methodological foundations of the discipline are by their nature Eurocentric and thus have proved inadequate for the study of non-Western art traditions. The resurgence of interest in primitivism, a phenomenon that highlights the relationship between Western and non-Western arts, is certainly interconnected with the reevaluation of the language and ideology underlying art-historical practice today. Representing one of the principal directions taken by the avant-garde, the renewed

All translations, unless otherwise noted, are those of the author.

inquiry into primitivism also participates in the broader critique of modernism.[1]

The phenomenon of primitivism is itself a subject of enormous complexity, due primarily to two factors. The first involves the difficulty in discerning a rationale underlying the chaotic mix of styles identified as "primitive." Europeans in the eighteenth and nineteenth centuries grouped a diversity of styles under the rubric of "primitive," including Trecento Italian, Polynesian, Archaic Greek, Egyptian, and Japanese.[2] For example, Friedrich Schlegel's admiration of the "primitives" exhibited at the Musée Napoléon in 1802 included Fra Angelico, Dürer, and Van Eyck.[3] P. F. H. d'Hancarville found it useful to compare the outline style of Greek vase painting to Italian Gothic panel paintings.[4] It was just as common to use the name of a style perceived to be "primitive," such as Chinese, Gothic, or Egyptian, to describe other imagery considered early or undeveloped. Thomas Jones characterized the ancient Roman wall paintings found in the Villa Negroni in 1777 as "painted Ornaments much in the Chinese taste."[5] The influential art critic Théophile Gautier compared the expressive drawings of Rodolphe Töpffer to the graffiti of street urchins since both possessed "des lignes dignes de l'art étrusque." Gautier also saw that Töpffer was inspired by "des byzantins d'Epinal."[6] In 1821 T. E. Bowdich, an Englishman who had carried out a diplomatic mission to the Ashanti, published a study in which he compared West African customs, beliefs, and arts to those of ancient Egypt.[7] That this strange brew of "primitive" art was accepted by modern artists is more than demonstrated by the free mixing of "primitive" imagery in their compositions.

For all the difficulty in identifying "primitive" art, it is equally as vexing to define primitivism. The dearth of modern art works that, although primitivizing in style, exhibit documentable examples of direct visual borrowing from "primitive" art traditions illustrates the rather surprising fact that these so-called primitive arts were rarely more than an indirect influence. Picasso's *Demoiselles d'Avignon* (Fig. 1), an image essential to any history of primitivism, quotes no one "primitive" source directly. Gauguin's primitivizing figures are notoriously hybrid in construction, a typical example being the strange figures standing to the right and left of Tehamana (Fig. 2) that belong to no one style, although they incorporate traces of Buddhist, Easter Island, and Tahitian sculpture. In his 1938 study, Robert Goldwater addressed these difficulties by arguing that European artists were influenced as much by the *idea* of "primitive" art as by specific visual images; in short, that the "primitive" existed in the eye and mind of the European beholder.

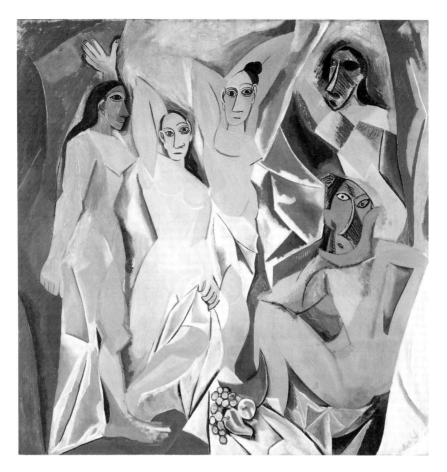

Fig. 1. Pablo Picasso, *Les Demoiselles d'Avignon*, 1907, oil on canvas. Museum of Modern Art, New York. Acquired through the Lillie P. Bliss Bequest

If primitivism was an "attitude productive of art," Goldwater reasoned that "primitive art only served as a kind of stimulating focus, a catalytic which, though not in itself used or borrowed from, still helped the artists to formulate their own aims because they could attribute to it the qualities they themselves sought to attain."[8]

Although Goldwater's thesis advanced a conception of primitivism far more sophisticated than simple stylistic influence, it presented the primitivizing attitude and the "primitive" catalyst as simultaneously amorphous and protean, lacking any defining form yet capable of any form. Is it possible to

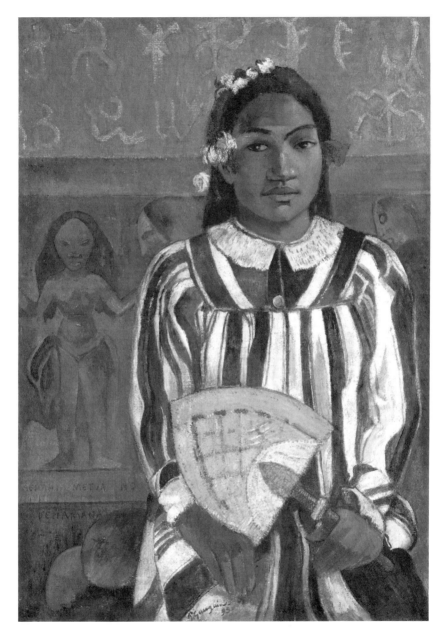

Fig. 2. Paul Gauguin, *Ancestors of Tehamana*, 1893, oil on canvas. The Art
Institute of Chicago, gift of Mr. and Mrs. Charles Deering McCormick

look beyond the individual assumptions and intentions of modern artists for whom "primitive" art was a "catalytic" to a broader cultural framework of ideas concerning "primitive" expression? A careful reading of period sources from the eighteenth and nineteenth centuries, including voyage accounts, ethnographic studies, art criticism, and popular literature, suggests that this might be the case. The efforts to reconstruct the origins of culture began in earnest during the Enlightenment era, the earliest such enterprise being Giambattista Vico's landmark treatise of 1725, *La scienza nuova*, which drew its evidence from Homeric poetry, the Bible, Roman descriptions of ancient Germans, Gauls, and Picts, as well as traveler's accounts of New World peoples. In fact, the notion of "primitivity" as an infant state of development through which all cultures passed was an invention of Enlightenment universalism.

"Primitive" art, as the notion developed during the eighteenth century, would be more accurately described as a collection of visual attributes that Europeans construed to be universally characteristic of early, or primal artistic expression.[9] The discussion of primitivism in modern art and aesthetics must then begin with the invention of "primitive" art itself, a set of ideas (remarkably consistent and long-lived) forged primarily during the eighteenth century through vigorous debate concerning the origins and development of artistic expression.[10] Rather than the paintings and woodcuts of Gauguin, the publication of Vico's highly original *New Science* lies much closer to the origins of primitivism because it first articulated, in a systematic manner, the essential framework of ideas through which eighteenth- and nineteenth-century Europeans would understand "primitive" expression. The debates concerning "primitive" art gave little attention to specific stylistic traditions but focused instead upon those attributes that Europeans identified (and later assimilated) as *Urformen*, primordial forms of expression, among them the hieroglyph, the grotesque, and the ornamental. This set of ideas remained remarkably constant, so much so that Gauguin and Picasso's conceptions of "primitive" expression were still firmly rooted within that framework of ideas nearly two hundred years later.

It should be stressed at this juncture that the term "primitive" will be used in this study to refer only to this European conception. The derogatory connotations of the term "primitive" have provoked efforts to find less value-laden substitutes. The real need is not for neutralized substitutes, but for recognition that the term does not describe a Yoruba figure or an Egyptian relief, but a set of ideas belonging to Europeans. "Primitive" does accurately characterize the figures that Gauguin painted alongside Tehamana, however.

These hybrid figures can only be described as "primitive" because they partake of many styles while belonging to none. The term does not describe actual art traditions for which the proper names and descriptions for actual styles already exist.[11]

Understanding "primitive" art as a collection of visual attributes goes some distance toward explaining the seemingly chaotic comparisons and conflations made between radically different art traditions. It also provides a clearer explanation for the tendency to emulate the idea of "primitive" imagery more frequently than literal stylistic motifs. The efforts to identify specific masks or patterns borrowed by European artists have begged the question of what early expression represented to the European imagination in the first place. Approaching "primitive" art as a framework of ideas that determined the extent of visual borrowing and the nature of stylistic influence provokes an entirely different set of questions. If the designation as "primitive" defined certain art traditions as peripheral, as subartistic, as the Other, what functioned as the center, the standard, the norm? Did avant-garde artists accept the normative definition of "primitive" art or did they rewrite it?

This study will examine the aesthetic framework through which certain visual characteristics were defined as "primitive" and assimilated by primitivizing European artists. Key indicators of the deep aesthetic structures that comprise "primitive" art exist in the nomenclature that Europeans employed to describe imagery radically different from their own. Used repeatedly, not only in scholarly works but in missionary accounts, popular travel journals, exhibition reviews, and artists' statements, a surprisingly small set of terms indicates not only that a general notion of "primitive" art was widely held, but also that a common set of expectations was imposed upon it. It was these terms—grotesque, ornament, caricature, hieroglyph, and idol—that provided the conduit through which the hybrid creature described as "primitive" art eventually exerted stylistic influence. They furnished the link between European *ideas* about "primitive" art and the actual *emergence* of primitivizing styles in modern art and significantly influenced the directions primitivism could and could not take. Without being stripped of their original names and meanings, renamed and codified within the European taxonomy of art, these "primitive" traditions could not have been emulated by Western artists. It hardly needs saying that the translation of any visual tradition, African, Oceanic, or Egyptian, into European awareness as "primitive" ornament or grotesque idol severely reduced its visual and cultural richness.

The frame serves as an apt metaphor for the way in which established categories of European thought were imposed upon "primitive" peoples in an effort to translate them into European experience. They not only provided answers; they literally determined the questions and issues addressed to "primitive" societies, isolating certain characteristics while obscuring others completely. An engraving for the cover of the periodical *Les Colonies françaises* (Fig. 3) illustrates this principle well. Published in 1892 during the height of imperialism and for a readership specifically concerned with the colonies, the compositional structure of the image literally frames New Caledonia as a French colony. In the outer frame we read all the accoutrements of French governance; vigilance, power, order, while the inner panel isolates those aspects of New Caledonia that justify European domination; sloth, idolatry, ignorance. Here "civilization" is literally imposed upon "savagery," giving it purpose and direction.

Remarkably, the manner by which cultures defined what was unknown to them was described by Vico in his *New Science* as early as 1725. Vico was speculating as to how the first peoples attempted to understand and to name the strange world that surrounded them:

> It is noteworthy that in all languages the greater part of the expressions relating to inanimate things are formed by metaphors from the human body . . . and from the human senses and passions. Thus, head for top or beginning; the brow or shoulders of a hill; the eyes of needles . . . ; mouth for any opening; . . . the belly of a sail; . . . a vein of rock or mineral, . . . the bowels of the earth.

but went further to claim that this was a cultural phenomenon fundamental to all cultures:

> All of which is a consequence of our axiom that man in his ignorance makes himself the rule of the universe, for in the examples cited he has made of himself an entire world. So that, as rational metaphysics teaches that man becomes all things by understanding them, this imaginative metaphysics shows that man becomes all things by *not* understanding them . . . , for when man understands he extends his mind and takes in the things, but when he does not understand he makes the things out of himself and becomes them by transforming himself into them.[12]

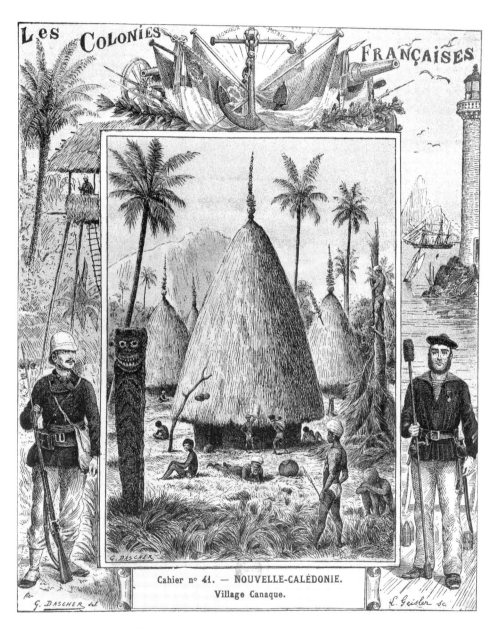

Fig. 3. *Nouvelle-Calédonie. Village Canaque*, engraving in *Les colonies françaises*, cahier no. 41, 1892

It is my argument that the principal framework of ideas that defined "primitive" art was that of the *classical tradition* as institutionalized in academies of art throughout Europe. The classical norm cast the "primitive" as a dark mirror image of itself. The dynamic between the "primitive" and the classical tradition determines the chronology of this study. Commencing with the first crucial definition of "primitive" art in Giambattista Vico's *La scienza nuova* of 1725, it ends with what is traditionally understood to be the beginning of primitivism, Pablo Picasso's *Demoiselles d'Avignon* in 1907. Although there was interest in "primitive" art before Vico, his was the first of a series of attempts to define this phenomenon in a comprehensive manner; more important, these are the ideas that took hold in the European imagination. Picasso's *Demoiselles* exhibits the most radical primitivism within the classical framework in its incorporation of the most anticlassical form of "primitive" expression, that of the grotesque. Picasso's artistic dialogue was still primarily with the classical tradition, but the early twentieth century saw the emergence of other frameworks, most notably that of Freudian psychoanalysis, which shifted and modified European conceptions of "primitivity." Thus, Picasso represents both a beginning and an endpoint in the history of primitivism.

The move from Vico to Picasso is also a move from theory to practice, from ideas about "primitive" expression to the emulation of those ideas by artists. Although one of the principal aims of this book is to establish the fundamental framework of ideas concerning "primitive" art, it is equally important to demonstrate that those ideas became conduits for artistic borrowing. Theory shaped practice. For this reason Chapters 2, 3, and 4 focus upon particular aspects of "primitive" expression and present case studies in which the assimilation of that expression was advocated, attempted, or actually realized.

As distorted as the early representations of "primitive" art may have been, their portrayal was in many respects more complex than those found in many art-historical accounts of primitivism. It is quite simply the case that we have looked at primitivism from the twentieth century backward and have substituted a predominantly formalist frame for the classical one. This has created a kind of intellectual chiaroscuro, highlighting those "primitive" influences that led toward abstraction via a deliberate naïveté and a rejection of illusionistic devices while obscuring other significant variants of primitivism almost completely. The importance of modernism's rejection of naturalistic representation, liberating the formal elements of art from a mimetic role to an expressive one, has directed our attention to issues related to

form, virtually excluding those related to content. Framed in this manner primitivism is then described as suddenly appearing with the advent of modernism. The European admiration for the crude and naïve has been very well documented: experiments with linear abstraction by neoclassical artists, Courbet and popular imagery, Manet and the impressionists' emulation of Japanese arts, or the impact of African sculpture upon Cubist art. Even in the case of Gauguin, discussions of his primitivism have concentrated mainly upon his flattening of form and space, his cloisonné pooling of vivid color, and his inclusion of occasional Polynesian motives. Relatively little attention has been given to Gauguin's own characterization of his art as decorative, to his obvious interest in the grotesque, or to his use of hieroglyphics, all characteristics associated with "primitive" expression.

A reading of the principal eighteenth-century treatises concerned with the origins and development of representation reveals a far more complex set of characteristics ascribed to "primitive" art, naïveté being only one of them. Closer attention to these earlier discussions suggests that the avant-garde was so successful in overthrowing the classical tradition that it managed to rewrite its own past. But the classical tradition was the shaping force of primitivism; recognizing that fact extends our understanding of the phenomenon and brings to light the contributions of other early proponents of a primitivizing style in art.[13] This study will explore those terms ascribed specifically to the *artistic expressions* of "primitives," terms that derived from the classical tradition and characterized the "primitive" as powerful imagination ungoverned by reason. Although eighteenth- and nineteenth-century observers were keenly interested in these topics, they have not been extensively discussed in the scholarly literature.[14] Exploring the fuller definition of "primitive" art provided by period sources brings to light the efforts of Runge and Meryon, artists not usually associated with the development of primitivism. But it also deepens our understanding of the primitivism of Gauguin and Picasso by demonstrating the extent to which these "primitive" aesthetic structures shaped and directed their work.

1

The Sleep of Reason: "Primitive" Art as the Inverse of Classicism

The ornament of a savage tribe, being the result of a natural instinct, is necessarily true to its purpose.
Owen Jones, *The Grammar of Ornament,* 1856

Perhaps we have too readily dismissed eighteenth- and nineteenth-century descriptions of "primitive" arts such as the statement above for their overt bias and ethnocentricity, assuming that these designations, because inaccurate, were without meaning or system. To the contrary, a careful examination of these terms shows that, however derogatory and misapplied they were as descriptions of a Bambara mask or a Maori canoe prow, they nevertheless carried specific aesthetic meanings within the classical tradition and fit into a complex and consistent European interpretation of "primitive" art. While it is not surprising that a Maori canoe paddle design (Fig. 4) or a club from the Easters Archipelago (Fig. 5) were consistently excluded by Europeans from the realm of "fine art," it does not follow that this imagery went undefined. In fact, European observers relied upon a restricted lexicon that was repeatedly used to describe all manner of "primitive" imagery. These two examples were lumped into the category of "ornament" and character-

Fig. 4. Sydney Parkinson, *Maori canoe paddle*, 1771, wash drawing. By permission of the British Library

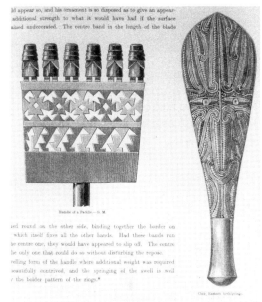

Fig. 5. Owen Jones, *Club*.
Easter's Archipelago,
published in *The Grammar of
Ornament* (London, 1856)

ized as "ingenious" and "full of invention." The nomenclature for "primitive" art provides the best argument that it was the classical tradition, as institutionalized in art academies throughout Europe, that served as the principal framework through which a variety of imagery was assimilated.

The use of a small set of terms like "grotesque" and "ornament" not only suggests a classical framework but also its presumption of reason as the governing artistic faculty. Rationality formed the core of academic precepts, which held that the construction of an idealized image, in which both form and action were perfected, was the highest attainment of an artist. The foundation of academic pedagogy upon the rule of reason[1] framed the key characteristic of "uncivilized" imagery as unreason, and the key terms used to describe these forms were predominantly those from the periphery of the classical tradition. The grotesque and the ornamental were among those elements of physicality and disorder allowed to exist on the edges if controlled by centrifugal force of the center. They were the marginalia to the rational text, the darkness that fell just outside the aureole of the light of reason, the bestial, lusty satyr that by contrast heightened the proportioned beauty and sober intellect of the Apollo. They were allowed to exist

only in a controlled, subservient role, as an embellishment to the rational structure.

The normative aesthetic in Europe during the eighteenth and nineteenth centuries was the institutionalized classicism taught in academies of art; non-Western as well as nonclassical art traditions were measured against its standards by those Europeans quoted throughout these pages, from Captain Cook to Baudelaire to Gauguin.[2] Close attention to the descriptions of "primitive" art suggests that its presumed lack of reason was the fundamental issue that separated it from the arts of "civilized" peoples. Although naïveté and lack of illusionism were qualities repeatedly attributed to "primitive" art, they were actually subcategories within the larger issue of ratiocination. As a result, rethinking the nature of primitivism requires, however unlikely it may seem, that we appreciate the extent to which *reason* was fundamental to academic classicism in particular and to European conceptions of "fine art" in general.

Giambattista Vico was the first to advance a systematic analysis concerning the state of early peoples based upon this hypothesis: "Hence poetic wisdom, the first wisdom of the gentile world, must have begun with a metaphysics not rational and abstract like that of learned men now, but felt and imagined as that of these first men must have been, who, without power of ratiocination, were all robust sense and vigorous imagination . . . for they were furnished by nature with these senses and imaginations."[3] The "primitive" was immersed in the immediate, physical experience of his senses without the mediation of abstract ideas. The inability to reflect meant that the "primitive" relied all the more heavily upon his imagination and passions to understand the world. Being almost "all body," the "primitive's" mind had little control over matter. Vico wrote: "Before, in the time of Homer, the peoples, who were almost all body and almost no reflection, must have been all vivid sensation in perceiving particulars, strong imagination in apprehending and enlarging them . . . and robust memory in retaining them."[4]

Europeans of the eighteenth and nineteenth centuries often commented on the "primitive's" apparent inability to reflect. The Comte de Bougainville wrote of the Tahitians: "Everything strikes them, yet nothing fixes their attention: amidst all the new objects which we presented to them, we could not succeed in making them attend for two minutes together to any one. It seems as if the least reflection is a toilsome labor for them."[5]

Even accounts of Japanese art, written more than one hundred years later,

applied variations of this idea in order to explain the appearance of Japanese prints. Elisa Evett observed that while European attitudes toward Japanese art were complicated by new studies of perception and child development [!], the familiar contrast of civilized abstraction to "primitive" physicality still formed the backbone of many arguments. Michel Revon wrote in 1896 that "the human eye does not perceive colors the same way in all cultures . . . the eye of the Japanese perceives the abstract with infinitely less accuracy and the concrete with infinitely more acuteness than ours. . . . We distance ourselves from nature: they immerse themselves in it; we are reflective while they are observant."[6] As was common in European characterizations of "primitive" peoples, the Japanese were sometimes described as childlike, their immediate and vivid experience of the world contrasted with Europeans' objectification and abstraction of raw experience: "For the Japanese . . . nature is marvelous scenery of unceasing variety, which constantly brings new delights. . . . The least details of this display are the things which interest them. . . . At the same time, the higher faculties of their intelligence are enfeebled, or rather, from lack of use they have atrophied. . . . The least effort to make an abstract generalization for them is impossible."[7]

Not surprisingly, the "primitive" was believed to live in the immediate present, with little sense of past or future. One critic of T. E. Bowdich's 1819 study of the Ashanti of West Africa mocked the idea that "primitives" had any culture worthy of study: "The 'history' of the Ashantees, to which Mr. Bowdich has dedicated a whole chapter, is, like that of all other savages who can neither read nor write, the history of a day, and little worthy of notice."[8] Even those who envied the "primitive's" supposed simplicity did so in the belief that he lived by the laws of nature and was virtually bereft of culture. This constitutes the deeper theme of Duché de Vancy's 1786 representation of Easter Islanders in something like a *fête primitive*, with conversational groups and individual poses clearly derived from Watteau (Fig. 6).[9] His juxtaposition of European to Pacific Islander works as a contrast of rational, historical culture with nonrational, ahistorical existence. The Frenchman, so determined to measure the massive stone head, functions very literally as a self-aware, historical force breaking into an unreflecting state of suspended animation. In marked contrast to the Frenchman, the Easter Islanders set for themselves no greater enterprise than to pilfer three-cornered hats, handkerchiefs, and other curiosities. Eighteenth-century Europeans knew that the Easter Island monuments were ancient and believed that the contemporary inhabitants had no more insight into the

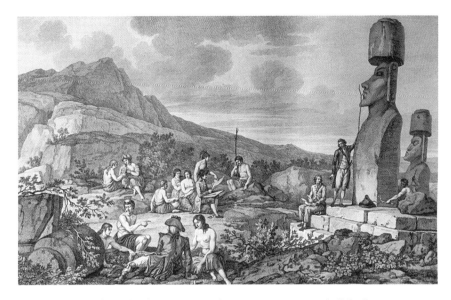

Fig. 6. Gaspard Duché de Vancy, *Insulaires et monuments de l'Ile de Pâques*, engraving by Godefroy after a drawing from life, April 9, 1786. Published posthumously in *Atlas du voyage de La Pérouse* (Paris, 1797)

meaning of the handiwork of their ancestors, and even less interest in them, than the Europeans themselves. This seemed to confirm European beliefs that "primitive" peoples shared only minimal cultural tradition and lived with little awareness of past or future.

Gauguin also populated his painted Polynesian idylls with youthful figures who seemed to exist outside of real time and real history: "These nymphs, I want to perpetuate them, with their golden skins, their searching animal odor, their tropical savors. They are here what they are everywhere, have always been, will always be."[10] As is well known, Gauguin equated his attempts to find ever more "primitive" states of being with a return to his childhood, his own state of innocence. Hence his famous claim, "Sometimes I have gone far back, farther back than the horses of the Parthenon . . . as far back as the Dada of my babyhood, the good rocking-horse."[11] In works such as *Mahana no Atua* (Fig. 7), we peer into a world enshrouded in myth, ignorant of history and governed by instinct and emotion. In the foreground, two of the three figures huddle in fetal positions, asleep or barely waking. The state of slumber clearly struck a parallel with the "primitive's" presumed absence of reason and lack of progress.

The image of the sleeping "primitive" awakened by civilized Europe

Fig. 7. Paul Gauguin, *Mahana no Atua* (Day of the Gods), 1894, oil on canvas.
The Art Institute of Chicago, Helen Birch Bartlett Memorial Collection

actually found its precedent in the pre-Enlightenment imagery of the first
conquests, as did images of idol worship and cannibalism. A striking example
is Theodore Galle's engraving after Stradanus entitled, *Vespucci Landing in
America*, of the late sixteenth century where the explorer awakens an
allegorical America from her slumbers in a hammock (Fig. 8). While
Vespucci holds the symbols of Christian belief, government, and science,
America possesses no attribute but her stupor and, to drive the point home,
natives in the distance busy themselves with skewering human flesh for a
meal. In François Gérard's 1814 frontispiece to von Humboldt's multivolume
study of American natural history (Fig. 9), Minerva and Mercury, symbols
of the culture and commerce of Europe, appear philanthropic in their desire
to help a weak and helpless America to her feet. As late as 1902, Herbert
Ward cast in bronze his *Sleeping Africa* (Fig. 10), a plainly allegorical figure
whose slumber embodies the supposed barbarity and ignorance of the entire
African continent, the visual equivalent (and near contemporary) of this
characterization of Africa: "reduced to eternal immobility: no progress, no

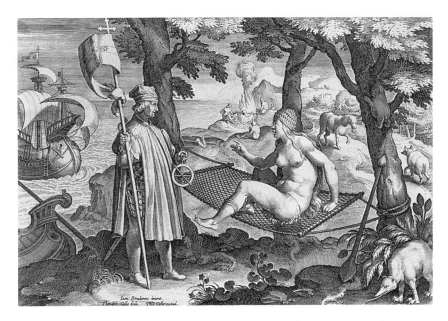

Fig. 8. Theodore Galle, after Stradanus, *Vespucci Landing in America*, late sixteenth century, engraving. Metropolitan Museum of Art, New York, The Elisha Whittelsey Collection, The Elisha Whittelsey Fund, 1949

invention, no desire for knowledge, no pity, no moral sentiment."[12] These same slumberers emerge as a prominent theme in the work of Paul Gauguin. His representations of idols and somnambulant natives combined two favorite themes of the symbolist movement: the fascination with the irrational and the juxtaposition of the sensuous with the diabolical.[13]

The "primitive's" lack of reason also foreclosed the possibility of a systematic form of written language as well as an abstract alphabet. This seems to have been an issue of great consequence to Europeans who presumed that "primitive" cultures lacking a written language therefore possessed no history, scripture, or code of laws (at least none that Westerners could recognize). The important role that language played in the interpretation of "primitive" cultures was reflected in the hierarchies imposed upon them. Europeans did indeed distinguish between less "primitive" and more "primitive" peoples. For example, Japanese culture was occasionally described as "primitive," but was more often seen as exotic, whereas African or Oceanic peoples were rarely identified as anything but "primitive." A principal threshold seems to have been the issue of literacy. As early as 1589, José de

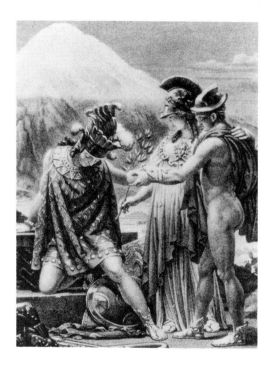

Fig. 9. François Gérard,
Humanitas, Literae, Fruges,
1814, engraving

Acosta, a Spanish Jesuit, outlined three levels of "barbarians": "the first level are literate, like the Chinese; the second live in stable settlements with organized social institutions, like the Mexicans or Peruvians; [the third are] those who have barely the rudiments of organized life."[14] Vico's *New Science* used the development of language as the principal means to identify levels of civilization, and argued, as did many Enlightenment treatises to follow, that the acquisition of a written language with an abstract alphabet marked the key moment of passage for any culture.

The inability to abstract from experience lay at the heart of European evaluations of "primitive" expression. Certainly "primitive" art could be little more than spontaneous outbursts of emotion or fantasy. The idea that any "primitive" expression belonged to an established tradition rarely entered the minds of even the most objective observers. Père Lafitau stated that the Huron and Iroquois did not have a fine-arts tradition: "It must seem strange, indeed, that, having intelligence and manual skill in doing so many little handicrafts . . . , yet they have spent so many centuries without inventing any of those arts that other peoples have brought to such high perfection."[15] Even when considering the arts of Japan, a tradition much

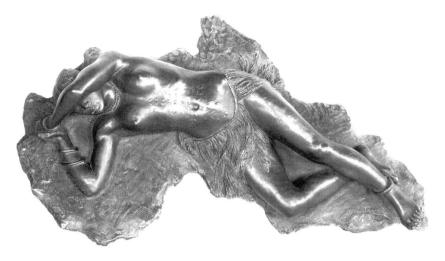

Fig. 10. Herbert Ward, *Sleeping Africa*, 1902, bronze. Department of
Anthropology, Smithsonian Institution

more readily admired by Europeans, great effort was spent upon theories
that explained the absence of European artistic attributes such as chiaroscuro
and linear perspective. Evett observes that "these explanations betrayed
critics' resistance to the notion that the peculiarities of Japanese art might
be the outcome of a self-referential, internally motivated system of aesthetic
preferences."[16]

More than one hundred years later Eugène Delacroix interpreted the
presumed lack of an art tradition as an enviable state because "primitive"
artists had no conventions with which to conform:

> One needs great boldness if one is to dare to be oneself: it is above
> all in our time of decadence that this quality is rare. The primitives
> were bold in a naïve fashion, without knowing . . . that they were
> so; as a matter of fact, the greatest of boldness is to step outside of
> convention and of habits; now, the men who arrive first have no
> precedents to fear; the field was free for them.[17]

Delacroix's idea was later picked up by many artists of the avant-garde who
felt burdened by history and tradition and equated "primitive" art with
uninhibited expression, free of conventions and rules to which to conform.
Indeed, the art critic Jules Laforgue praised impressionist artists for their

ability to *forget* tradition and convention in order to recover a "primitive" vision: ". . . forgetting the pictures amassed through centuries in museums, forgetting his optical art-school training . . . by dint of living and seeing frankly and primitively in the bright open air . . . has succeeded in remaking for himself a natural eye, and in seeing naturally and painting as simply as he sees."[18] In *The Grammar of Ornament* (1856), Owen Jones advocated reform in the decorative arts and wrote with admiration of Oceanic designs: "the eye of the savage, accustomed only to look upon Nature's harmonies, would readily enter into the perception of the true balance both of form and colour."[19]

The notion that these arts were entirely spontaneous expressions with no direction from an established visual tradition also derived from Rousseau's conception that the closer one lived to nature, as did the "primitive," the freer one was of culture. This was the idea behind frequent descriptions of the "primitive" and his artistic creations as naïve, or rude. While these terms were sometimes used pejoratively, they were just as often a back-handed compliment, with connotations of childlike simplicity and freedom from learned conventions. Lack of sophisticated technique was more than compensated by a lack of guile. A nineteenth-century American missionary's account of an African carver reveals the conflation of naïveté in style with personal innocence and sincerity: "some rude work of art which he displays with pride, something upon which he has expended astonishing labor for beauty's sake alone—crude enough, to be sure, but giving 'thoughts that do often lie too deep for tears.' "[20] Vico himself drew a connection between unaffected, direct speech and truthfulness, considering both to be the natural condition of the uncivilized: "Since barbarians lack reflection, which, when ill-used, is the mother of falsehood, the first heroic . . . poets sang true histories. . . . And in virtue of this same nature of barbarism, which for lack of reflection does not know how to feign (whence it is naturally truthful, open, faithful, generous, and magnanimous)."[21]

Like the notions of the noble savage or "primitive" golden age, the naïveté admired in "primitive" art belied Europeans' concern that their own fine arts tradition was sliding into decadence. The pedantic nature of the academic curriculum as well as its rigid adherence to visual conventions had begun to provoke criticism by the mid-eighteenth century. The naïveté of "primitive" expression was frequently contrasted to the "subterfuges of language, the artifices of style, brilliant turns of the phrase," associated first with the rococo and subsequently with a bankrupt academic tradition.[22] As the nineteenth century progressed, it became common to contrast the

empty sophistication of European art to the rude truth to be found in "primitive" expressions. In 1869, Champfleury claimed that the lack of chiaroscuro in popular prints was "less barbarous than the mediocre art of our exhibitions in which a universal cleverness of hand makes two thousand pictures look as if they have come from the same mold."[23] Many like Champfleury admired the naïveté cultivated by artists of the avant-garde. Emile Zola, for example, wrote that Manet's paintings had an "elegant awkwardness" and "sweet brutality" and compared them to *Images d'Epinal* and Japanese prints.[24]

A second trait attributed to the "primitive" was his capacity for deep feeling and great passion, qualities that were featured in both the noble savage as well as in his opposite number, the savage brute. Vico had proposed in his *New Science* that "primitive" man knew only what he "felt and imagined" and progressed by increments from a purely sensorial, experiential understanding of the world toward an analytical, reflective one: "Men at first feel without perceiving, then they perceive with a troubled and agitated spirit, finally they reflect with a clear mind" (75). The first poetry came from this wellspring of "primitive" passions: "the founders of . . . nations, having wandered about in the wild state of dumb beasts and being therefore sluggish, were inexpressive save under the impulse of violent passions, and formed their first language by singing" (77).

Vico used the example of Homeric poetry to describe the passionate nature of the "primitive" mind. It is worthwhile to follow his argument because it anticipated later appreciations of "primitive" styles by recognizing that the rationality gained by civilized man was not without a cost: "By the very nature of poetry it is impossible for anyone to be at the same time a sublime poet and a sublime metaphysician, for metaphysics abstracts the mind from the senses, and the poetic faculty must submerge the whole mind in the senses; metaphysics soars up to universals, and the poetic faculty must plunge deep to particulars" (314). One senses here the beginnings of a major shift from a classically based aesthetic. Vico not only believed that the arts originated with early man, he also argued that truly poetic expression belongs to the "primitive" faculties: "For it has been shown that it was deficiency of human reasoning power that gave rise to poetry so sublime that the philosophers which came afterward, the arts of poetry and of criticism, have produced none equal or better, and have even prevented its production" (314). Remarkably, in this one sentence Vico identified what was to become the principal challenge to academic pedagogy, that learning and reason do not create art.[25] The imagination and

feelings were the wellspring of creativity, a source that too much reason could obscure. Vico rebuked those who criticized the crudity of Homer's phrasing, his "vulgar customs, licenses in meter," or "wild and savage comparisons" (325–26), countering that "Homer was an incomparable poet, just because, in the age of vigorous memory, robust imagination, and sublime invention, he was in no sense a philosopher" (327). Furthermore, "the poetic and critical arts [of Vico's day] serve to make minds cultivated but not great. For delicacy is a small virtue and greatness naturally disdains all small things" (314).

This distinction would be repeated by others. William Whewell, reviewing the exhibits of the 1851 exhibition, remarked favorably upon the "primitive" arts displayed there and followed this with a summary of the evolution of the arts:

> For, as you know, Criticism does come after Poetry: the age of Criticism after the age of Poetry; Aristotle after Sophocles, Longinus after Homer. And the reason for this has been well pointed out in our time: —that words, that human language, appear in the form in which the poet utters them . . . before they appear in the form in which the critic must use them: language is picturesque and affecting first; it is philosophical and critical afterwards: —it is first concrete, then abstract: —it acts first, it analyzes afterwards. And this is the case, not with words only, but with works also.[26]

Such value-laden contrasts were matched by calls for regression and renewal in the arts. Owen Jones recommended the ornament of "savage tribes" to English artisans, praising the "true instincts" apparent in this unlettered art. Gauguin repeatedly contrasted his affinity with the deep emotion and mystery of the "savage" with bitter ridicule for the sophistication of modern Europeans that distanced them from true artistic feeling. Achille Delaroche, in a highly complimentary review of Gauguin's work, recognized the artist's attempt to assimilate both "primitive" naïveté and deep feeling into his work: "Gauguin is the painter of primitive natures: he loves them and possesses their simplicity, their suggestive hieraticism, their naïveté a little awkward and angular. . . . And how the serenity of these natives overwhelms the vanity of our insipid elegancies."[27]

While naïveté and unrestrained passion were attributed to both the "primitive" and his art, the traits of vivid imagination and great invention were cited just as frequently. Moreover, "primitive" imagery itself was

described with a more specific vocabulary as monstrous, grotesque, carica-
tured, ornamental, and hieroglyphic. These terms derive from the classical
tradition and cast "primitive" art into a dynamic with it.

The French Academy, prototype for other art academies of Europe, fixed
standards and hierarchies for the "fine arts" that were (at least in theory)
uniform and systematic. As a consequence, the judgment of what did not
constitute "fine art" was quite striking in its consistency. By establishing
what was central, the academic standard also decreed what was peripheral.
This dynamic interrelationship between any culture and that which lies
beyond its experience was the subject of a collective project directed by Yuri
Lotman and B. A. Uspenskij in 1973.[28] In a set of theses they proposed that
each type of culture creates "its corresponding type of 'chaos,' " and
therefore, "culture and non-culture appear as spheres which are mutually
conditioned and which need each other" (2). According to the situation of
the particular culture, its "chaos" ". . . may sometimes be constructed as a
mirror reflection . . . or else as a space which, from the position of an
observer immersed in the given culture, appears as unorganized, but which
from an outer position proves to be a sphere of *different organization*" (3).

As we have seen, Europeans broadly portrayed "primitive" art as belong-
ing to no artistic tradition whatsoever. But the more concerted attempts to
describe "primitive" art cast it as subordinate to (nonculture) *and* as the
inverse of the classical tradition; irrational to rational, grotesque to beauty,
wild invention to intellectualized order, matter to mind, and so on. One
could visualize this interdependent relationship by imagining a culture as a
planet and its corresponding chaos as the surrounding gravitational field. It
is the planet, that is, the collective mass of a particular culture, that
determines the extent of its gravitational field and hence, the orbit of the
moons of outside experience around it. To carry the metaphor one step
further, only certain aspects of this outside experience can be held in orbit
by the gravitational pull of a given culture. Other elements will remain
beyond its periphery and understanding altogether.

This dynamic is exemplified by the routine characterization of African
masks such as that illustrated in Figure 11 (from the Etoumbi region and
thought until recently to have been an influence upon Picasso in 1907) as
"caricatured." The fact that European observers from a variety of back-
grounds reached for the same word points toward a classical center that
defined these masks as its opposite (to idealized beauty), its necessary chaos
(to order and proportion), and located it in the established peripheral

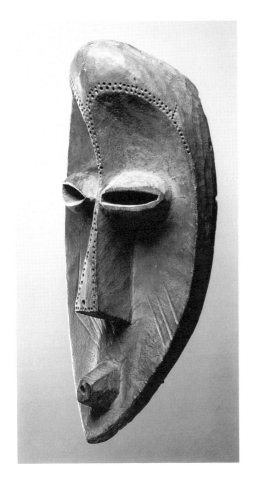

Fig. 11. Mask, Etoumbi region, People's Republic of the Congo, wood. Musée Barbier-Müller, Geneva

category of caricature. What could not be named or placed were those characteristics, such as performance, that did not correspond to the classical center and thus fell completely outside its orbit, invisible to European observers. Another example of this phenomenon can be found in the description by Philippe Burty, a Parisian art critic, of a model or mask made in Oceania by his contemporary, Charles Meryon. Making no effort to identify the particular Oceanic subject or tradition emulated by the artist, Burty characterized his mask as "grotesque savage" and compared it to an "antique faun."[29] In doing so, he translated only those aspects of the mask that could be held within the peripheral orbits of academic classicism and understood through its established categories.

Since academic classicism provided the principal framework through which a variety of other styles were named and understood, it is important to sketch the broad outlines of academic theory, leaving the individual variations of interpretation for discussion in Chapters 2 through 4. The Académie Royale, established by Louis XIV in the mid-seventeenth century, provided the classicizing foundation upon which other academies of art were established in the eighteenth and nineteenth centuries.[30] Thomas Crow argues for the essential magnanimity and *inclusiveness* of the eighteenth-century version of this institution, writing that "our received picture of the Academy as a monolithic, exclusionary body has been largely a myth."[31] The Academy could tolerate *Poussinistes* and *Rubénistes*, rococo and classical styles, and even the low realism of Chardin or Greuze. During the last quarter of the eighteenth century, Jacques-Louis David's powerful compositions reinstituted the classical model with a new moral and political force. In a particularly significant intersection of events, the first major influx of arts from the South Pacific and the Pacific Northwest entered Europe at just this moment when the classical tradition was reasserting its dominance. It was this renewed classicism against which "primitive" arts were measured and from which most of the nomenclature was taken to describe them. It must be emphasized, of course, that academic classicism provided the aesthetic model against which other traditions were measured, but the Academy as an institution did not impose these judgments.

During the nineteenth century the Academy found itself in the oxymoronic state of defending classical values while at the same time annexing nonclassical subject matter. The incorporation of medieval subjects or exotic costume pieces was rarely more than a superficial level of assimilation that left the academic pedagogy intellectually diminished but in place. The extreme eclecticism of academic art during the nineteenth century clearly indicates that the doctrine preached was more rigidly fixed than the art practiced. A distinction must be made between the varieties of artistic theory and practice that existed within the Academy during any given period and the broader perceptions (from both within and without the institution) of what the Academy espoused. It is that broader perception of academic classicism which concerns us here, for that was what Europeans reached for when confronted with radically different stylistic traditions. Burty provides a wonderful example of this process. Burty was a man of sophisticated tastes, an enthusiastic proponent of Japanese art and a supporter of several artists of the avant-garde. But when presented a mask of a "grotesque savage," his frame of reference was still the classical tradition.

This stereotyping of academic art was even more pronounced in the works of those dissenting artists and critics who defined themselves by their opposition to it. As the nineteenth century progressed, an increasing number of artists emulated one "primitive" model or another as a vehicle to escape or a weapon to attack the classical tradition. The belief that the classical norm was deeply entrenched inspired avant-garde artists to continue to rebel against it well into the twentieth century. Significantly, the visual characteristics ascribed to "primitive" art through this dominant classical framework continued to define what "primitive" meant throughout the nineteenth century and consequently shaped the possibilities and parameters of primitivism.

Academic pedagogy advanced a decidedly rational approach to the visual arts, casting them as participants in the liberal arts and as conveyors of great ideas. History painting was the genre of the serious artist. He was a man of ideas, not a mere artisan, and his rhetorical narratives were meant to teach and persuade the viewer. The artist-academician received rigorous training not only in technique but in history, literature, and aesthetics. Albert Boime writes: "The academy reasserted the equality of the plastic arts with the liberal arts, a principle it now declared by virtue of its theoretical instruction."[32] Since ratiocination constituted the key division between "primitive" and civilized, the primacy given to reason within the Academy ensured that "primitive" art was defined principally on this issue. Immersed in an immediate, physical experience of the world, the "primitive" had no means to objectify this experience and could create neither a naturalistic illusion nor a dramatic narrative. Narrative and illusion were twin issues, both deriving from the "primitive's" inability to mediate between himself and experience. Without the tools of rationality, the "primitive" could not master the abstract systems of illusion and narrative that formed the cornerstone of fine art in both the academic doctrine and the general expectations of the European public.

Owen Jones's illustration of an "ornament" from the Easters Archipelago illustrates the ways in which allegedly nonrational art traditions ran head-on into the exceeding rational expectations of academic art. Published in 1856, the illustration represents a type of "primitive" expression known to Europeans from the 1770s onward (see Fig. 5). The utilitarian (actually ceremonial) nature of the object was the first and most obvious reason to exclude it from a fine art tradition that inhabited the world of ideas and eschewed utility (and objecthood). It failed in both form and content as well, lacking convincing illusion and didactic narrative. This "primitive" expression pro-

vided clear evidence to the European observer that its maker could not muster the rational faculties necessary to impose order upon random experience in order to give it meaning and beauty. Unable to abstract from experience, the "primitive" could only manipulate line and color upon a two-dimensional surface. His fanciful patterns might suggest a smiling human face, but his designs could not pierce the club's surface with an illusion of a three-dimensional head. Just as important, the design lacked a narrative, an event isolated from experience and arranged for maximum dramatic and didactic effect. The submersion of the human figure within the pattern and the determination of its form by an ornamental scheme was further evidence that the "primitive" was not the master of his world. The "primitive" was as deeply in the thrall of nature as was the face within the pattern on the club. Moreover, "primitive" cultures were presumed bereft of the literary and historical sources so central to academic narratives. Instead, the sensual pattern cavorted upon the surface of the club with seemingly no responsibility to convey a higher meaning. Rather than speaking to the (European) viewer, the pattern remained mute and physical, the embodiment of the "primitive's" unfettered imagination.

Vico was precocious in recognizing the level of abstraction necessary to create both illusion and narrative. He argued that sculpture might be attempted by "primitives," but painting was not among their arts since an illusion of three-dimensionality on a two-dimensional surface was beyond their grasp. By way of example Vico observed that painting was neither mentioned in biblical nor Homeric accounts, although these early cultures were able to do some rudimentary carving in relief:

> The arts of casting in low relief and of engraving on metals had already been invented, as is shown, among other examples, by the shield of Achilles. Painting had not yet been invented. For casting abstracts the surfaces of things along with some relief, and engraving does the same with some depth, but painting abstracts the surface absolutely, and this is a labor calling for the greatest ingenuity. Hence neither Homer nor Moses ever mentions anything painted and this is an argument of their antiquity.[33]

Winckelmann, too, thought sculpture to be the more rudimentary art, requiring less abstraction than painting; even a child could give some sort of form to a soft mass, Winckelmann reasoned, but the child could not draw a three-dimensional form on a flat surface.[34]

Baudelaire pursued these same ideas in his essay on sculpture. He suggested that sculpture could reveal the particular talents of the "primitive" since it was itself the more "primitive" art form: "The origin of sculpture is lost in the darkness of time; it is therefore an art of Caribs. . . . We find that all peoples carve fetishes very skillfully long before they take up the art of painting, which is an art of profound reasoning and one whose enjoyment demands a particular initiation."[35] Baudelaire extended this observation to European peasants, claiming that they could not appreciate painting because they lived in a world devoid of higher thought: "Sculpture compares much more closely to nature, and that is why our peasants, who are delighted by the sight of a particularly well-turned piece of wood or stone, will remain insensible to the sight of the most beautiful painting."[36] A similar judgment appeared in William Oldfield's 1865 account of aboriginal Australians. Oldfield reported that these people could not recognize colored engravings of themselves and would respond only to "rude" and "exaggerated" drawings.[37]

Narrative was considered to be beyond the reach of the "primitive" artist because it, too, required the powers of abstraction. First of all, narrative presupposed a well-developed sense of history and an established literary tradition (though crude narratives could be made by cultures with an advanced oral tradition, as in Homeric Greece or biblical times). In addition, the narrative required the artist to select a particular event and to stage it in such a manner as to bring out the most dramatic aspects of the action. All of these tasks were utterly beyond the more "primitive" peoples who possessed so little self-reflection. In *The New Science*, Vico devoted far more space to the development of "primitive" expression than to the creation of illusionistic effects. He postulated that emblems and hieroglyphs served as the "primitive" form of narrative. Looking from within a tradition that valued art as visual discourse, and put *istoria* at the top of the genres, Europeans typically described that "primitive" imagery which had no suggestion of language as "ornament" and that which did as "hieroglyphic."

Without ratiocination, what fired the creative engines of the "primitive" artist? Again, Vico provided the interpretation that became the standard: the "primitive" imagination was unencumbered by reason, and was even more powerful than that of a civilized person, since reason subdued the imagination: "Imagination is more robust in proportion as reasoning power is weak" (*New Science*, 116). Vico noted also, that the "primitive" imagination had no direction or boundaries and easily fell prey to the senses and passions of the physical body: "it is . . . beyond our power to enter into the vast imagination of those first men, whose minds were not in the least

abstract, refined, or spiritualized, because they were entirely immersed in the senses, buffeted by the passions, buried in the body" (118).

This undirected imagination accounted for the enormous invention evident in "primitive" arts to European observers. The inventive power was remarked upon quite early by none other than Albrecht Dürer. Viewing Aztec artifacts in 1520, Dürer admired "the subtle *ingenia* of men in foreign lands."[38] In the Renaissance tradition, *ingegno* connoted native wit or natural ability; in other words, the creativity and ability to do things that could not be taught. Even in the Renaissance, *ingegno*, invention, and fantasy were overlapping concepts.[39] By the eighteenth century they were used interchangeably to describe the astonishing creativity found in many "primitive" arts. The *Dictionnaire de l'Académie française* of 1776 defined *ingénieux* as "plein d'esprit, plein d'invention."[40] The Comte de Bougainville also noted the "primitive's" "skill and ingenuity in the few necessary instances of industry. . . . It is amazing with how much art their fishing tackle is contrived" (*Voyage*, 258). Sydney Parkinson, an artist who sailed with Cook on his first voyage to the South Pacific, wrote of the Maori that "their fancy is wild and extravagant."[41] A few decades later, in 1819, T. E. Bowdich noted a similar element of fantasy in Ashanti arts. Of their architecture he wrote that "the windows were open wood work, carved in fanciful figures and intricate patterns."[42] William Whewell's thoughtful review of the Crystal Palace exhibition in 1851 included a meditation upon the "Progress of Art and Science": "man is, by nature and universally, an artificer, an artisan, an artist. We call the nations, from which these specimens came . . . rude and savage, and yet how much is there of ingenuity, of invention . . . in the works of the rudest tribes!" (*General Bearing*, 4–5).

While ingenuity was a highly valued trait, it was no substitute for the great learning required of the artist. Genius and invention had to be directed, shaped, and made to embellish the essential structures of narrative and illusion. Ingenuity made the difference between a competent artist and the artistic genius, but without careful cultivation it was quick to overrun its boundaries. Thus the fantasy and invention of "primitive" art exhibited the native wit of its maker but it was unredeemed by rational structure. The frequent designations of "primitive" imagery as ingenious were often phrased in such a way as to imply that even though the artist lacked reason, he was surprisingly clever and innovative considering his limitations. Perhaps this is most apparent in the connotations of ingenuity's etymological sister, *ingénue*: "naïf, simple . . . sans déguisement, sans finesse."[43]

Although the French Academy built upon the classical tradition as articu-

lated through Renaissance art and theory, the institutionalization of these ideas seems to have elevated the rational ordering of experience to an all-powerful role, while diminishing the force of the imagination. To be sure, the academic emphasis upon the rule of reason was based squarely upon Renaissance ideals. But the classical tradition of the Renaissance valued nonrational faculties like *ingegno* and *furia* as well, in fact recognizing them as the traits that distinguished the inspired genius from the competent artist. For all the treatises on proportion and composition, the ultimate test for a painted or sculpted figure was whether it seemed to live and feel. This was a test for the artist's full faculties, not just the talking head of reason.

This semblance of life was not the pinnacle of academic achievement, however. As we shall see, the Academy disembodied the classical tradition by making it a tyranny of reason, reducing the creative imagination to a cameo role as the initial inspiration for a painting or sculpture. Clarity, ideal beauty, universality, and order were the hallmarks of academic classicism.[44] It was the *idea*, born in the mind of the artist and carefully incarnated into idea-lized form, following standardized formulas for representation, that was the locus of creativity in academic thought. In his preface to the *Conférences de l'Académie Royale de Peinture et de Sculpture (1669)*, Félibien wrote that the artist must first "have a perfect knowledge of the thing which one intends to represent, of those parts which compose it, and of the means by which one must proceed. And this understanding that one obtains, and creates according to these rules, is in my opinion that which one can give the name of Art."[45]

The categorization of individual ideas and practice into a systematic aesthetic theory had already begun in the late sixteenth century with the publications of Lomazzo.[46] The curriculum and published discourses of the academies continued this tendency but evidenced the passion for system and formulas that was the hallmark of the reign of Louis XIV and, with an increasingly scientific cast, of the Enlightenment. A simpler observation might also be that the academic curriculum emphasized those aspects of art that could be taught. Imagination, invention, inspiration had traditionally been considered inborn, native faculties. Finally, the influence of Cartesian thought upon academic pedagogy cannot be underestimated. This was especially apparent in the academy's belief that "every element in a painting, whether formal or expressive must as a logical part of a rational order unfailingly contribute to the demonstration of a central dramatic idea."[47] Three concepts in academic classicism played a particularly important role

in Europeans' interpretation of "primitive" art: *ut pictura poesis*, artistic license, and the *dessin idéal*.

Ut pictura poesis was critical to the interpretation of "primitive" art. The phrase "as is painting, so is poetry," gathered together several ideas key to the "humanistic theory of painting." Broadly interpreted, *ut pictura poesis* linked the visual and the verbal as sister arts and thus included painting and sculpture among the liberal arts. Their most important commonality, according to Aristotle, was that both poetry and painting should depict "human nature in action."[48] This idea was reinstated emphatically during the Renaissance: "the core of the new as of the ancient theory that painting like poetry fulfills its highest function in a representative imitation of human life, not in its average but in its superior forms, [was] . . . important and central to any final estimate of the painter's art."[49]

The expectation that the visual be verbal became even more fixed within the academic system. Although other genres flourished in European arts from the seventeenth century onward, history painting consolidated its position as the most noble genre and was institutionalized in the French academy as the chief concern of the *grand peintre*. Félibien wrote that while the "mere representation of things [was] a mechanical process," the truly great artist was one who presented noble themes: "il faut représenter de grandes actions comme les Historiens."[50] The model for aspiring students was the *peintre-philosophe* Nicholas Poussin. Rémy G. Saisselin has argued that the rise of art criticism in the eighteenth century (with the first regularly held Parisian exhibitions in 1737) imposed further literary expectations upon painters: "Because the art critics were men of letters, consequently, they did not look at paintings the way painters, amateurs, connoisseurs, *curieux*, or collectors did, and they expected the paintings to do something the paintings were often not intended to do. The new critics looked at paintings as if they were texts, as if they were literature in the form of images."[51] Most of the art criticism did indeed cast a cold eye upon the still life, portrait, and genre subjects that flourished during the rococo era, calling instead for a return to noble and uplifting themes.

The other issue engaged in Horace's *Ars poetica* that intersected with European confrontations with "primitive" art was that of artistic license. Horace's discourse on the limits of invention could be construed to argue for or against artistic license.[52] Academic doctrine took the latter reading, believing that the inventions of the artist's imagination must be closely regulated by the rational faculties. The rich meanings of the term "invention" in Renaissance thought were flattened to such a prosaic level that to

most academics "invention" referred to the choice of an appropriate sub-
ject.[53] Needless to say, Europeans accustomed to these notions of art found
"primitive" art to be mute, visual play, all wild invention with no mediating
verbal component whatsoever.

Consider Joseph Banks's characterization of Maori carving seen during
Cook's first voyage:

> Their boats were not large but well made, something in the form of
> our whale boats, but longer . . . on the head of every one was
> carved the head of a man with an enormous tongue reaching out of
> his mouth. These grotesque figures were some at least very well
> executed some had eyes inlaid of something that shone very much;
> the whole served to give us an Idea of their taste as well as their
> ingenuity in execution.[54]

Even while some Europeans expressed admiration for "primitive" invention,
their interest was tempered by a discomfort with its extremes. Although
Joseph Banks clearly recognized the ingenuity of Maori art, he connected it
with the grotesque and repeatedly commented upon its "wild taste."[55]
George Förster, also with Cook, less charitably called the figurehead of a
Maori canoe "a misshapen thing, which with some difficulty we perceived
was a human head, with a pair of eyes of mother of pearl, and a long tongue
lolling out of its mouth."[56] Apart from the issue of excess, "primitive"
ingenuity was not considered enough to create works equal to the fine arts
of Europe. Europeans drew a clear line between the "primitive's" play of
fantasy and the sophisticated transformations necessary for the creation of a
work of fine art as defined by the Academy. The academic tradition in
eighteenth- and nineteenth-century Europe kept a tight rein upon the
imagination, much more so than its Renaissance prototype.

The rule of reason was perhaps most directly embodied in academic art
through the concept of the *dessin idéal*. If *ut pictura poesis* dealt with
content, the *dessin idéal* was the governing formal principle. *Dessin* had as
its foundation the rule of mind over matter and the rule of theory over
nature. Correct proportions and spatial relations, standardized gestures, as
well as conventions of beauty and decorum were imposed upon unruly
nature. While *dessin* referred specifically to the act of drawing, its broader
meaning extended to the artist's formulation of the idea for his composition.
As Boime writes: "Drawing alone was taught at the Academy and the
Academy emphasized it as the theoretical element uniting all branches of

art" (*Academy*, 4). The inception of the work of art was in the mind of the artist and drawing was the embodiment of the idea into visual form. According to the painter Antoine Coypel, the artist must first learn how to think before learning how to paint: "Avant donc que de peindre, apprenez à penser."[57]

Primitivism: The Embrace of the Peripheral

Where does the primitivism of avant-garde artists fit into the classical framing of "primitive" art? The emulation of "primitive" art by modern artists has traditionally been described as a discovery or an epiphany, in which certain artists broke radically from accepted norms to incorporate "primitive" expressions that would eventually lead to the overthrow of the academic tradition. But the avant-garde did not so much break from the aesthetic norms as turn them upside-down, because the center of academic classicism determined the ways in which they rebelled against it. These artists understood "primitive" art in exactly the same ways as their contemporaries, but inverted the value ascribed to its characteristics. Gauguin, too, characterized Polynesian arts as ornamental, but inverted this "fact" from an inferior trait to one superior to academic rhetoric. Primitivizing artists held the same assumptions concerning the nature of "primitive" art and used the same nomenclature. The critical difference lay in their rejection of the classical center, a rejection that led them to embrace its presumed opposite, the peripheral "primitive." These artists seeking to overthrow academic classicism nevertheless operated within its system. They reinterpreted the *non*classical as *anti*classical and turned the periphery as a weapon against the center. In short, the reasons for admiring "primitive" art were just as culture-bound as those reasons for rejecting it.

The dissatisfaction with the fine-arts tradition and the desire to rejuvenate it prompted the incorporation of "outside" elements on the periphery. By the controlled assimilation of the wild and untamed, the old and staid might be reanimated. Lotman, Uspenskij et al. described the phenomenon in this way:

> The active role of the outer space [periphery] in the mechanism of culture is particularly revealed in the fact that certain ideological systems may associate a culture-generating source precisely with

the outer, unorganized sphere, opposing it to the inner, regulated space as culturally dead . . . that which is not culturally assimilated, but which constitutes the germ of future culture. ("Theses," 4)

Primitivism in the visual arts was (and is) an urge toward deliberate regression combined with an even more compelling desire for rejuvenation.[58] This sentiment was forcefully articulated by Friedrich Schiller in his essay, *On the Aesthetic Education of Man* (1793–95). Schiller argued that it was no longer possible for a youth to learn to be a great artist; instead, the aspiring artist-prophet must travel back in time to study from the ancients themselves:

> No doubt the artist is the child of his time; but woe to him who is its disciple, or its favorite. Let a kind deity take the infant betimes from the breast of his mother, let it nourish him with the milk of a better age, and let him mature beneath the distant skies of Greece. Then when he has become a man, let him return to his century as a foreigner, not to delight it with his appearance, but rather, terrible like Agamemnon's son, to cleanse and purify it.[59]

If primitivism was synonymous with a desire for rejuvenation, it was also fueled by a wish to escape the responsibilities of reason and to allow nonrational faculties, the imagination, the passions, the spiritual, freer reign.

In the progression of primitivism in the visual arts from the late eighteenth century to the early twentieth, the peripheral boundaries of modern European culture were extended as those elements that had existed on the fringe were assimilated. The peripheral net was cast farther and wider as a voracious modern culture incorporated one "primitive" style after another more radically "other," moving beyond its own historical "primitives" of ancient Greece to its own contemporary folk "primitives" to the Japanese "primitive" and, finally, to the outer reaches of the "primitive," the Oceanic and the African. As the boundaries of modern culture extended, its "forefield" of "primitive" traditions "steadily expanded" toward those most alien to Europeans.[60]

Chapters 2 through 4 will pursue the implications of several key terms used to characterize "primitive" art. They will progress from the most readily admired and assimilated aspects to the least, from the two-dimensional to

the three-dimensional, from the most verbal to the most mute. Each of these terms depends upon the idea of the "primitive's" vivid imagination, but each chapter will expand upon a different aspect of this imagination. Hieroglyphics were considered to signify the "primitive's" corporeal imagination, his investing of tangible things with intangible ideas. They were the closest to narrative and the most readily noted by Europeans. Ornament and the ornamental grotesque were the products of "primitive" fantasy and invention. The monstrous grotesque, caricature, and the idol represented the darkest reaches of the "primitive" imagination overheated by violent passion and frightful superstition.

2

Poetic Monsters and Nature Hieroglyphics: The Precocious Primitivism of Philipp Otto Runge

Philipp Otto Runge's *Tageszeiten* (Times of day), four compositions developed between 1802 and 1810, represent one of the more remarkable examples of Romantic experimentation. Of particular significance is Runge's move toward a primitivist aesthetic through the incorporation of a hieroglyphic structure for the *Tageszeiten*. While many of the German Romantics, including F. Schlegel, Wackenroder, Novalis, and Tieck, were fascinated with the hieroglyphic and the arabesque (visual structures they understood to be "primitive"), Runge went beyond the aesthetic theory of his compatriots to actually assimilate these "primitive" elements into his compositions.[1] It is surprising, then, that his efforts have not been recognized in the literature on primitivism. This chapter will consider European interpretations of the hieroglyph as a "primitive" expression and the effects of this idea upon the emergence of primitivizing styles in European art. The debate concerning hieroglyphs best exemplifies the role played by nonnarrative visual language in the emergence of primitivism.[2] Hieroglyphs were the imagery most closely related to the written word and, perhaps for this

reason, seem to have been the first element of "primitive" expression to attract the attention of Europeans, which makes its absence in the literature of primitivism particularly puzzling.

As we have seen, the formative debates concerning the nature of "primitive" art gave as much importance to the *means of expression* as to purely formal concerns. Europeans measured these other art traditions not only by a standard of illusionism but with an expectation of narrative. Looking from within an academic tradition that valued *histoire* above all other genres, *ut pictura poesis* played as much a part as the *dessin idéal* in European interpretations of "primitive" art. The Romantic interest in the hieroglyphic has been overlooked to a large extent because it was concerned with a "primitive" or prerational vehicle for meaning, and not just a more "primitive" means to represent form. Its omission suggests that we have represented primitivism with a kind of intellectual *chiaroscuro*, highlighting those variants that led toward abstraction via a deliberate naïveté and a rejection of illusionistic devices, while obscuring other significant efforts almost completely. This hypothesis would seem to be corroborated by the fact that the experiments in linear abstraction by Runge's contemporaries, John Flaxman or the *Barbus*, have been carefully researched and included in the literature on primitivism.[3] Establishing that a number of Romantic artists and thinkers identified the hieroglyph as a "primitive" and poetic means of expression that they then adopted as a weapon against academic narrative is to mark the commencement of an alternate path in the development of primitivism.

The earliest Enlightenment studies of "primitive" peoples paid unusual attention to hieroglyphic and emblematic imagery. This included a range of imagery, from pictographs and reductive signs, such as tattoos, to various kinds of emblemata. What these hieroglyphs shared was that they were a pictured, or visual language rather than a fixed, abstract alphabet. While Vico only briefly discussed relief carving, he made repeated comparisons between poetic expression and hieroglyphs, and between "primitive" emblems and contemporary heraldry. Père Lafitau, an unusually observant chronicler of the Iroquois, described no Huron or Iroquois imagery except tattoos and hieroglyphs in his *Moeurs des sauvages* of 1724. Hieroglyphic figures were not new to Europeans, of course. The Renaissance fascination with Egyptian hieroglyphics was quickly extended to Aztec codices, perhaps the first "primitive" imagery to be illustrated by Europeans with any semblance of accuracy (as opposed to the numerous fantastical representa-

tions of savage idols). Woodcut copies of Aztec codices are reported to have been published as early as 1615, and reproductions of the *Codex Mendoza* appeared in Samuel Purchas's travel accounts in 1625.[4] The Bérighen cabinet acquired for the Royal Library of Louis XV in 1732 included prints of Aztec "hieroglyphics" from the Vatican Library, the Imperial Library of Vienna, the Royal Library of Dresden, and the Royal Library of Berlin.[5] In his famous observations of 1519 regarding Aztec artifacts, Albrecht Dürer made particular mention of those objects made of precious metals and "two books such as the Indians use."[6] It should be added that virtually all the objects made of precious metals were collected for that particular property and quickly melted down.

The European bias toward imagery that seemed to speak was expressed not only through their interest in hieroglyphics but also through their attention to tattooing and totemic imagery. A striking example can be found in Jacques Le Moyne's representation of a Florida chieftain, Outina, and his retinue, as engraved and published in 1591 by Theodor de Bry in his *Great Voyages* (Fig. 12). The figures in the foreground are literally walking totems and living histories, their tattoos overlaid with medallions, their heads surmounted by heads of animals.

The Renaissance had interpreted hieroglyphics as a mystical language, perhaps created by a priestly caste, whose sacred meaning was intentionally veiled to all but the initiated.[7] Enlightenment theorists such as Vico (1725), Père Lafitau (1724) and later, Antoine Court de Gébelin (1773–82) offered a new interpretation, that hieroglyphics were the first written language of early peoples, a physical alphabet made of objects rather than of abstract letters. The invention of an abstract alphabet marked the threshold through which a given culture passed from a "primitive" state into a rational, civilized one. Vico conjectured that prior to the development of an abstract alphabet, histories and scriptures took the form of either spoken poetry or emblematic imagery: "Thus the first language in the first mute times must have begun with signs, whether gestures or physical objects, which had natural relations to the ideas [to be expressed]. . . . Scholars have failed to understand how the first nations thought in poetic characters, spoke in fables, and wrote in hieroglyphs."[8]

While Vico only briefly discussed relief carving, he made repeated comparisons between poetic expression and hieroglyphs. Pointing out that the Egyptians were not the only culture to invent a sign language, he wrote that "all first nations spoke in hieroglyphs . . . by a common natural necessity." He continued: "In the West Indies the Mexicans were found to

Fig. 12. Theodore de Bry, after Jacques Le Moyne de Morgues, *Outina on a Military Expedition*, engraving, from de Bry, *Great Voyages* (Frankfurt-am-Main, 1591), part 2

write in hieroglyphics," and in North America Indians "distinguish families by their totemic symbols; which is the same use that is made of family coats-of-arms in our world" (*New Science*, 142–43). Vico considered the European heraldic tradition to be a vestige of the "primitive" hieroglyph, or emblem, that had carried over into civilized society. Although learned emblems had developed from the heraldry, Vico noted that "they have to be explained by mottoes, for their meanings are [now merely] analogical; whereas the natural heroic emblems were such from the lack of mottoes, and spoke forth in their very muteness. Hence they were in their own right the best emblems, for they carried their meaning in themselves" (161).

Père Lafitau, in his *Moeurs des sauvages américains* of 1724, illustrated the use of hieroglyphics by the Iroquois (Fig. 13) and explained in the caption that an ancient Pict (from prehistoric Britain) stands on the left and two North American Indians on the right, one of whom is "engraving his portrait on a tree and writing, in his own manner, what he desires to make known by this monument."[9] Lafitau also recognized the tattooing he ob-

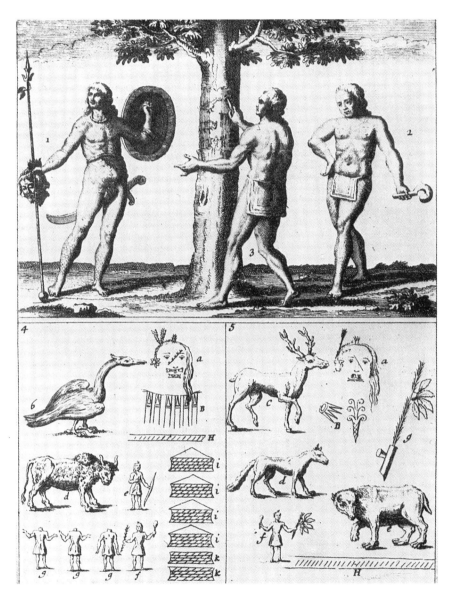

Fig. 13. *Hieroglyphs of the American Indian,* engraving, from Joseph-François Lafitau, *Moeurs des sauvages américains* (Paris, 1724)

served among the Iroquois as part of the hieroglyphic tradition and compared the American tribes to the barbarians that the Romans had named in derision "the lettered ones, or the chiseled ones" (2:43). He wrote: "The figures which the Indians have graven upon their faces and bodies serve them as hieroglyphs, writings and memoirs. . . . He supplies the lack of alphabet . . . with characteristic marks which distinguish himself personally" (2:43). When Europeans sailed into the South Pacific during the last decades of the eighteenth century, they too were fascinated by the tattooing customs of the Maoris and Marquesans, as well as by pictographs encountered at Easter Island. During the first of Cook's three voyages, Sydney Parkinson made a wash drawing, "Head of a Chief of New Zealand, the Face curiously tattoowed, or mark'd, according to their Manner" (Fig. 14).

Lafitau extended his rationalist explanation of "primitive" emblematic language to the masking practices of the Iroquois as well as to the hybrid creatures of classical mythology. Drawing upon his five years among the Iroquois, he proposed that the satyr was not a mythical creature at all but a poetic figure that represented powerful warriors and leaders. Illustrating this, Lafitau placed two mythical satyrs in the center of the engraving and flanked them with a prehistoric German and an American Indian (Fig. 15), reasoning that:

Fig. 14. Sydney Parkinson, *Head of a Chief of New Zealand, the Face curiously tattoowed, or mark'd, according to their Manner,* engraving after drawing, c. 1769, from Hawkesworth, *Voyages* (London, 1773), pl. 13

Fig. 15. *The Origin of the Myth of the Satyr*, engraving,
from Joseph-François Lafitau, *Moeurs des sauvages
américains* (Paris, 1724)

These species of extraordinary men with horns on their head, goat's
feet and tails hanging from their backside, have nothing of reality
and only owe their existence to the imagination of poets, to the
hieroglyphic expressions of the earliest times and to the ignorance
of later centuries. . . . Since the style of writing and the taste of the
first centuries dealt in allusions and emblematic figures, they took
pleasure in enveloping all that they had to say within fabulous
conceptions which were like so many enigmas which were under-
stood very well by those to whom they were spoken, but which
were not understood well enough by those who came too late after
them. (2:19–20)

In short, these emblematic figures were taken too literally by later (more rational) generations. Despite his arguments for the hieroglyph as crude alphabet, Lafitau also maintained the interpretation of hieroglyphics as man's natural desire to speak of divine things through a symbolic, mysterious language (1:100).

These two interpretations, crude alphabet and sacred language, shared the notion that hieroglyphics were poetic by nature, being allusive and suggestive in their meaning (whether by intention or by default) rather than descriptive and prosaic. Vico saw hieroglyphs and emblems as the visual equivalent of poetry, each juxtaposing and conjoining objects in such a way as to suggest possible meanings, and described these metamorphic, hybrid forms as "poetic monsters" (*New Science*, 131). Unable to abstract concepts or universals from experience, the "primitive" communicated his meaning *poetically* through the combined properties of various objects: "The heroic language was a language of similes, images, and comparisons, born of the lack of genera and species. . . . They expressed themselves by means of gestures or physical objects which had natural relations with the ideas" (315–16, 139). This notion was echoed by other perceptive observers, including Captain Etienne Marchand, in his description of the arts of the Northwest Coast, written in August 1791: "The taste of ornament prevails in all works of their hands; their canoes, their chests, . . . articles of furniture . . . are covered with figures which might be taken for a species of hieroglyphics: fishes and other animals, heads of men, and various whimsical designs, are mingled and confounded in order to compose a subject."[10]

Theories concerning "primitive" expression would have remained within the boundaries of ethnography except for their pertinence to the rising debate concerning the use of allegory (this term loosely used to describe a variety of symbolic and emblematic figures) versus dramatic narrative in the fine arts. The real kernel of the argument lay in the interpretation of *ut pictura poesis*, the relationship of the visual to the verbal.[11] This debate involved a distinguished list of eighteenth-century theorists, including the Abbé Du Bos, Shaftesbury, Diderot, Winckelmann, Lessing, Herder, and Quatremère de Quincy, and was of consuming interest to the emerging Romantic movement. Dramatic (and didactic) narrative was the norm, of course, institutionalized through the influence of the French Académie Royale and held up as the noblest genre an aspiring artist could choose.

Narrative had become an exceedingly rational visual language through academic pedagogy, which imposed a system of ideal relations upon visual experience in order to stage its grand, literary themes most effectively. The narrative portrayed a dramatic moment taken from a chronological se-

quence, with standardized gestures and facial expressions so that the narratives might be more accurately "read" by the viewer. In his influential meditation upon the relationship of word to image, G. E. Lessing observed that the painter can only choose a single moment from the flux of experience, so that if "their works are made not merely to be seen, but to be considered . . . then it is certain that that single moment . . . can never be chosen too significantly."[12] Rémy Saisselin has characterized this institutionalized version of *ut pictura poesis* as a "devolution" from painting as a form of poetry to "painting as an alternate form of writing or, perhaps better, painting as *écriture*. It became not so much silent poetry as silent discourse" ("Painting and Writing," 121). In contrast to didactic narrative, the meanings of allegorical figures and emblematic compositions were decidedly less circumscribed and fixed. Rather than subjugating the physical and sensuous nature of art to the exposition of grand ideas, the hieroglyphic image was unabashedly physical and only suggested possible meanings through the juxtaposition or the conjoining of concrete objects.

In his *Réflexions critiques sur la poésie et sur la peinture* (1719), the Abbé Du Bos argued that allegorical figures spoke an outmoded visual language that might have been meaningful in earlier times but was unsuited for modern audiences. Du Bos admitted that the older allegorical figures were well known to all, but he objected to allegorical figures of a "modern date . . . such as are daily invented by painters," calling them "strangers and vagabonds . . . , a kind of cypher, whereof nobody has the key and very few are desirous of having it."[13] Shaftesbury, with similarly rationalist inclinations, described intentionally enigmatic emblems as perversely obscure and pandering to superstition, and denounced them as: "Enigmatical, preposterous, disproportional, gouty and lame forms. . . . Egyptian hieroglyphics. Magical, mystical, monkish and Gothic emblems."[14] Because the hieroglyphic figure (in contrast with narrative) seemed all unrestrained sensuality and invention, it provoked debate regarding artistic license. Du Bos appealed directly to Horace's discourse: "Painters, 'tis true, are poets, but their poetry does not consist so much in inventing chimeras and extravagant conceits, as in imagining justly what passions and sentiments ought to be attributed to their personages, according to their character and supposed situation . . . and in making us form a right conjecture of those sentiments" (*Réflexions*, 1:157).

There remained, however, a strong inclination toward the emblematic and hieroglyphic for the same reasons that damned them in other quarters: poetry, visuality, and sacred mystery. The old literary warhorses seemed nearly exhausted and a mounting chorus of voices lamented the loss of

invention and of imagination. George Richardson, a British architect who specialized in the decoration of interiors, published in 1779 an updated edition of Cesare Ripa's *Iconologia* with his own funds (though the book was sufficiently popular to warrant a second edition).[15] Richardson appealed to the fact that the ancients themselves had made great use of emblematic figures:

> The celebrated Cavaliere Ripa with indefatigable study made a collection of the Emblematical Figures of the ancient Egyptians, Greeks and Romans, and published them together with others of his own invention. The ancients, delighted with these images ingeniously concealed under them the mysteries of nature and philosophy, of divinity and religion. The prophets veiled their sacred oracles with enigmas; OUR SAVIOUR himself comprised most of his divine mysteries in parables. (i)

Though not an aesthetician, Richardson's observations went to the heart of the criticism leveled against the literary character of academic painting. He further noted that the poetic qualities of the allegorical and emblematical were perhaps closer to the real genius of the visual arts:

> It is therefore necessary to enlarge the compass of this sublime art [painting], and make it extend to those objects that do not fall within the province of our external senses. This may appear, at first sight, an extraordinary attempt, and be even looked upon by many as a romantic one; but it will be found, upon a closer examination, not only that painting may be thus extended, but also, that its highest perfection consists in this method of employing it. (iii)

During the last decades of the eighteenth century, the conviction that stagey academic narratives were nearly bankrupt of meaning led many to yearn for the interiority and suggestion of more poetic expression.[16] Nowhere were these ideas so well advanced as among the German Romantics, who sought to rejuvenate art by returning it to its origins and beginning again. Johann Georg Hamann's own poetic style perhaps expressed these associations best: "Poetry is the mother-tongue of the human race; even as the garden is older than the ploughed field, painting than script; as song is more ancient than declamation; parables older than reasoning. . . . The

senses and passions speak and understand nothing but images. The entire store of human knowledge and happiness consists in images."[17]

The German Romantics joined the interpretation of the hieroglyph as "primitive" expression with that of sacred language. A strong pantheism led many to the notion that the natural world was the hieroglyph of God and consequently, the contemplation of nature's alphabet could reveal divine truths. But the meaning of these divine hieroglyphics of nature was long lost to rational, civilized peoples, and (following Rousseau's lead) were legible only to the natural eye of the "primitive." Novalis believed that in the childhood of humanity the language of nature was understood and re-created through hieroglyphs: "The hieroglyph of nature has an emblematical character only as long as man is separated from nature."[18]

Art, too, was a divine language and so, the artist should speak through meaningful correspondences in the natural world, creating hieroglyphs with which he could express essential truths to the human spirit.[19] In his influential *Confessions from the Heart of an Art-Loving Friar* (1797), Wilhelm Wackenroder drew a connection between divine creation and artistic creation in a brief essay entitled "Concerning TWO WONDERFUL LANGUAGES and their mysterious power":

> Art is a language of a totally different kind than Nature; but it also has, through similar obscure and mysterious ways, a wonderful power over the hearts of human beings. It speaks through pictures to mankind, and thus makes use of a hieroglyphic script, whose signs we recognize and understand in their outer appearance. But it fuses the spiritual and supersensual in such a moving and admirable way into these visible forms that our whole being, and everything around us, is stirred and shaken profoundly.[20]

Philipp Otto Runge incorporated these ideas concerning hieroglyphic expression into a new visual language, and in doing so advanced toward a primitivist aesthetic.[21] Runge's interest in hieroglyphics drew upon the theories of several German aestheticians, from the writings of Schelling, Hamann, and Herder to the more immediate influences of Tieck, Wackenroder, and Friedrich Schlegel. Schlegel stated in his *Gespräch über die Poesie* (1799–1800) that the arabesque was "die älteste und ursprünglichste Form der menschlichen Phantasie"[22] and went further to link this "primitive" expression to characteristics in the arts of contemporary Romantic writers and painters. While hieroglyphic expression was considered a necessity for

the nonrational "primitive," it was the deliberate choice of the Romantic artist to regress to a more primal visual language. Runge sought to recover what he perceived to be a simpler and more youthful means of expression by intentionally rejecting certain aspects of his own art tradition that he found to be overrefined and insincere.

Runge believed that he lived in the last years of a passing age and that the old formulas in the arts were no longer adequate. By 1802, the twenty-five-year-old artist arrived at the conclusion that history painting was dead (Michelangelo's *Last Judgment* was the last great statement in this genre, according to Runge)[23] and that academic training, which he had briefly undertaken in Copenhagen, had diverted the arts from their true genius: "Art as we now see it is a convoluted and learned thing . . . ; but if people looked at the world as children, art would be a pretty language."[24] His search for "true art" led Runge in a familiar direction, back to the past: "I have tried to penetrate what true art may be, what an artist must seek to obtain first, what may be the first beginning of a work of art."[25] Runge did not take the easier step into historicism, particularly the overt medievalizing of his contemporaries, the Nazarenes, but looked for the deeper structures of meaning in the arts of the past. He consciously rejected simple stylistic borrowing, comparing it to copying letters from another language without being able to read or understand them.[26]

To Runge's mind, landscape was the vehicle through which a modern artist would find his highest expression. It was no picturesque landscape that Runge intended, but one that embodied divine mysteries. Contrary to the academic dictum that the narrative should instruct the viewer through the representation of human actions, Runge sought to enrapture and transport him to a higher spiritual awareness through a new kind of landscape. The artist maintained that the evolution of this new genre would first "lead more toward arabesques and hieroglyphs; however, from them the landscape would emerge."[27]

Runge hoped to coalesce these ideas into a masterwork, a cycle of four compositions, or emblems, of the *Tageszeiten*, a plan cut short by the artist's death at the age of thirty-three. If we look at the one intact painting from the cycle, a small version of the *Morning* (1808; Fig. 16), we find an image distinctly different from the art of its time. The stylistic influences for the *Tageszeiten* provide further evidence for Runge's primitivist tendencies. The emphasis upon contour and the reduction of modeling (especially in the drawings and prints related to the series, and to a lesser extent in the paintings) derive from "primitive" sources, most notably Greek vase paint-

Fig. 16. Philipp Otto Runge, *Morning*, from the *Tageszeiten*, 1808, oil on panel.
Kunsthalle, Hamburg

ing, medieval panel painting, and the linear abstraction practiced by John Flaxman and other neoclassical artists. The proponents of linear abstraction rejected the formal values of high finish, atmospheric effects, and accomplished illusionism for simpler, plainspoken renderings that did not attempt to fool or titillate the eye. Diderot's axiom, "Paint as they spoke in Sparta," foreshadowed the goals of these artists, which included those students of David known as *les Primitifs* as well as the German Nazarenes. Runge had seen Flaxman's line drawings from Homer and Dante (1793), as well as Tischbein's drawings of classical vase paintings in the collection of Sir William Hamilton (4 vols., published 1791–95). Runge himself illustrated the Ossian "legend" with line drawings in 1804.

But Runge went beyond this reductive imagery to actually incorporate a *compositional structure* associated with "primitive" expression; that of the arabesque. The *Tageszeiten* are closest to Raphael's famed *grotteschi*, fantastical, metamorphic ornaments painted by Raphael and his studio in the private apartments of the Vatican (1516), which were themselves inspired by the discovery of Roman wall decorations. Runge knew of these arabesques, as well as those discovered in the ruins of Herculaneum and Pompeii, and created several decorative compositions in this mode (Fig. 17).[28] It is instructive to compare Runge's *Morning* with an engraving of one of a group of Roman and Renaissance arabesques published in 1789 (Fig. 18).[29] Like the arabesque, Runge's *Morning* presents fantastic, metamorphic figures arranged in an outer frame with a more allegorical scene filling the inner frame. If the *Morning* resembles the arabesque in format and invention, it also differs profoundly. Runge's compositions carry deep meaning for their viewer while the arabesque is an invention of sheer fantasy with no pretense toward significance. Runge's contemporaries recognized that Runge's intentions extended far beyond the fanciful arabesque, as Tischbein wrote in 1806:

> If one compares these works with others, one must count them among the genre of arabesques. . . . The artist, certainly one of the most fascinating of our age, has put meaning in the sequence and sense in the detail, so that his leaves are not only apt to be pleasant to the eye, but simultaneously exciting to our inner sense; in fact, the meaning develops from allegory to mysticism.[30]

These stylistic influences, while crucial, must be matched by the influence that the *idea* of "primitive" expression as hieroglyphic had upon Runge. Instead of "successive narration," Runge wrote in 1807, he used "character-

Fig. 17. Philipp Otto Runge, *Arabesque: The Joys of Hunting*, 1808–9, pen and
aquarelle on paper. Kunsthalle, Hamburg

Fig. 18. *Le plafond de la Ville-Madame, peint après les dessins de Raphaël*, ceiling design, from M. Ponce, *Arabesques antiques* (Paris, 1789). Ryerson and Burnham Library, The Art Institute of Chicago

istic signs" that he arranged in constellations of form and color in order to produce the total effect he desired.[31] The artist suggests his meaning to the viewer through the juxtaposition of natural forms, stacking and layering these forms, enframing one with another, so that the meaning is accumulated and deepened by these multiple associations. In describing Runge's imagery as "nature hieroglyphics," Schlegel rightly understood that the artist intended his compositions to be hieroglyphic in both form and meaning.[32] To this end, Runge developed a complex visual language that drew upon several sources while being dependent upon none.

Runge broke the holds of narrative by adopting a decorative structure and investing it with meaning. His pictorial composition of a frame within a frame diminishes the traditional illusionistic window as a stage for dramatic action. In the inner frame, layered associations of child, morning, sunrise, Aurora, are presented with the iconic centrality of the medieval altarpiece and the mirror symmetry of heraldic emblems, without directly quoting either.[33] The bilateral symmetry and the multiplication of seraphim in the upper registers clearly disengage from narrative exposition, a break intensified by the wonderfully metamorphic figures that fill the outer frame, moving from botanic to human and from dark to light. These figures are hieroglyphic in themselves, Vico's poetic monsters, Schlegel's nature hieroglyphics. But these fluid, evolving outer forms also set up a hieroglyphic relationship with the more static figures of the inner frame, and serve to "indicate both the close and the more remote relationships and transitions from one picture to the next."[34]

Runge added to the hieroglyphic density of these images by his selection of formal characteristics as well. He wrote a treatise, *Die Farbenkugel* (Hamburg, 1810), on the expressive potential of color and light, even attempting to work out a system where certain colors evoked musical tones as well as certain emotions (and, it should be added, well in advance of Baudelaire's concept of synesthesia).[35] In sum, the entire fabric of the *Tageszeiten* was invested with meaning and spoke to the viewer in a manner that was "primitive" and prerational. Rather than dealing with "airy abstractions" as one scholar suggests, Runge's intentions were quite the contrary. He *reembodied* profound themes by making them hieroglyphic, juxtaposing and conjoining physical objects in such a manner that they suggested meanings, not to the intellect but to the imagination.

The primitivist intentions of the *Tageszeiten* are further corroborated by Runge's use of linear abstraction, reductive imagery often described as hieroglyphic by contemporary observers. In terms of pure representation, Flaxman's line drawings are to sophisticated illusionism what the hieroglyph is to dramatic narrative: each reduces description, one visual and the other verbal, to evocative suggestion. A. W. Schlegel compared Flaxman's linear abstractions to poetry because "their few, allusive lines stimulate the spectator to complete the forms in his imagination."[36] It is essential, however, that we recognize the distinction between Flaxman and Runge in the matter of *ut pictura poesis*. Flaxman's radically reductive figures and space serve to condense the narrative by removing all that is extraneous to it. His disembodiment of the physical world has the result of binding the viewer's

imagination to the literary text even more tightly. A similar relationship can be argued between Blake and Runge. Blake is certainly much closer to Runge in temperament, and his subjects are more often mythical figures of his own invention than those of past literature. Still, Blake's imagery, though far more poetic and visionary than Flaxman's, tells its stories through the actions of human figures (though the balance between verbal and visual begins to shift toward the latter in his later works, especially *The Book of Job*). Seen in this light, Runge's *Morning* takes on even greater richness, incorporating as it does a more "primitive" means of representation within a more "primitive" vehicle for the expression of meaning. His hieroglyphs appeal to the viewer's imagination to fill out the image, while simultaneously making the creation of the illusion and the creation of meaning more apparent.

Runge's deliberate regression anticipated the later, more self-conscious avant-garde in many respects. Runge, too, felt extreme dissatisfaction with both the illusionism and the painted literature taught in the academies. Further, he was arguably the first of a series of modern artists to retreat from traditional narrative exposition by incorporating some aspect of the hieroglyphic as a more "primitive" form of expression. Runge's attempt to create images that, to use Vico's words, "carried their meaning in themselves" and "spoke forth in their muteness," led him to reconfigure his compositional structures, rejecting the rational causality of history painting in favor of the imaginative evocation of myth, dream, and memory.

3

"Primitive" Ornament and the Arabesque: Paul Gauguin's Decorative Art

The field of inquiry regarding the primitivism of Paul Gauguin has been so heavily traversed that there seems little left to discuss. The rich variety of "primitive" sources that influenced his work, including Japanese, Pre-Columbian, Egyptian, Polynesian, and medieval, have received particular attention.[1] The centrality of ornament to European conceptions of "primitive" expression indicates, however, that Gauguin's stated desire to make his art decorative needs further study. The ornament of "primitive" cultures had become a consuming issue for European intellectuals, ethnographers, and aestheticians by the mid-nineteenth century, and Gauguin's ornamental aesthetic should be understood as an important contribution to this debate.

The fascination with ornament exhibited in both aesthetic and anthropological theory of the nineteenth century was rooted in the notion that the impulse toward ornament lay at the origins of art. Ornament was seen as a cultural fossil, an artifact that retained clues to the origins of art-making; it was also, however, understood as a fundamental building-block of style, a kind of DNA that carried the imprint of the key characteristics of a style.

Tied to these ideas was the notion that ornament was the natural province of the "primitive," both being "almost all body and no sense" (to use Vico's phrase). Many nineteenth-century aesthetic and ethnographic theorists identified ornament as the most elemental of artistic expressions and readily associated it with the most "primitive" of cultures. Gottfried Semper regarded ornament as the first aesthetic impulse to emerge once the basic needs to ensure survival were met. In his *Grammar of Ornament* (1856), Owen Jones characterized ornament as a fundamental artistic impulse: "From the universal testimony of travellers it would appear that there is scarcely a people, in however early a stage of civilisation, with whom the desire for ornament is not a strong instinct."[2]

Viewed from a European perspective, many "primitive" images were described as ornamental simply because they embellished utilitarian objects. An intricately carved Maori canoe prow would routinely be categorized as decorative, which automatically relegated it to the wrong side of the carefully drawn academic division between art and craft. The deep-seated conviction that the "primitive" possessed little or no power to reason, however, also led Europeans to conclude that ornament would be the expected *limit* of any two-dimensional "primitive" imagery. As in the war club illustrated by Jones, the manipulation of pattern and material could neither break through the surface into an illusionistic space nor organize the shapes into a meaningful narrative. Furthermore, ornament was believed to be the offspring of the imagination and therefore the "primitive" was by nature well-suited to its creation. Indeed, "primitive" imagery exhibited all the marks of a runaway imagination to many European observers. One of Captain Cook's officers wrote of South Sea Island imagery: "their fancy is wild and extravagant and I have seen no imitations of nature in any of their performances."[3]

Much of the "primitive" art available to Europeans in the late eighteenth and early nineteenth centuries, from medieval altarpieces and cathedral facades to the carved implements and bark cloths brought from the South Seas, conformed to what they considered an ornamental aesthetic. That is to say, much "primitive" imagery made narrative and illusion the equal, even the subordinate of pattern. A Maori paddle or Easters war club were readily classified as ornamental because of the astounding manipulation of material and complex curvilinear patterns that overwhelmed figural representation. The "primitive" art traditions of Western art history exhibited ornamental tendencies as well. Byzantine mosaics or black-figured Greek vases balanced mimetic intentions in dynamic tension with brilliant pattern,

pure unmodulated color, pronounced linear rhythms, as well as the distinct shape of the format itself, the curve of the vase, or the wall surface. Of course, the arts of such historical "primitives" seemed to fit into a continuum of progression in Western art from conceptual styles based upon the structures of ornament toward the perceptual structures of illusionistic representation. The ornaments of living "primitives" fit no such progressive model, but seemed frozen in an original state. As late as 1916, A. D. F. Hamlin described the "essential character" of "savage" ornament as that of "arrested development. It is often interesting and effective, but seems incapable of further progress. It is sterile, and as a subject of study, quite outside the field of the historic styles." Hamlin drew a distinction between "savage" arts, which were contemporaneous with civilized arts, and "primitive" arts, which represent the first phase of both prehistoric and historic styles. Continuing his biological analogy, Hamlin argued that savage ornament was stunted, while "primitive ornament often reveals the promise and potency of indefinite life. The one is a dwarf, the other an infant."[4]

Nonetheless, many Europeans found much to admire in the ornamental sensibilities of "primitive" arts, and they frequently commented upon the skill with which these "curiosities" were made.[5] A survey of late eighteenth-century illustrations of "artificial curiosities" reveals a particular interest among Europeans in the ornamental and in the fanciful grotesque, such as the Maori house carving illustrated in the accounts of Cook's voyages (Fig. 19). Frequently represented artifacts were Maori canoe prows (Fig. 20) as well as beautifully patterned canoe paddles (Fig. 9). Europeans of this era were also fascinated with the wide variety of patterns applied to the *tapa* bark cloth used throughout Polynesia. Books of these patterns, made from actual squares of the cloth mounted onto the page, were popular with the European public. In a 1788 commentary upon the Tahitians, Grasset Saint-Sauveur expressed his admiration:

> Their principal manufacture is that of their fabrics, which they derive from the *Morus Papyrifera*. With the application of color to this tissue, these islanders have developed a superiority and fecundity of genius which would astonish our most skilled craftsmen. After seeing a number of these painted fabrics, one would believe that they had taken as their models the best materials and most beautiful cloths of India, of China and of Europe available in our shops.[6]

Captain Cook was impressed with the carving skills, masonry work, and embroidery of several Oceanic groups, writing of the New Zealanders in

Fig. 19. J. F. Miller, *House Carving from New Zealand*, engraving, from Hawkesworth, *Voyages* (London, 1773)

particular that "they want neither taste to design, nor skill to execute whatever they take to hand."[7] Joseph Banks wrote that the Maori war canoes "were really magnificently adorned . . . both [bow and stern] were richly carved with open work."[8] These compliments were primarily directed toward the artisanship and ingenuity of "primitive" manufactures, and never intended to equate them with the fine arts.

As with the hieroglyph, discussions of "primitive" ornament were framed by existing ideas within the classical tradition. Ornament had traditionally played a carefully circumscribed and subordinate role in the classical tradition, one that was restricted still further by academic classicism.[9] Its purpose was to enhance the rational structures of illusion and narrative, to please the eye in order for the didactic message to be more readily communicated to the intellect. Ornament was closely regulated because its powerful pull on the imagination and its sensuous delights of color and pattern made it a

Fig. 20. Charles Meryon, *Sketch of Maori canoe prow*, 1842–46, pencil drawing.
British Museum, Department of Prints and Drawings

potentially subversive force upon the serious artist. This idea had, of course, been debated in Western art since the famous passage by Horace in his *Ars poetica*, which described the freakish inventions of the poetic imagination when loosed from the sobering influence of reason and judgment. This could lead a painter "to couple a horse's neck with a man's head, and to lay feathers of every hue on limbs gathered here and there, so that a woman, lovely above, foully ended in an ugly fish below."[10] Ingenuity, or *ingegnium*, had always been closely connected to *ornatus* within the classical tradition,[11] so the "primitive's" surfeit of invention, unrestrained by reason, would at best result in exceedingly fanciful patterns and at worst, monstrosities like that described by Horace.

"Primitive" ornament fell far below the twin standards of the *dessin idéal* and *ut pictura poesis*. "Primitive" expressions were clearly the result of free flights of fancy rather than purposeful *dessin*. For example, Diderot denounced the ornamental character of Chinese art (the most influential nonclassical style of his day) on this point, drawing the connection between rationality and *dessin*. He described Chinese art as "a heap of confused ornament which has no apparent reason; a bizarre variety of things without relation or symmetry, as in the arabesque or in the Chinese taste, they are without design."[12] In short, without reason and judgment there was no *dessin*, and without *dessin* the inevitable result was misshapen, bizarre, and merely ornamental. Ornament also subverted *ut pictura poesis*, since it dodged meaning by appealing more to the senses and imagination than to the intellect and challenged the preeminence of the human action by merging figure and space into pattern or dispensing with the figure altogether. Ornamental structures of repetition, opposition, and metamorphosis resisted the causality of narrative, which depended upon the clear articulation of spatial and temporal relationships.

Europeans also described many examples of ornament as "grotesque" or "arabesque." For example, Joseph Banks characterized Maori taste as grotesque.[13] Père Lafitau also noted the Iroquois's "grotesque imagination."[14] The terms seem to have been used interchangeably (as we have seen with the hieroglyph and arabesque) and referred to a particular species of ornament: hybrid, metamorphic figures, particularly in a two-dimensional format (including relief carving). Associated with great fantasy, such hybrid forms were also identified as arabesques.[15] But the grotesque could refer to the horrific, monstrous, and the caricatured as well. This connotation was commonly employed to describe three-dimensional "primitive" imagery. This horrific grotesque was not the product of fantasy and ingenuity, but

seemed to erupt from darker and more violent passions. As opposed to the arabesque's association with ornament under discussion here, the monstrous grotesque was frequently used to describe the "primitive" idol and fetish (and will be taken up in Chapter 4).

As a term, the grotesque came into use during the Renaissance to describe the fantastical paintings found in newly excavated grottos from ancient Rome and were associated with the artist's powers of invention and of fantasy. Grotesques were the *sogni dei pittori*, or the "dreams of painters."[16] These connotations carried over into academic classicism. The *Dictionnaire de l'Académie des Beaux-Arts* cited as the main characteristic of a grotesque as "the fantastical blend of ornament and the figure which employs extremely disparate elements, human figures, animals, strange vegetation, caprices which are monstrous and contrary to nature."[17] Grotesqueries were subject to even greater censure than other kinds of ornament because of the characteristics cited in the entries above: caprice, extravagance, strangeness. Being a particularly audacious ornament, they were vivid examples of artistic license as suggested in the following definition from the *Dictionnairie of the French and English Tongues* (1611): "Pictures wherein (as please the Painter) all kinds of odde things are represented without anie peculiar sence, or meaning, but only to feed the eye."[18] Academic pedagogy was by its nature antithetical to such fantasy as were the more rationalist aestheticians of the eighteenth century who considered even this level of fantasy inappropriate to modern art. A similar stance was taken by Johann Christoph Gottsched, a proponent for the return to classicism, who proclaimed that "to imagine something without sufficient reason is to dream or to indulge in fantasies. . . . Still, clumsy painters, poets and composers frequently resort to this method, which results in the creation of sheer monstrosities, which might be called daydreams."[19] The academic censure of a European artist's willful indulgence in the grotesque was strong, but the "primitive" grotesque was rejected out of hand since it was believed that it was made with no conscious choice whatsoever.

These classical interpretations of "primitive" ornament were joined, and to a large degree echoed, by new ethnographic and aesthetic theories that emerged in the mid-nineteenth century and continued well into the twentieth, when studies of "primitive" sculpture began to eclipse those of ornament. Robert Goldwater recognized this keen interest in two-dimensional imagery as well as the repeated use of the term "ornament" to describe it, noting that Edward Tylor's landmark study in cross-cultural ethnography (*Primitive Culture*, 1871) dealt only sparingly with imagery and categorized

it as ornament (*Primitivism*, 16). Sir John Lubbock also used the designation in his influential book, *The Origin of Civilization*, published in 1870. Even Schweinfurth, in his *Artes Africanae* of 1875, "confines himself to the study of two-dimensional art, which, like other authors of the time, he refers to as ornament" (19). The ornament of "primitive" peoples became a consuming issue for European ethnographers (and for some aestheticians) in the latter half of the nineteenth century, a fascination Goldwater acknowledged: "The almost exclusive concern . . . with two-dimensional art is indicative of the peculiar bias of their aesthetic attitude. They were searching for the origins of art, and thought they had found them in a stylized ornament, which, if they could not appreciate, they could at least explain as the misapplication of a naturalistic art impulse" (*Primitivism*, 21). The "peculiar bias" observed by Goldwater was the presumption that all ornament should naturally evolve toward naturalistic representation, the main debate concerning whether it began as geometric or organic.

In a 1956 study of African art, A. A. Gerbrands attributed the explosion of studies on ornament between 1890 and 1910 to the influence of evolution-ist theory.[20] "Inherent in evolutionism [was] an almost all-compelling inter-est in the origin of human culture in all its facets," and ornament was considered to be the most fundamental of artistic endeavors.[21] Certainly the bulk of archaeological artifacts were two-dimensional and "thus it is under-standable that this . . . form of art was thought to be the most original." But Gerbrands also pointed out that prehistoric and "primitive" sculpture gen-erated far less interest than ornament and conjectured that this was because sculptural figures were not so easily arranged into a neat progression of styles (*Art as an Element of Culture*, 27–28). The implication of evolutionist theories, especially those of Alfred Court Haddon, was that ornamental designs could ostensibly be collected, like so many cultural fossils, and arranged in a chronological order of progression toward the presumedly universal goal of naturalism. Not surprisingly, attempts to construct a neat evolutionary scheme for the progression from "primitive" to fine art were repeatedly confounded by the actualities of living and dead "primitive" cultures.[22] Despite mounting evidence that a society's technical accomplish-ments were not synonymous with its cultural sophistication, Gerbrands noted that "in the years just before the first world war, Lamprecht and his pupils . . . still attempted to solve the problem of the origin of art by means of children's drawings" (40).

Ornament was also the focus of intense aesthetic debate. The ideas of the architect and theoretician Gottfried Semper were particularly influential

during his own mid-century era and continued to draw response from the following generation, especially through the work of Alois Riegl. Semper and Riegl represented one of two important lines of thought concerning the nature and significance of ornament, the other developed by thinkers associated with what might be broadly characterized as the Gothic Revival and (later) the Arts and Crafts movement. These latter artists and aestheticians include John Ruskin, A. W. N. Pugin, William Morris, Owen Jones, Viollet-le-Duc, Ruprich-Robert, Grasset, and others. Clearly, the complexity of these debates cannot be fully represented here; however, there are several key themes advanced by these groups that set the stage for Gauguin's particular form of primitivism. One other important influence upon Gauguin's aesthetic that must be considered was Baudelaire's concept of *correspondance*.

In his *Der Stil in den technischen und tektonischen Kunsten oder praktische Aesthetik* (1861–63) and in a series of lectures to the Royal Academy in London a decade earlier, the architect and aesthetician Gottfried Semper argued that the first artistic impulse was not to fashion a crude representation of natural forms but to satisfy a more fundamental desire for order.[23] Thus, initial artistic efforts were not organic but geometric, their forms reflecting the materials from which they were made and the crude techniques used to work those materials. Only upon mastery of the material would the forms move toward the imitation of nature. Semper believed that the origins of all artistic expression could be found in the primary devices, or forms used to impose order, for example, in knots, plaiting, seams, and bands. In short, the origins of art were located in the fundamental acts of transforming natural materials into *made* objects. He further argued that artistic meaning was not superimposed upon the material but actually spoke through it. Michael Podro makes this point quite clearly in his analysis of Semper's theory: "It is not only central to Semper's conception that techniques can yield metaphors, it is also central to his view that the literal character of the material and technique are not themselves objects of our stylistic appreciation unless their potential has been brought out by their handling" (*Critical Historians*, 47).

Semper argued a truth-to-materials aesthetic that he shared with Ruskin, Morris, and Viollet-le-Duc, among others, and that was not without reformist intentions. His discussion of *Urmotiven* can be read as a prescription for contemporary artists and designers:

> The theory of *Urmotiven* and the early forms derived from them could develop as the first, art-historical part of a theory of style.

> Without doubt there is a feeling of satisfaction when, in the case of
> a particular work, even if ever so distant from its origin, the *Urmotiv*
> runs through it as the underlying keynote of its composition: it is
> certain it will have the artistic effect of clarity and freshness which
> is very desirable as it will put a stop to arbitrariness and meaning-
> lessness while giving positive guidance to invention. The new is
> connected to the old without being a mere copy and is freed from
> its subjection to the influence of empty fashion. [24]

Semper's attention to technique, to the formal organization of material
means, and to the nonverbal and subnarrative aspects of expression, pro-
vided a more fundamental set of theoretical tools that were more readily
applicable to *both* Western and non-Western styles. His models, however,
were almost exclusively classical ones, Greek and Renaissance in particular;
more important, Semper maintained the traditional separation of structure
and ornament. Although he shunned the notion of ornament as mere
embellishment, and argued that it should be structurally symbolic, Semper
saw its role as one that enhanced the structure but was subordinate to it.

In *Stilfragen* (1893) and other essays written during the 1890s, Alois Riegl
acknowledged his debt to Semper while arguing against strictly materialist
theories of artistic development. Riegl sought to establish a theory of style
by isolating and analyzing the development of specific decorative motifs.
Like Semper, he argued that, in the decorative arts, surface ornamentation
must eschew naturalism for schematized and symbolic designs. Riegl drew
a crucial distinction between ornament and argument, the latter represented
by the subject matter of fine art, which should be conveyed in a naturalistic
rather than schematized manner, and by the structural elements of architec-
ture. [25] It is especially significant that Riegl thought ornament and argument
had initially been confused with one another until the Greeks separated
subject matter/structure from ornament, setting the two upon separate paths
of development. This characterization of the divergence of argument from
ornament is strikingly similar to Vico's understanding that the development
of the abstract alphabet instigated a radical separation of reason and imagi-
nation, the verbal and the visual. Further, Riegl's examples of the confusion
of ornament with argument included Egyptian art and Chinese art, but
could easily be extended to other styles typically described as "primitive,"
including Gothic, Byzantine, Maori, and so on.

In *Spätrömische Kunstindustrie* (1901) Riegl softened the distinctions he
had initially drawn between fine and decorative arts. More important, he

advanced the concept of *Kunstwollen*, claiming that stylistic development was not simply determined by technical considerations or by attempts to imitate nature, but by a universal human "will to form." Styles were shaped by the cultural messages they were meant to carry, and the motivations for art-making were complex and situational. Both Semper and Riegl began their inquiries concerning the origins and development of style on a more fundamental and universal level and attributed the creative act to more primal motivations at a time when academic pedagogy still held art to be a form of rational discourse. In doing so, they took crucial steps toward leveling the field upon which artistic expression was judged and opening avenues for more balanced considerations of "primitive" arts.

There was a related discussion of ornament, however, that ran parallel to that of Semper and Riegl. This line of argument, advanced by Ruskin and Viollet-le-Duc among others, pursued what might be described as an *expressive* theory of ornament. While both groups argued against mimesis in decorative design and for a truth-to-materials aesthetic, Riegl and Semper proposed a schematized image that existed in a distinct and separate relationship to structure/argument.[26] Ornament was reductive form, abstracted from technique or from natural forms. The other theory of ornament saw it as a living, organic force that literally animated structure/argument and made the structure expressive by fusing with it. Here ornament was made to act like natural forms and to exhibit their vitality.[27] In his *Discourses on Architecture*, Viollet wrote that "in our opinion the best architecture is that whose ornamentation cannot be divorced from the structure."[28] In a design for iron supports, he does just this (Fig. 21). The spiraling decorative patterns are merged with the structure, the tensile strength of the material allowing the stylized tendril and leaf forms to be a functional support. Viollet exploits the liquid malleability of his material in order to capture the growth processes of nature (the correspondence to Maori spiral patterns is striking) rather than simply imitating leaves or vines. This also allows an emphasis upon invention as well as abstraction on the part of the artist. Gauguin clearly fits into this latter aesthetic, which grew out of the neo-gothic movements of the Romantic era, was merged by Viollet-le-Duc with a protofunctionalist aesthetic, picked up an important stylistic impetus from Japanese prints, and emerged into symbolism and art nouveau. For Gauguin, ornament became the expressive structure of his compositions, displacing rational space and causal narrative.

As with the hieroglyphic, "primitive" styles were understood and translated into European experience through peripheral aesthetic categories. And

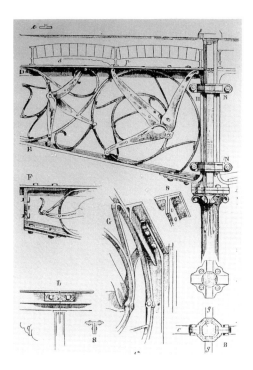

Fig. 21. Eugène Viollet-le-Duc, *Design for Iron Supports*, engraving, from *Discourses on Architecture* (Paris, 1863 and 1872), lecture 13

again, the inversion of the negative valuation of "primitive" ornament was made by artists and aestheticians who were dissatisfied with normative academic tradition. Proponents transformed liabilities into assets without significantly redefining the nature of "primitive" ornament itself. As a result, these ornaments and grotesques were still described as spontaneous and imaginative because they were unburdened by the illusionistic tricks and ponderous narratives of more "advanced" arts. Already accepted as one of the earliest of artistic expressions, the emulation of "primitive" ornament was viewed by many, including Gauguin, as a return to creative origins. Interest in ornament also reflected a desire to actively subvert *dessin* and *ut pictura poesis*, giving the imagination the dominant creative role.

Once certain kinds of "primitive" ornament were assimilated, the influence they exerted upon the fine-arts tradition was both widespread and extremely complex.[29] In a recent article, Joseph Masheck explores the parallels between nineteenth-century debates concerning ornament and the progression toward abstraction in the nineteenth century. Masheck argues that the advocacy of abstraction and truth to material found in essays and

anthologies about ornament created a strong impetus toward formalism in general and abstraction in particular. Masheck also discusses the uneasy, shifting relationship between the categories of fine and decorative arts in nineteenth-century Europe. Clearly, the interest in "primitive" ornament intersected with these formalist concerns. However, the move by primitivizing artists to emulate specifically "primitive" ornament was inextricably tied to other aesthetic issues, including the overthrow of reason in favor of imagination as well as the rejection of established conventions in favor of artistic invention. Further, as I have suggested above, the turn toward ornament by certain artists, as with the turn toward the hieroglyphic, was not only a move toward abstraction but toward a more vital means of expression. In the following pages, I shall consider two important developments: Owen Jones's advocacy of "savage ornament" and Paul Gauguin's desire to create a "decorative art."

Owen Jones, a Victorian designer and aesthetician, reversed the argument that the "primitive" was only capable of creating ornament, maintaining that the "primitive" was uniquely gifted in the invention of ornament. Jones advanced a sort of proto-*Kunstwollen* argument concerning the compelling desire for expression: "Man's earliest ambition is to create. To this feeling must be ascribed the tattooing of the human face and body, resorted to by the savage to increase the expression by which he seeks to strike terror on his enemies or rivals, or to create what appears to him a new beauty" (*Grammar*, 13). Praising the "skillful balancing of the masses" and the "judicious . . . arrangement of . . . squares and . . . spots," Jones contrasted "primitive" ornament to the decadence he perceived in Victorian design:

> [W]hat we seek in every work of Art, whether it be humble or pretentious, is the evidence of mind, the evidence of that desire to create . . . and which all, feeling a natural instinct within them, are satisfied with when they find it developed in others. It is strange, but so it is, that this evidence of mind will be more readily found in the rude attempts at ornament of a savage tribe than in the innumerable productions of a highly-advanced civilisation. (*Grammar*, 14)

In his *Grammar of Ornament* (1856), Jones recommended that English artisans follow the example of "primitive" ornament in order to restore the vitality and invention lost to oversophisticated design:

> The ornament of a savage tribe, being the result of a natural instinct,
> is necessarily true to its purpose; whilst in much of the ornament of
> civilized nations, the first impulse which generated received forms
> being enfeebled by constant repetition, the ornament is oftentimes
> misapplied . . . all beauty is destroyed . . . by superadded ornament
> to ill-contrived form. If we would return to a more healthy condi-
> tion, we must even be as little children or as savages; we must get
> rid of the acquired and artificial, and return to and develop natural
> instincts. (*Grammar*, 16)

Jones's *Grammar* was one of many anthologies of ornament and design
published from the mid-nineteenth century on. His criticisms of contempo-
rary design paralleled those of John Ruskin and William Morris, especially
in calling for a return to nature as the source of good and fitting design.
Jones was also influenced by the theories of Semper, particularly his idea
that good ornament was integral to the design and indicative of the function
of any object or building. Unlike Semper, Jones preferred nonclassical design
and understood ornament to be expressive rather than reductive or sym-
bolic.

Although other anthologies included occasional examples of nonclassical
ornament, the *Grammar* kept almost exclusively to nonclassical and non-
Western styles and was the first to illustrate Oceanic imagery as a suitable
source for inspiration. Furthermore, Jones's advocacy of a form of primitiv-
ism in the decorative arts anticipated the arguments and examples used by
Gauguin more than thirty years later. Several years after the *Grammar*'s
publication, John Leighton included a chapter on the "Ornament of Savage
and Early Tribes" in his anthology, *Suggestions in Design*. Leighton's 1880
anthology also recommended "primitive" design as an antidote to European
decorative arts in need of revitalization:

> It is not an unprofitable study, when we endeavor to go back for the
> purpose of examining the works of those earlier races of men among
> whom some of the most elementary forms of ornamentation have
> arisen. . . . They patiently carved their canoes and other woodwork
> with notches and curves of every description, until they gave the
> whole surface a quiet richness and beauty. . . . This they did, too,
> from an innate love of ornamentation.[30]

Seconding Jones, *Suggestions in Design* characterized "primitive" ornament
as more pure because it was closer to nature's inspiration and example:

The carving of surface they did upon the true principle upon which ornamentation should be applied. . . . Thus we find that the earliest inspirations of nature will invariably lead men right if they will but follow these natural promptings. Instead of which, as man becomes more educated, he scorns the works of nature, thinking he can safely trust his own powers. He soon begins to pile up his ornament upon his own works, loses their original and appropriate forms in crowded and vulgar ornamentation . . . until at length he arrives at an agglomeration of forms, which . . . are neither useful nor convenient for the purpose intended. (16)

Jones and Leighton were only concerned with the decorative arts, however, and made no claims for "primitive" ornament beyond that. Moreover, Jones's argument dealt exclusively with design and did not pursue the possibilities of meaning embedded in some of his illustrated examples of "savage" ornament. In his *Grammar*, figurative relief carving from the South Pacific was illustrated alongside purely abstract pattern work with no distinction between the merely decorative and the intentionally meaningful (Fig. 22).

Paul Gauguin took the next step on both counts. By extending his artistic production into areas traditionally deemed as craft, he intentionally broke the boundaries between the fine and applied arts. Just as important, Gauguin made efforts to incorporate the ornamental characteristics associated with "primitive" art into his paintings. As had others before him, Gauguin associated ornament with the very early stages of artistic development, and in *Avant et Après* (Paris, 1923) argued that decoration was the key to Polynesian art:

One does not seem to suspect in Europe that there exists, among the Maoris of New Zealand, as with the Marquesans, a very advanced decorative art. Our fine critics are fooled when they take all this for a Papuan art. In the Marquesan especially there is an unheard-of sense of decoration. Give him a subject of the most mediocre geometrical forms and he will succeed in keeping the whole harmonious and in leaving no displeasing or incongruous empty spaces. The basis is the human body or the face, especially the face. One is astonished to find a face where one believed there was nothing but a strange geometric figure. Always the same thing, and yet never the same thing. (79–80)

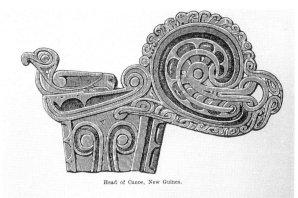

Head of Canoe, New Guinea.

eometrical patterns formed by the interlacing of equal lines in the orna-
ient of every savage tribe, and retained in the more advanced art of every
ivilised nation.

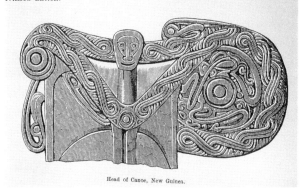

Head of Canoe, New Guinea.

Fig. 22. Owen Jones, *Details from New Zealand and New
Guinea Canoes,* engraving, from *The Grammar of
Ornament* (London, 1856)

Several essential themes emerge in this short statement. In asserting that
the Maori and Marquesan had an advanced decorative art, Gauguin argued
that this sophisticated aesthetic had evolved along a separate and altogether
different path from that of European art, and further implied that attempts
to judge it by European standards would be fruitless. These decorative
compositions were so different, in fact, that Europeans would have to learn
to see the figures embedded in the geometrical patterns (here Gauguin
turned the tables on those Europeans who wrote that "primitives" could not
see illusionistic figures but only recognized "rude" drawings). By drawing
attention to the geometric character of Maori and Marquesan imagery, he
further distinguished its evolution from the inexorable march toward natu-

ralistic representation that Europeans had presumed to be universal. Gauguin ridiculed European critics who could not differentiate between "primitive" styles, pointing out that this advanced decorative art was not "Papuan." Here he distinguished between Polynesian art and the arts of Papua, New Guinea (part of Melanesia), characterizing the latter as truly savage, its sculptural forms horrible and grotesque.[31] The distinction was significant. Gauguin's description of Maori and Marquesan ornaments portrayed them as arabesques, ingenious patterns into which various fanciful figures are interwoven. Although Polynesian arts included figures that could be described as "monstrous," Gauguin obviously thought that ornamental invention was its dominant expression. However, "Papuan" art was placed squarely within the monstrous tradition of the grotesque. Gauguin closes by underlining the long-standing connection between the ornamental impulse and a high level of invention: "Always the same thing, and yet never the same thing."

Gauguin's characterization of his work as decorative tied directly into contemporary arguments in the decorative arts. Gauguin's decorative imagery respected wall surface by diminishing the modeling of forms and perspectival space and stylizing imagery. Gauguin sought not only to banish trompe-l'oeil but to transfer meaning from narrative to ornament. Achille Delaroche, in a sympathetic review of Gauguin's paintings which the artist included in *Avant et Après*, recognized that the artist was breaking free from academic narrative, from its "rhetoric of torsos."[32] Delaroche claimed that "Orphic art, seems therefore about to take the place of the discursive modes of discredited thought" (41).

In pronouncing his desire to be decorative, Gauguin pursued an aesthetic that flew in the face of the serious didactic duties ascribed to the fine arts. To be decorative was to be speechless and merely pleasurable, and therefore trivial. In addition, it elevated the imagination's ability to invent above rationality's ability to speak and to imitate. However, Gauguin did not intend to abandon meaning but to find a vehicle for meaning other than narrative: "You see, although I understand very well the value of words—abstract and concrete—in the dictionary, I no longer grasp them in painting. I have tried to interpret my vision in an appropriate décor without recourse to literary means and with all the simplicity the medium permits: a difficult job."[33] Although Gauguin did not entirely rid his compositions of narrative content, he went to great lengths to replace the visual description of literary subjects with a visual image that communicated without words.[34]

Gauguin's efforts to invest ornament with meaning have much in common

with Runge's experimentation with the hieroglyphic because he, too, turned to a more "primitive" form of expression. Color and pattern are bound together with structure and meaning, ornament and argument willfully confused. The compositional structure and the expressive content are animated by making them ornamental. Gauguin freed color from the subordinate role of description, allowing it to take on a more expressive role; he emphasized linear rhythm and pattern at the expense of sculptural contours. Gauguin's ideas concerning color and suggestive decoration expanded upon Baudelaire's idea of *correspondance*: "There is an impression resulting from any certain arrangement of colors, lights, and shadows. It is what is called the music of the picture. Even before knowing what the picture represents . . . frequently you are seized by this magic accord . . . this emotion addresses itself to the most intimate part of the soul."[35]

This synthetic, decorative imagery did not so much "speak" to the viewer as strike a resonance, a "magic accord." The hieroglyph was frequently conflated with the arabesque and grotesque, all three being comprised of fantastic, often metamorphic, ornamental figures. Some commentators, including Baudelaire and Ruskin, attempted to delineate the subtle differences of intention that lay beneath fantastical figures that seemed quite similar. In his *Modern Painters*, John Ruskin described three forms of grotesques, the third being a "thoroughly noble one" that most closely matched the functions of the hieroglyph: "A fine grotesque is the expression, in a moment, by a series of symbols thrown together in bold and fearless connection, of truths which it would have taken a long time to express in any verbal way and of which the connection is left for the beholder to work out for himself."[36]

Gauguin began to explore the range of expression possible in preverbal, purely visual compositions that relied heavily upon both the hieroglyphic and the ornamental. Together they formed the key elements of the artist's new visual language. The extent to which they overlapped in Gauguin's synthetic art was illustrated in descriptions such as this: "on the purple soil long serpentine leaves of a metallic yellow make me think of a mysterious sacred writing of the ancient Orient."[37] The undulating pattern of yellow on its complementary purple was invested with suggestive meaning, and would, thought Gauguin, provoke an intuitive response from the viewer. Gauguin employed pattern and color for creating poetic suggestion, diminishing the role of tangible objects. Consider his description of the *Les Misérables* (Fig. 23), an 1888 self-portrait where both colors and objects carry meaning:

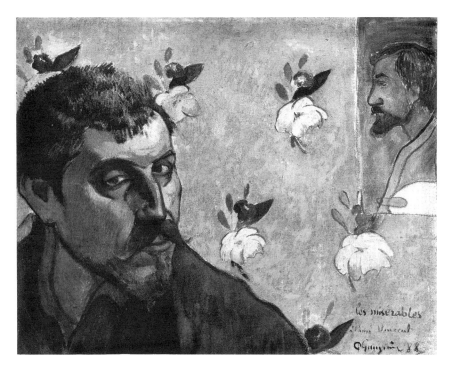

Fig. 23. Paul Gauguin, *Les Misérables*, 1888, oil on canvas. Vincent van Gogh
Foundation/National Museum Vincent van Gogh, Amsterdam

> The face is flushed, the eyes accented by the surrounding colors of
> a furnace-fire. This is to represent the volcanic flames that animate
> the soul of the artist. The line of the eyes and nose, reminiscent of
> the flowers of a Persian carpet, epitomize the idea of an abstract,
> symbolic style. The girlish background, with its childlike flowers is
> there to attest to our artistic purity.[38]

This gives us some idea as to what Gauguin meant when he used the terms
decoration and ornament to describe his work. Of those artists and writers
in the symbolist circle, Maurice Denis and Albert Aurier seem to have
understood with particular clarity the visual language Gauguin sought to
develop. Denis acknowledged Gauguin's influence upon him and his fellow
Nabis, writing that: "They have chosen in their works to have the expression
carried through the décor, through the harmony of the forms and colors,

through the material employed, over the expression carried by the sub-
ject."[39] Denis wrote further:

> We substituted for the idea of "nature seen through a tempera-
> ment," the theory of equivalence or of the symbol: we stated that
> the emotions or states of mind induced by any sight were accompa-
> nied in the imagination of the artist by plastic signs or equivalents
> capable of reproducing these emotions or states of mind without
> any need to produce a *copy* of what had originally been seen.
> (*Théories*, 161 and 259)

These signs were also interpreted by the symbolists to be a more primitive,
elemental language and clearly derived from Romantic ideas concerning the
hieroglyphic. Aurier called for a return to art "as it was divined by the
instinctive geniuses of the early ages of humanity."[40]

Gauguin's synthetism did not meet with much understanding outside the
immediate circle of symbolist artists and intellectuals. Even a critic favorably
disposed to the artist's exotic and decorative imagery balked at having his
viewing pleasure interrupted by a suggestion of deeper meaning. While
André Fontainas praised "the careful study of arrangement in his canvases,
which are primarily decorative," he lamented, "If only M. Gauguin were
always like that! . . . But too often the people of his dreams . . . vaguely
represent forms poorly conceived by an imagination untrained in metaphys-
ics, of which the meaning is doubtful and the expression is arbitrary." For
this reviewer, Gauguin was best when painting exotic fantasies. He rejected
the artist's poetic evocations, stating that "abstractions are not communi-
cated through concrete images."[41]

Achille Delaroche, who shared an affinity for symbolist ideas with Gau-
guin, did realize that the artist's ornamental style was not a rejection of
content but a shift into another, more poetical form of expression: "The
artist will interest us less, therefore, by a vision tyrannically imposed and
circumscribed . . . than by a power of suggestion that is capable of aiding
the flight of the imagination or of serving as the decorator of our own
dreams, opening a new door on the infinite and the mystery of things." In
his remarkable review of Gauguin's work, Delaroche applauded its break
from the "anecdotic" to the "significant and the general" in order to create
a "synthesis of impressions." Delaroche reserved particular venom for the
history paintings produced in the academies, contrasting what he sarcasti-

cally described as their "rhetoric of the torso" with Gauguin's "suggestive decoration."[42]

And while Gauguin's paintings and carvings do move toward the ornamental, they also move toward the hieroglyphic (though Gauguin would have called it synthetic). This is particularly discernible in a compositional device used by Gauguin in genres other than the narrative, such as his portraits and still-life subjects, and in the relief carvings. In *Soyez amoureuses et vous serez heureuses* (Fig. 24), narrative has been banished altogether in favor of imagistic layering from which one can only infer possible meanings from the sum of associations made. Similarly hieroglyphic stacking of imagery can be found in many of the still lifes and portraits, especially the self-portraits.

Gauguin was interested in and aware of hieroglyphic traditions, including the arts of Egypt and Pre-Columbian cultures, as well as the cryptic pictographs found on Easter Island. The Easter Island forms appear in several of Gauguin's compositions, including *Ancestors of Tehamana*. This painting is also a layered composition, its meaning built through associations. The pictographs run in a band behind the figure of Tehamana, and above a "primitive" figure of no particular derivation. Gauguin seems to suggest that they describe, in a language we can no longer read, the history

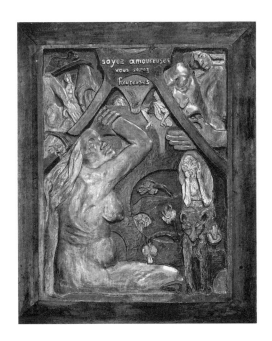

Fig. 24. Paul Gauguin, *Soyez amoureuses et vous serez heureuses*, 1889, polychromed wood panel. Courtesy, Museum of Fine Arts, Boston

of Tehamana, and as such represent the mythic, "primitive" world he so desired to recover.[43] The use of hieroglyphic figures to allude to a nonnarrative and nonrational state was a visual device developed very early by Gauguin. The first use of overtly hieroglyphic figures seems to be in his painting of his daughter Aline asleep, *The Little Dreamer* (Fig. 25). Above the child, figures that are only cursorily wallpaper patterns flicker about, as though giving us a glimpse of the dreams of childhood (the analogy with the "primitive" is obvious) that we, too, have long lost. Gauguin's inclusion of a toy jester here, almost as an intermediary between viewer and child, begs comparison with the strange figure to the lower right of Tehamana, which plays a similar role. The similarities of these two compositions consolidate our sense of Gauguin's ideas and makes it clear that the hieroglyphic elements in his work did not depend solely upon the stylistic influence of Easter Island pictographs. They were themselves incorporated into a visual language through which the artist sought to find a more "primitive" expres-

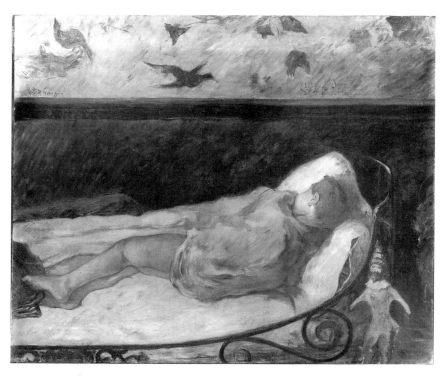

Fig. 25. Paul Gauguin, *The Little Dreamer, study (Aline)*, 1881, oil on canvas. Ordrupgaardsamlingen, Copenhagen

sion. That this "primitive" expression was prerational and hieroglyphic is made especially apparent in the painting, *Te Rerioa, The Dream* (Fig. 26). Here Polynesian figures sit in what is less a room and more the dream itself, surrounded by cryptic figures that derive from no source but Gauguin's imagination.

Gauguin's desire to create a new visual language was not completely fulfilled. He did succeed in assimilating both hieroglyphic and ornamental structures into his compositions that substantially displaced academic illusionism along with its prosaic narratives. Ornament was, like the hieroglyphic, a visual expression that Gauguin clearly associated with the "primitive"; together they formed the core of his primitivism. The next major step in the development of primitivism was to be made by Pablo Picasso, who effected an even more radical break from the classical tradition by assimilating, in addition to elements of the arabesque and the hieroglyphic, the monstrous grotesque embodied in "primitive" sculpture.

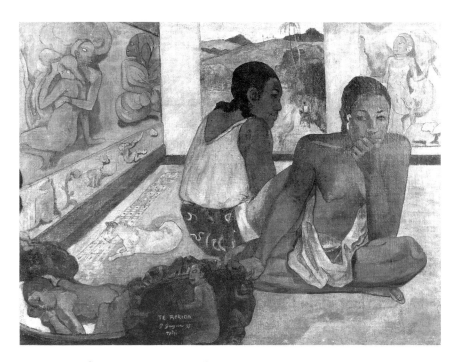

Fig. 26. Paul Gauguin, *Te Rerioa, The Dream*, 1897, oil on canvas. Courtauld Collection, London

quesan versus Ashanti, Chinese versus Pompeiian, were far less sharply drawn.

Idols and fetishes were undoubtedly the most reviled of "primitive" arts and the only images to be systematically destroyed (Fig. 27). Furthermore, "primitive" sculpture was the last to be assimilated into European primitivism. The reaction of Archibald Campbell, an adventurer and explorer of the early nineteenth century, serves to demonstrate the bias against three-dimensional figures. Campbell admired the designs painted upon tapa bark cloth by the Sandwich Islanders: "They often paint a variety of patterns, in which they display great taste and fancy."[2] He elaborated that: "In every article of their manufacture these islanders display an extraordinary degree of neatness and ingenuity" (197–98). But Campbell's praise died when he turned to the sculptures, much like those depicted in the above illustration, that surrounded sacred places: "On the outside are placed several images made of wood, as ugly as can be well imagined, having their mouths all stuck round with dog's teeth" (175–76).

These two terms, the idol and the grotesque, illuminate the two affronts

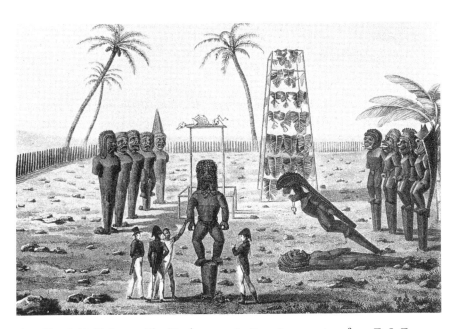

Fig. 27. J. E. V. Arago, *The King's marae in Hawaii*, engraving, from E. J. F. LeGuillou, *Voyage autour du monde*, published in Arago's *Atlas historique* (Paris, 1842), pl. 87

posed by most "primitive" sculpture: their embodiment of pagan superstition and irrationality, and their perceived deformity of the human figure. In the eighteenth century, the designation of these figures as idols revealed the censure of the Judeo-Christian tradition against graven images, as well as the censure of modern rationalist thought against religious dogma and superstition. Their description as grotesque or caricatured reflected an equally strong rejection by the standards of ideality and rationality of the classical tradition. These *Urformen* were the most peripheral of all and their incorporation by European artists represented the most radical inversion of the classicism. This chapter will examine Europeans' characterization of "grotesque idols" and then consider two very different attempts to emulate them.

In many respects, a discussion of "primitive" idols falls outside the immediate concerns of this study since this designation was primarily the work of the Judeo-Christian tradition and not of academic classicism. Nonetheless, the European reaction to these "idols" was so powerful, even in the increasingly secular eighteenth and nineteenth centuries, that it warrants attention here. The connection between the idol and its grotesque appearance also bears consideration. In addition, the magical powers of the idol played a role in the primitivism of both Gauguin and Picasso.

"Primitive" idols were disliked and feared by Europeans and were frequent targets for destruction because they seemed to embody the irrational superstitions and savagery of "uncivilized" peoples.[3] In his recent study *The Gothic Idol*, Michael Camille described the attributes of the idol in Christian imagery, which included a grotesque or monstrous appearance, associations with sexuality and other forms of carnality, as well as a material, false nature.[4] Eighteenth- and nineteenth-century representations of "primitive" idols conform quite closely to these attributes. Alfred Burdon Ellis's description of African sculpture in *The Land of Fetish* (Dahomey) was a typical reaction: "By the side of each road leading from the town grotesque clay images, roughly fashioned into the human shape in a crouching position . . . may be perceived," and "They also place a ridiculous caricature of the human form, made from grass, old calabashes, or any rubbish, on the doorposts of their houses . . . to keep evil spirits from entering therein."[5] A French missionary, Noel Baudin, opened his treatise on fetish worship with this observation: "The European on arriving in Guinea encounters at every step in the negro villages idols of wood or clay, as grotesque as they are unclean . . . daubed with cock's blood and palm oil by their stupid adorers."[6]

Another nineteenth-century observer described a "huge wooden idol, painted red and white, and rudely fashioned in the shape of a woman," and a "large mbuiti or idol house . . . about halfway down the street, with a monstrous wooden image inside, which the villagers hold in great reverence." Further, "the village idol . . . was a monstrous and indecent representation of a female figure in wood."[7] John Williams, an eighteenth-century missionary, wrote of a conversion ceremony: "They walked in procession, and dropped at our feet fourteen immense idols . . . carved with rude imitations of the human head at one end, and with an obscene figure at the other."[8]

The idol's appearance was often exaggerated to make it as horrific as Europeans had imagined. In an eighteenth-century publication, brave Christian soldiers, wielding a crucifix and an axe, topple a grotesque, bestial idol (Fig. 28). The crucifix brings light into the darkness the idol once

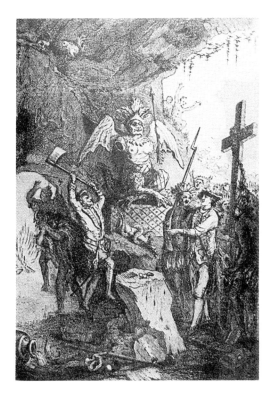

Fig. 28. *Destroying Idols*, engraving, from Page du Pratz, *Histoire de la Louisiane* (Paris, 1758)

reigned while the pagan priests retreat to the symbolic shadows of the cave on the left.[9] Idols were frequently illustrated as the motivators or overseers of barbaric sacrifices. Baudin's *Fetichism and Fetich Worshippers* (1885) represents an initiation rite for a fetish priest (Fig. 29). The neophyte, seated in the same manner as the idol opposite him, prepares to be possessed by the fetish spirit, after which "the fetish priests . . . have the flesh of the victims cooked" (76).

The destruction of idols was routinely carried out as part of the process of conversion to Christianity. The following excerpt from an 1858 mission report, *Day Dawn in Africa*, conveys the degree to which "primitive" sculpture symbolized pagan barbarity and the zeal with which it was destroyed:

> Before closing this chapter we will give an extract from a letter which we received lately from a teacher at Cape Palmas, Thomas Toomey. . . . It gives a most encouraging account of the demolition of idols. . . . When we arrived at Middletown, The Bishop preached, after which I spoke. Here we destroyed many idols, threw some into the sea, and set fire to others . . . ; and now for Fishtown,

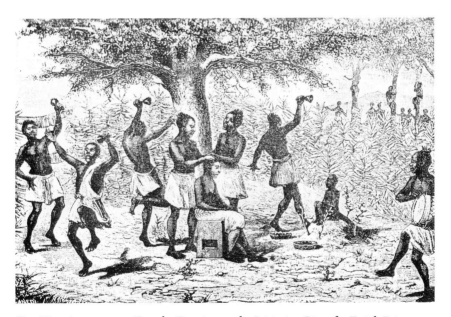

Fig. 29. Anonymous, French, *Dancing at the Initiation Rite of a Fetish Priest*, engraving, from Noel Baudin, *Fetichism and Fetich Worshippers* (London, 1885)

> where the greatest work of destruction took place. . . . We were
> permitted to destroy the idols of thirty houses—also the great town
> gree-gree. . . . This was considered their greatest idol, and the
> people were very much afraid of it. It was growing late, and we had
> to stop our delightful work.[10]

If idolatry was horrible in its consequences, it was also seen as ridiculous in
its practice. In 1575, André Thévet wrote disparagingly of African cultures:
"If there ever was abominable idolatry, brutish superstition, and ignorance
in the world, you will find it among these poor people. . . . This people is
so stupid, bestial, and blinded by folly that it accepts as divinity the first
thing it encounters in the morning when it wakes up."[11] "Primitive" super-
stition was also the subject of an illustration by Jacques Le Moyne that
depicted the French explorer Laudonniere's encounter with natives of
Florida who seemed to be worshiping the monument left by the previous
French expedition (Fig. 30), literally acting out Thévet's hyperbolic claim.

During the Enlightenment some attempts were made to explain the
presence of idols in "primitive" cultures. Lafitau and Vico referred to
"primitive" sculpture as idols and did not dispute that the "primitive" lived
in the darkness of superstition, but they sought to explain this as a charac-
teristic of early societies. Père Lafitau, like many progressive clergy, be-
lieved that all men were inspired with the knowledge of God in the
beginning. But with the passage of time, this knowledge became confused
and was replaced with superstitions. Vico took a decidedly more modern
viewpoint, that idols were irrational rather than pagan. He theorized that,
in their attempts to control a frightening, inhospitable world, prerational
peoples invented deities to which they attributed human characteristics:

> [O]n the origins of idolatry: that the first people, simple and rough,
> invented the gods "from terror of present power." Thus it was fear
> which created gods in the world. . . . They imagined the causes of
> the things they felt and wondered at to be gods. (This is now
> confirmed by the American Indians, who call gods all the things
> that surpass their small understanding.) (*New Science*, 120, 116)

Vico concluded that as the powers of reason increased, idolatry and super-
stition would naturally diminish. Captain Cook's descriptions of idols also
avoided excessive negativism and seem at pains to play down the importance
of these sculptures on the Isle of Amsterdam:

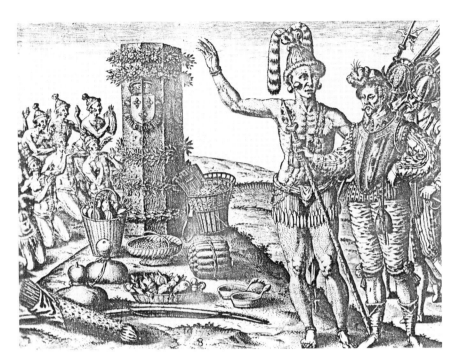

Fig. 30. Theodore de Bry, after Jacques Le Moyne de Morgues, *The Natives of Florida Worship the Column Erected by the Commander on His First Voyage*, engraving, from de Bry's *Great Voyages* (Frankfurt-am-Main, 1591), part 2

> At one corner of the house stood an image rudely carved in wood, and on one side lay another; each about two feet in length. . . . I . . . asked Attago, as well as I could, if they were gods. Whether he understood me or no I cannot say; but he immediately turned them over and over, in as rough a manner as he would have done any other log of wood, which convinced me that they were not representations of the Divinity. . . . I have no idea of the images being idols; not only from what I saw myself, but from Mr. Wales' informing me that they set one of them up, for him and others to shoot at.[12]

But European references to idols turned even more negative and sarcastic as "primitive" peoples became colonial subjects. During the height of imperialism, idols were repeatedly presented as the embodiment of the worst aspects of "primitive" life. The "primitive" was characterized as a child, easily fooled and frightened, dependent upon rational white settlers

to guide him. A nineteenth-century American missionary reported that: "In wandering around, I found evidences of superstition on every hand. At the entrance of every town, there is generally a kind of mound or structure which is intended to keep the . . . evil spirit away. . . . Another kind of idol used by these deluded people . . . is composed of one small idol and a wooden rattle. In the hands of the witch doctor . . . it is thought to be of great value."[13] Secular travelers like Paul du Chaillu thought the slavish obedience to idols pathetic and ridiculous:

> My builders came to me to say they dared not remove Rabolo's fetich, and prayed me not to touch it. . . . However, I was firm, and when Rabolo came I was peremptory in demanding that the rubbish should be cleared away. He submitted at last, and commenced to cut down the bushes which covered the talisman, and dig up the mysterious relics. . . . In the ground . . . were also two wooden idols. We removed the whole, and I need not tell my readers that no evil consequences ensued. As to Rabolo and his subjects, they flattered themselves that it was this powerful fetich which brought me to settle on this spot.[14]

Frequently represented in travel and missionary accounts during the nineteenth century, Oceanic and African sculpture only entered into the fine arts in the Polynesian subjects of Gauguin.[15] Gauguin was intensely interested in the beliefs of Polynesian peoples because they represented to him a prerational vision of the world. In two of his most famous compositions, *Vision After the Sermon* (1888) and *Manao Tupapao* (Spirit of the Dead Watching, 1892), the artist attempted to reveal something of the supernatural world that cohabited with the natural worlds of the Breton and the Tahitian. His frequent inclusion of an idol (or for that matter, a roadside Calvary) ran contrary to eighteenth-century idylls that downplayed or excluded such examples of superstition. For Gauguin, however, superstition and terror were key components of the "primitive" idyll: "Here near my cabin, in complete silence, amid the intoxicating perfumes of nature, I dream of violent harmonies. A delight enhanced by I know not what sacred horror I divine in the Infinite."[16] In a number of paintings, idols brood over the charmed dream that was Gauguin's conception of the "primitive" state. Gauguin portrayed "primitive" existence as a kind of somnambulant state, a waking dream. He wrote to a friend, "Seeing this leads me to think, or rather to dream, of the time when everything was absorbed, numb, prostrate

in the slumber of the primordial, in germ."[17] Gauguin's slumberers, such as those on the shore in *Mahana no Atua* (Day of the Gods, 1894), appear repeatedly in paintings and prints. The artist's description of the idol in *Whence Come We? What Are We? Where Are We Going?* (Fig. 31) conflates its hypnotic spell with the dream-state from which Gauguin claimed to have produced it:

> [T]he idol is there not as a literary symbol but as a statue, yet perhaps less of a statue than the animal figures, less animal also, combining my dream before my cabin with all nature, dominating our primitive soul, the unearthly consolation of our sufferings to the extent that they are vague and incomprehensible before the mystery of our origin and of our future. And all this sings with sadness in my soul and in my design while I paint and dream at the same time with no tangible allegory within my reach—due perhaps to a lack of literary education. Awakening with my work finished, I ask myself: "Whence do we come? What are we? Where are we going?"[18]

An entry from the *Dictionnaire de l'Académie des Beaux-Arts* (1694) drew a connection between the grotesque and the monstrous and stressed its comic element: "le mot—grotesque s'emploie également pour designer les personnages ou les objets bizarres dont la forme caricaturale provoque le rire." This definition echoed Horace's rhetorical question in the opening lines of *Ars Poetica*, that, when confronted with the sight of grotesque creatures, "would you restrain your laughter, my friends . . . ?"[19] The other emotion provoked by such monsters was that of horror, as evidenced by this typical description of "primitive" sculptures (in this case, Hawaiian shrine figures), taken from a nineteenth-century travel account: "a group of distorted beings, bearing some resemblance to the human form, with hideous features of uncouth proportions."[20] In the Romantic era, the sinister undertones of the grotesque were more fully cultivated. Victor Hugo recognized in his 1827 essay on the grotesque that it could elicit both laughter and horror: "The grotesque . . . is everywhere; on one hand it creates the deformed and the horrible, on the other the comic and buffoonery."[21] And as we have seen above, many European accounts of "idols" conjoined the horrible with the ridiculous, such as Ellis's description of "grotesque clay images," and "ridiculous caricatures."[22] Ellis, however, betrayed a certain awe when confronted with some of these "fetishes": "the faces of these gods are

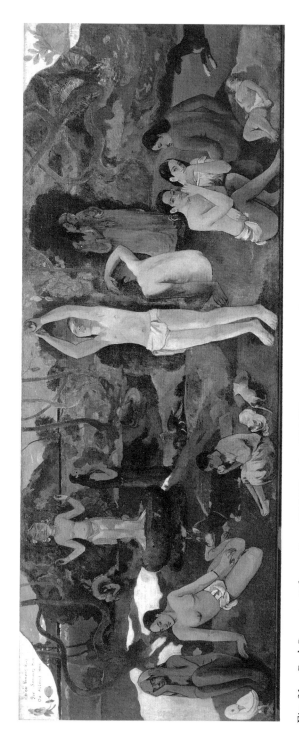

Fig. 31. Paul Gauguin, *Whence Come We? What Are We? Where Are We Going?*, 1897, oil on burlap. Courtesy, Museum of Fine Arts, Boston, Tompkins Collection

fearfully and wonderfully made. The eyes are represented by large cowries, the hair by feathers, and the gash which takes the place of the mouth is garnished with the teeth of dogs, sharks, goats, leopards, and men" (46–48).

The terms "caricature" and "grotesque" were frequently used as though they were interchangeable during the eighteenth and nineteenth century. Thomas Wright's *A History of Caricature and Grotesque*, published in 1865, posited that one type of caricature was the unintended result of the first crude attempts at artistic expression: "A tendency to burlesque and carica-ture appears, indeed, to be a feeling deeply implanted in human nature, and it is one of the earliest talents displayed by people in a rude state of society. . . . In fact, art itself, in its earliest forms, is caricature; for it is only by that exaggeration of features which belongs to caricature, that unskilled draughtsmen could make themselves understood.[23] But if a figure was caricatured due to lack of skill, it was more commonly described as carica-tured or monstrous because of an imagination overheated by violent passions and irrational superstitions. Used in this sense, caricature meant a figure or face de-formed, exaggerated, distorted. Vico had argued that while ration-ality tempered experience with understanding, the mind of the "primitive" was at the mercy of his sense impressions, "buffeted by the passions" and "buried in the body" (*New Science*, 118). Descriptions of sculpture often included references to the "primitive's" passion, as seen in this discussion of Hawaiian shrine figures (much like those illustrated in Figure 27) which concludes that the "expression in their horrid features . . . combined with their various attitudes leads to the conclusion that the sculptor had endeav-ored to personify in them a very violent passion of the human mind."[24]

His lack of reason made it impossible for the "primitive" to impose upon raw experience the calm beauty and measured proportion so important to the classical tradition. Attempts to fashion a human figure would inevitably result in chaos, creating "shapeless divinities" that would easily fit Mon-taigne's definition of the grotesque as "a monstrous body, pieced together of diverse members, without definite form, having neither order nor propor-tion."[25] Europeans accustomed to academic sculpture found this definition fitting for the distortions and recombinations of forms they saw in many "primitive" expressions. These grotesques seemed to be direct inversions of the ideal beauty revered by the Academy, an ideal exemplified by the legend of Zeuxis. This Greek artist searched for perfect beauty, but, unable to find it in any one model, he solved the dilemma by combining the most beautiful parts of five different figures into a perfect, composite whole. In

contrast, the benighted "primitive" seemed to turn this ideal upside-down, joining unrelated and ill-proportioned forms together to create a monstrosity.

Beauty did not reside in a perfectly proportioned body alone, however, but in the physiognomy and facial expression of the figure. The neoclassical ideal of beauty required a near complete absence of expression. Winckelmann cautioned artists that in order to create "lofty beauty," they must achieve

> the absence of individuality; that is, the forms of it are described neither by points nor lines other than those which shape beauty merely, and consequently produce a figure which is neither peculiar to any particular individual, nor yet expresses any one state of the mind or affection of the passions, because these blend with it strange lines, and mar the unity. According to this idea, beauty should be like the best kind of water . . . ; the less taste it has, the more healthful it is considered, because free from all foreign admixture.[26]

In his essay, *Laocoön, On the Limitations of Painting and Poetry* (1766), Lessing seconded Winckelmann on this point: "There are passions and degrees of passion which express themselves in the countenance by the most hideous grimaces, and put the whole frame into such violent postures that all the beautiful lines are lost which define it in a quieter condition. From these, therefore, the ancient artists either abstained wholly or reduced them to lower degrees in which they were capable of a measure of beauty. Rage and despair disfigured none of their works."[27]

Alexander Cozens took up the problem of expression versus beauty in his *Principles of Beauty Relative to the Human Head* (London, 1778), setting for himself the challenging task of preserving idealized features, "uncharactered and unimpassioned," while suggesting particular emotional states. He cautioned that the artist should be extremely careful when factoring in the slight instabilities that registered feeling: "These superinduced characters I would be understood to mark so tenderly, as not to shew any degree of passion, nor to weaken the predominancy of beauty."[28] Cozens acknowledged, however, that "among mankind there shall be certain species of taste or fancy . . . [including] all the local tastes of beauty, as the Chinese, the Ethiopian, the Hottentot, etc., although the extravagance of some of them appear to Europeans to deviate from simple beauty into deformity" (7).

Indeed, much of "primitive" expression seemed to "deviate" into "extravagance" and "deformity," presenting the inverse of classical beauty by exaggerating features to the point that they evoked laughter or fear. Cozens wrote that "the effect of simple beauty on the spectator is admiration mixed with pleasure," while "the powers of the charactered beauties raise other emotions also, tending to interest the passions" (8). Those eighteenth-century observers of a rationalist and classicist bent either condemned or ignored the grotesque and caricatured in "primitive" art.[29] Especially telling in this regard were the repeated episodes of shock and denial as those who held the classical style to be the pinnacle of human rationality were confronted with actual examples of ancient art: Goethe's horror at the rude gigantism of the Doric temple at Paestum, or Winckelmann's confusion at the erotic imagery uncovered at Herculaneum.

However, antirationalist tendencies were rapidly taking hold during the latter half of the eighteenth century. William Hodges's painting of the Easter Island monuments (Fig. 32), completed in 1775, fired one of the opening salvos for the Romantic inversion of classical norms of proportion and beauty. The dramatically lit stone figures loom over the landscape. A human skull lies at their base. The suggestion of cannibalism or human

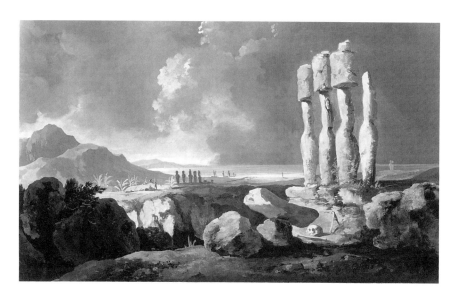

Fig. 32. William Hodges, *The Monuments of Easter Island,* 1775, oil on canvas. National Maritime Museum, London

sacrifice intrinsic in Hodges's presentation ran contrary to the more mundane explanation put forth by Cook and others on this second voyage. They believed that these massive figures were the monumental sarcophagi of an ancient culture little understood by the contemporary inhabitants of Easter Island.[30] Hodges's painting has been associated with the *et in arcadia ego* theme; and, indeed, his subject was certainly related to the representations of brooding ruins from the classical world inspired in large part by Piranesi's emotionally charged etchings of ancient Rome.[31] Yet the tone struck in the representation of classical ruins was an elegiac one, suggestive of mortality and lost grandeur. Hodges's interpretation certainly contrasts the heroic past with the present, but these monuments do not exude quiet melancholy but a hulking malevolence, heightened by the darkness of an approaching storm. These monstrous figures exert a power over the landscape as well as the viewer. Hodges seems to have been one of the first European artists to recognize the expressive potential of the grotesque and the monstrous in "primitive" art.[32]

The grotesque gained legitimacy as the Romantic sensibility came into its own. It was a particular interest of the French Romantics, including Victor Hugo and Charles Baudelaire, who rightly perceived that the grotesque was the exact contrary to classical beauty and therefore a key weapon to use against it.[33] Hugo claimed that the grotesque was an integral part of modern art because of its powerful expression. He argued that while there was only one standard of ideal beauty, the variations possible for the grotesque and the ugly were without limit. Furthermore, the French Romantics' fascination with the grotesque accentuated its diabolical aspect, subverting the rational construction of ordered beauty with the destructive threat of the irrational.

Baudelaire attempted to illuminate the nature of the caricature and the grotesque in his important essay, *De l'essence du rire* (1855).[34] He divided caricature into two categories: the *comique significatif* and the *comique absolu*. The former was a self-aware comedy, such as a political or satirical sketch, which stemmed from a sense of superiority and drew upon specific references to contemporary life. The absolute comic created works of powerful, even horrific expression, with no sense of the beautiful and with no intention of parody. Baudelaire associated "primitive" art traditions with the absolute comic and distinguished the significative comic as the product of "a shrewd and jaded civilization."[35] It is important to recognize that Baudelaire established self-reflection as the fundamental difference between the significative and absolute comic. "Civilized" art might undercut or

parody an established standard of representation by exaggeration or distortion, but "one of the distinctive signs of the absolute comic is that it is not aware of itself."[36] Although the French Romantics relied primarily upon the grotesques of the Middle Ages as their model, Baudelaire had other "primitive" styles in mind as well, including folk and children's art and what he described as "carib" art.

If Baudelaire's essay on the comic stands as an important intellectual step toward primitivism, it is in the work of his contemporary, Charles Meryon, that one finds a tentative artistic move toward primitivism via the grotesque. A graphic artist, Meryon was and still is best known for his suite of etchings, *Eaux-fortes sur Paris* (1850–54), which documented the medieval quarters of Paris. Both Hugo and Baudelaire admired this work immensely, drawn to the sinister, brooding atmosphere that suffused Meryon's city-views. The most celebrated etching of this suite, titled *Le Stryge* (or *The Vampire*), was that of a gargoyle hovering over Paris from the heights of Notre-Dame cathedral, feeding upon the wickedness and deceit of humanity spread out below (Fig. 33).

An entirely different group of works by this artist, long neglected, also deserve attention: his sketches devoted to the life and arts of Oceania, based on travels in the South Pacific, from 1842 to 1846.[37] In roughly two hundred drawings made during a four-year voyage, Meryon showed a precocious appreciation for the figurative sculpture of Oceania, specifically Maori and New Caledonian. His interest in Oceanic art deserves careful study, since these drawings demonstrate an aesthetic impulse quite advanced for its time and important to the understanding of primitivism in modern art. The Pacific sketches are not simply an interesting sidelight in the history of primitivism; they bear directly upon the style and subject of Meryon's only complete suite of etchings, the masterful *Eaux-fortes sur Paris*. The Oceanic sketches show that the Paris suite was considerably shaped by Meryon's experiences in the South Pacific and in fact was the result of a creative fusion, bringing that "primitive" world into the center of modern Paris.

Meryon actually resigned from a naval commission in order to pursue a career in the arts, but not before he had embarked upon a voyage (1842–46) to the South Seas on the frigate *Le Rhin*. During this time, Meryon sketched a wide range of subjects: coastal views, meteorological and botanical studies, sketches of fish and birds, and examples of Oceanic arts and peoples. These last feature primarily Maori culture, and include portraits of tattooed Maori men, sketches of Maori and New Caledonian dwellings, diagrams of canoe construction, and details of their richly carved prows and sterns. From

Fig. 33. Charles Meryon, *Le Stryge*, 1853, etching. The
Toledo Museum of Art

Meryon's sketches it is clear that the artist was interested in the more
expressive figurative sculpture, the types of "primitive" art least acceptable
to European taste and typically described as "grotesque."

In his drawings of Maori canoe prows and sterns (Figs. 20 and 34) Meryon
sketched their decorative whorls and patterns but also carefully recorded
the carved, grimacing figures, often showing both a side and frontal view.
He drew grimacing portraits of tattooed Maoris that have clear parallels with
their carved grotesques. Meryon also sketched New Caledonian masks, both
on location and upon his return to Paris in the Musée de la Marine (Fig.
35).[38] Even more intriguing is the account, in an 1879 memoir by the art
critic Philippe Burty, that while Meryon was stationed at Akaroa he actually

Fig. 34. Charles Meryon, *Sketch of Maori canoe prow*, 1842–46, pencil drawing. British Museum, Department of Prints and Drawings

made a model or mask of a "grotesque savage, whose soft, laughing face, except for the somewhat disturbing row of teeth, calls to mind that of an antique faun." This frustratingly vague reference leaves considerable confusion as to what this "model" actually was.[39]

Meryon's interest in Oceanic "grotesques" casts a new light upon his devotion to the medieval "grotesques" of old Paris. It demonstrates that the artist's appreciation for the grotesque did not originate with the Gothic imagery in the *Eaux-fortes sur Paris*, but developed several years earlier through his encounter with Oceanic sculpture. A letter from Meryon, preserved in the Bibliothèque Nationale, affords a glimpse into the process by which the artist shifted from Oceanic to medieval imagery. Upon his return to Paris, Meryon had begun work on an ambitious painting that combined historical narrative with a South Pacific setting, *Assassinat du Capitaine Marion du Frêne à la Nouvelle Zélande, le 12 Août 1772*.[40] But shortly after its completion, Meryon came to agree with his friend and fellow-officer on *Le Rhin*, A. E. Foleÿ, that New Zealand subjects were "out of place in Paris."

Foleÿ seems to have suggested that Meryon consider transposing his sketches of the Maori into prehistoric themes. Meryon replied in a letter dated 29 April 1848:

Fig. 35. Charles Meryon,
New Caledonian Masks, c.
1848, pencil drawing. British
Museum, Department of
Prints and Drawings

[Y]ou have reason to tell me that a New Zealand subject is out of
place in Paris; that it would have been much better to treat any
other subject, one more in keeping with what one knows and
understands here. . . .

Do you suppose that you would have great difficulty in convincing
me that you are correct when you claim to find in the life and
manners of the New Zealanders grand analogies, precious docu-
ments for staging scenes of the earliest inhabitants of Gaul? Al-
though I had never seriously imagined using recollections of our
former posting for a larger theme, I see with great pleasure your
ideas on this subject, all the more since, when reading a few
passages from Homer, I had seen obvious parallels between the
present-day Maoris and the ancient Greeks.[41]

Meryon seems to have taken Foleÿ's advice to transpose his observations of the Maori to related subjects more familiar to Parisians. He might simply have shifted to narrative paintings of medieval themes, typical of the *juste-milieu*, but for a formative encounter with Eugène Bléry in the same year. It was Bléry, a graphic artist, who convinced Meryon to turn from history painting to landscape and to try his hand at etching.[42] Meryon began sketching the medieval quarters of old Paris that were to be featured in his first and only complete suite, *Eaux-fortes sur Paris*. This was, in effect, a transposition from the geographically distant "primitive" to one chronologically distant, but in this case a "primitive" expression with direct historical significance to his audience.

The correspondences drawn so freely between Maori and Gaul, or Gaul and Greek, by Foleÿ and Meryon were by no means unusual, as we have seen. Contemporaries of Meryon, including one of the leading figures of the Gothic Revival in France, continued to make these associations. In a passage quite similar to Meryon's letter, Eugène Viollet-le-Duc drew a connection between the monsters carved for gothic cathedrals and the fabulous creatures of ancient myth and legend: "The old Gallic spirit carried over through Christianity. . . . these bestiaries which spread across our cathedrals and participate in a universal concert seem to be the final glimmer of the most ancient ages of our race."[43] Thus Meryon's leap from an Oceanic grotesque to a gothic one was not inconsistent with the practice of his era.

Certainly Meryon was cognizant of the stylistic affinities between Maori sculpture and gothic, especially the enormous vitality of linear rhythms, the fusion of structure and ornament, and the predilection toward the grotesque. An architectural detail (Fig. 36) reveals an interest in distorted and metamorphic forms similar to that found in the South Pacific sketches. Meryon never included the holy figures lining the jambs and portals of Notre-Dame, but chose to represent the gargoyles and ravens that inhabited the upper reaches of the cathedral. That Meryon could draw visual connections between seemingly divergent imagery is amply demonstrated in a letter dated 16 August 1847 in which he described his impression of Rouen Cathedral, comparing the timeworn facade of the edifice to the rock formations along the coast of New Zealand.[44]

Le Stryge is the most overt example of this shift from Oceanic to gothic grotesque. Jean Ducros has pointed out that a grotesque figure with a grimacing face and protruding tongue was common to both Maori and gothic sculpture.[45] While Meryon's etched gargoyle resembles the actual stone figure on the parapet of Notre-Dame quite closely, a profile sketch of a

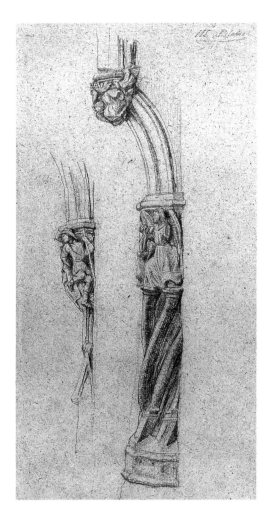

Fig. 36. Charles Meryon,
Architectural detail, c. 1851,
pencil drawing. British
Museum, Department of
Prints and Drawings

Maori figure indicates that the artist was aware of the striking similarities
between these two "monsters" (Figs. 37 and 38). Meryon seems to have
gone back to the lightly drawn original and, using a heavier pencil, accen-
tuated lines that correspond to *Le Stryge*, particularly the upper curve of
the eyebrow, the angular conjunction of the jutting brow and nose, and the
sharp downward hook of the nostril. Although this line is extremely light in
Meryon's sketch, the tongue of the Maori figure protrudes slightly, then
drops down at nearly a 90-degree angle, matching the sharp declivity of the
Stryge's nose more closely than that of the actual gargoyle. Another connec-

Fig. 37. Charles Meryon,
Sketch of carved Maori figure,
1842–46, pencil drawing. British
Museum, Department of Prints
and Drawings

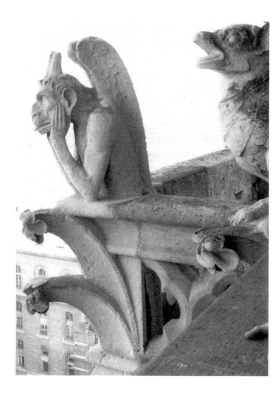

Fig. 38. Nôtre-Dame
gargoyle, nineteenth-century
restoration

tion with Maori imagery might be drawn from the initial title for the print,
La Vigie, or lookout. James Burke suggests that the title recalls Meryon's
naval experiences, where a lookout stood sentinel at the ship's prow.[46] A
further association is possible. The majority of the Oceanic figures that
Meryon sketched were those fixed upon the prominent prows of Maori
canoes, holding the same position as that of the sentinel.

The Oceanic sketches suggest that Meryon's affinity for the gothic went
far beyond historical documentation or preservation. The artist seems to be
motivated by a desire to recover something of a "primitive" sensibility lost
to the modern sophistication of nineteenth-century Paris. There is evidence
that he also understood the grotesque to be the *natural* expression of the
"primitive" mind, one with which he felt a considerable affinity. Consider
Jules Andrieu's account of a conversation with Meryon, published by Fred-
erick Wedmore in 1879:

> Taking up the etching which did not then bear the name of *The
> Stryge*, Méryon said to me, "You can't tell why my comrades . . .

fail with the Tower of Saint-Jacques? It is because the modern square is the principal thing for them, and the Middle Age tower an accident. . . . My comrades," added he, striking the *Stryge*, "my comrades are sensible fellows. They are never haunted by this monster." "What monster?" I asked, and seeing a reproachful look, I corrected myself, "or rather, what does this monster mean?" "The monster is mine and that of the men who built the Tower of St.-Jacques. He means stupidity, cruelty, lust, hypocrisy, —they have all met in that one beast."[47]

Understated though it may be, Meryon's description of his "sensible" comrades indicts their faith in progress, exemplified by the aggressive "modernization" of Paris (the *Eaux-fortes sur Paris* was created in the midst of Baron Haussmann's massive restructuring of the city), as naïveté mixed with hubris. Their confidence in scientific fact blinds them to other realities, the destructive threat of the irrational, embodied in this "grotesque spirit . . . hideous monster of stone," as Meryon himself described the *Stryge*.[48] These sentiments anticipated Gauguin's scathing attacks on the smug superiority of those who denounced Polynesian culture as savagery.

It is difficult to say how far Meryon might have pushed his interest in Oceanic art had he lived a reasonably long and healthy life. Some Maori and New Caledonian imagery did appear in his later work. From 1856 to 1866 (with most of the work done between 1863 and 1866) the artist labored upon a suite of etchings that he planned to publish as *La Nouvelle Zélande*. Meryon's mental health was already in rapid decline, however, and the project was never completed.[49] Those etchings that were finished show little of the creative power so evident in the *Eaux-fortes sur Paris*. The majority of these etchings depict Oceanic landscapes with little trace of the dramatic powers of composition that marked the Paris suite. Nonetheless, two of the etchings are notable. The completed frontispiece for this suite (1866) includes accurate representations of a variety of New Zealand artifacts (Fig. 39), including a *tiki* figure in the bottom center. The second etching of particular interest is an ode to a Tongan pilot, written by Meryon himself (1856; Fig. 40). Its patterned border combines recognizably Tongan designs and uses black and brownish-red inks that approximate the actual colors of Tongan tapa patterns.[50] Some of Meryon's later Parisian views incorporated Oceanic imagery into bizarre dramas. Maori war canoes and large fish swoop down upon the Ministry of the Marine in one etching dated 1865–66, while a figure wearing a New Caledonian mask is on one of several canoes lying

Fig. 39. Charles Meryon, frontispiece of *La Nouvelle Zélande*, 1866, etching. The
Toledo Museum of Art

offshore in another, the *Collège Henri IV*, of 1863–64.[51] While these portray
a fundamental conflict between the two worlds, it is unlikely that Meryon's
intentions will ever be discerned. The fundamental impact of Meryon's
encounter with the art and culture of the South Seas is not to be found in
these later etchings, however. The affinity for the grotesque, in both style
and content, that is nascent in the Oceanic sketches, reaches its maturity in
his powerful interpretations of medieval Paris.

Beyond these considerations, can a case be made for Meryon's participa-
tion in the development of primitivism? He anticipated Gauguin's guarded
admiration of Marquesan and Maori arts by forty years. Meryon's shift from
Oceanic to gothic, shortly after commencing his career as an artist, was a
retreat of sorts to a "primitive" more easily understood by his audience, but
this demonstrates all the more the precocity of his fascination with the Maori
and New Caledonian. It might be argued that Meryon was able to see
something in the gothic through his experience with the Oceanic (quite the
reverse of Gauguin's accretion of increasingly more "primitive" influences:
medieval, folk, Japanese, Pre-Columbian, and Egyptian, leading to the
Polynesian), and as a result was able to infuse his scenes with a sensibility
that was the most "primitive" aspect of his work.

Fig. 40. Charles Meryon, *Le Pilote de Tonga*, 1856,
etching. The Toledo Museum of Art

Meryon's efforts provide a more complex understanding of the develop-
ment of primitivism by demonstrating that in its everyday actuality it was a
fitful, experimental, and gradual process. In some respects, Meryon was
closer to primitivism in his representations of the gothic than to the Gothic
Revival because he attempted to see the world through the eyes of those
who fashioned monsters like the *Stryge*.[52] It is a primitivism more in content
than style because Meryon's representations remained sharply realistic.
Despite his predilection for the grotesque, he illustrated existing monsters
but did not invent one himself. The full incorporation of the grotesque in
both style and content would come much later, and not with Gauguin,

whose depictions of brooding, malevolent idols were not much different from the *Stryge*, but with Picasso's *Demoiselles d'Avignon* of 1907.

The Romantics' fascination with the grotesque and the monstrous held little charm for the realist and impressionist artists, but returned with full force with Gauguin and the symbolist movement.[53] However, it must be noted that an appreciation of the two-dimensional caricatures found in popular broadsheets, folk art, children's art, and some examples of "primitive" art developed during the nineteenth century, especially among the realists and impressionists.[54] As with other proponents of "primitive" expression, they made a virtue of what had been a fault, praising crude representations for their naïveté and directness of expression. Their popular associations and distance from academic conventions attracted the likes of Champfleury, who wrote a multivolume study of caricature. As Stanley Meltzoff observed: "Direct, spontaneous, and completely popular, [caricature] was at the same time the highest folk art and the lowest fine art. . . . Caricature as the most despised class of art was never admitted to the Salon" ("Revival," 284).

Certain nineteenth-century intellectuals and artists employed the term caricature to connote a suggestive representation that captured likeness without the mimetic techniques common to academic teaching. Rodolphe Töpffer, the Swiss caricaturist and writer, saw caricature as "pictorial invention," a visual shorthand that could capture the essential reality of a subject.[55] In an unpretentious summary of his aesthetic theory, *Réflexions et menus-propos d'un peintre genevois* (1848), Töpffer praised the imagery he observed to be common to all children and to all "savages" for this very quality of imagination and immediacy of expression: "Savages, as artists, readily have all of the force of our street urchins or the drummer-boys in our regiments" (1865 ed., 260). If one looks at the drawings of children, one will never see "the simple indications of the instinct for imitation that is said to be distinctive to the species and common to all human beings," but a "sign of intention, of a caprice, or, to put it more exactly, a sign of elemental beauty, unpolished, coarse, but nonetheless absolutely and exclusively born from thought" (260–61). The Easter Island monuments served as examples of the elemental caricature championed by Töpffer: considered in terms of their *conception* and not their *imitation*, the monuments were "cruel, hard and superior beings, brute divinities, but divinities nonetheless . . . and as signs they have already clarity and vigorous expression; they live, they speak, they proclaim that a creative thought has been infused in them and manifested through them" (260). Töpffer further argued that the artist

should set aside academic conventions and seek to discover formal equivalents for a particular figure or theme. The artist's true powers of representation would be revealed in his intuitive ability to summarize the particular character of a thing in a few quick strokes. In his *Essai de physiognomie* (Geneva, 1845) and in his numerous illustrated books, Töpffer did just this, exploring the variations in character and mood made possible with the slightest shifting of a line (Fig. 41).

Gauguin revived the Romantic interest in the (primarily sculptural) monstrous grotesque and his compositions frequently attempted to convey the dread and superstitious awe associated with idols and a "primitive" state of mind. Although Gauguin admired "primitive" sculpture, including Oceanic, his primitivist aesthetic was fundamentally an ornamental one that blunted the impact of any grotesque figure included in the composition. As an heir to the Romantic legacy, Gauguin introduced the diabolical into his Polynesian Golden Age, but it served to heighten by contrast the sensuality and beauty of the composition. Gauguin's small sculptures and relief carvings come closest to joining grotesque subjects with a rough, expressive style. The distorted self-portrait in the upper right of *Soyez amoureuses* (Fig. 24),

Fig. 41. Rodolphe Töpffer, *Essai de Physiognomie*. Geneva, 1845

with its thumb in its gaping mouth, is very close to the medieval grotesque-ries and shares their association with carnality. Still, the majority of relief sculptures carry over the languid, curvilinear pattern from his paintings, and the freestanding figures are too small and introverted to exert the aggressive menace or burlesque of the grotesque.[56]

It was Pablo Picasso who created an aggressive, extroverted primitivism during the explosively creative period in which the *Demoiselles d'Avignon* was painted. Picasso's *Demoiselles* (1907) embraced an even more radical primitivism because it assimilated sculpture, the most reviled of "primitive" arts, and because most of these sculptures were carved by Africans, the most reviled of "primitive" peoples.[57] I would add to this that Picasso's primitivism was built upon the grotesque tradition in Western aesthetics. In other words, Picasso incorporated the most remote and forbidden of "prim-itive" traditions through the most heavily censured of classical aesthetic categories.[58] In his essay on Picasso which concludes volume 1 of the *Primitivism* catalogue, William Rubin identifies the key elements of Picasso's primitivism: his appreciation of the "affective 'magical' force" and the "plasticity" of "primitive" sculpture.[59]

The grotesque, in all its significant forms, plays a substantial role in much of Picasso's work, but especially in his early primitivizing efforts. Both the formal invention (the "plasticity") and the expressive power that Picasso admired in *l'art nègre* double as key elements of the grotesque. As we have seen, Europeans frequently described "primitive" sculpture as grotesque for these same reasons. By translating African sculpture into the *Demoiselles d'Avignon*, Picasso created a primitivism that incorporated the grotesque in all its aspects: the arabesque (including its associations with the hiero-glyphic), caricature, and the monstrous. The relationship of the grotesque tradition to Picasso's primitivism in general and to the *Demoiselles* in particular will be the focus here.

The *Demoiselles* fully reveals for the first time what was to be one of the key elements of Picasso's work: his emphasis upon visual invention.[60] Rubin says as much in his statement that Picasso's primitivism "constituted a commitment to conception and invention (that is, genius) as over and against skill and virtuosity (talent)" ("Picasso," 242). The "plasticity" was one of the key inspirations taken by Picasso from African and Oceanic sculpture.[61] In fact, invention is the issue upon which the distinction between Cézanne's influence and "primitive" influence upon Picasso turns. Cézanne's aesthetic,

for all its richness and subtlety, did not allow for the stunning improvisation that was so vital to *Les Demoiselles* and to cubist imagery.[62]

Picasso's first full-scale painting to reveal the influence of *l'art nègre*, the *Demoiselles d'Avignon* displays great formal invention, with various inversions, reversals, and recapitulations. In many respects the painting is a fusion of contraries.[63] Picasso creates the two hybrid figures on the right by painting Africanized masks directly onto bodies to which they obviously do not belong. The breast of the standing Africanized figure is a square, not a circle, and is modeled in reverse so that it no longer seems to belong to the figure. In the most dramatic of these figurative arabesques, Picasso joins the absolute front of the squatting figure to its absolute back, letting the arm supporting the head serve as transition. Studies of the sketches leading to this particular figure demonstrate that its exaggerated physiognomy is in fact a playful metamorphosis from a sketch of a torso.[64] Picasso creates a spatial grotesque here as well, intersecting the figures with their surrounding space and conjoining foreground to background.[65] Exhibiting the characteristics of the arabesque, the *Demoiselles* is both overtly improvisational and a manifesto for artistic license. It highlights the invention of the artist by confounding and subverting the accepted norms of representation, appearing as a modern-day version of Horace's monstrous woman conjoined with a fish.

Caricature figures into the structure and intention of the *Demoiselles* as well.[66] An American critic, G. Burgess, wrote one of the earliest accounts of Picasso in the *Architectural Record* of 1910 and mentioned the artist's "sub-African caricatures."[67] It was the monstrous appearance of the *Demoiselles* that shocked Picasso's contemporaries. If Baudelaire had compared Picasso's Lautrec-inspired café scenes with the women of Avignon, he might have characterized the former as significative comic—clever and ironic—while the Africanizing figures approached the realm of the absolute comic. But on the most immediate level, *Les Demoiselles* incorporates the more horrific qualities of the monstrous and the idol. *Les Demoiselles*, for all its formal innovations that foreshadow the development of cubism, is a grotesque and frightening vision. The diabolical dream of Gauguin has been transformed into a waking nightmare. The painting is a violent and aggressive statement of pure physicality. The figures confront the viewer with the iconic, horrific expression so central to the European conception of the idol. The aggressive sexuality of the *Demoiselles* forges an additional link with the grotesque tradition and with the characterization of idols.[68] As classical beauty reflected rational order and intellectualized pleasure, the grotesque was, from satyrs

and centaurs onward, associated with bestiality. Translated into Judeo-Christian iconography, the grotesques on cathedral facades were personifications of various forms of carnality.[69]

These monstrous forms embody the second of those traits in African and Oceanic sculpture to be emulated by Picasso: their "affective, magical force." They communicate the same irrational emotions Picasso claimed to have felt during his first confrontation with "primitive" sculpture (mostly African) in the Trocadéro. Salmon described some of the sculptures owned by Picasso as "grimacing idols."[70] Picasso's recollection of his first significant encounter with African and Oceanic sculptures there combined a recognition of them as "magic things" with a very physical revulsion to their grotesque presence.[71]

The *Demoiselles d'Avignon* confronts the viewer with an awful aspect that was recognized by both Picasso's detractors as well as his supporters. In her recent study, Patricia Leighten described the impact of the painting upon Picasso's contemporaries, an impact some described as the explosion of a bomb.[72] The firsthand accounts employed a vocabulary that pointed to the grotesque. Kahnweiler wrote that "to everyone the painting seemed to be something crazy or monstrous."[73] Salmon related the following: "Nudes came into being, whose deformation caused little surprise—we had been prepared for it by Picasso himself . . . and even earlier by Cézanne and Gauguin. It was the ugliness that froze with horror the half-converted."[74] Since the association of the monstrous grotesque with the idol was a longstanding one, it is not surprising to find a connection made between Picasso's "primitivized" imagery with idols and magic by observers outside of Picasso's immediate circle. Members of the Russian avant-garde sensed the magical power of Picasso's proto-cubist paintings, some of which were part of the Shchukin collection. Georgy Chulkov wrote:

> Picasso's work reaches its culmination in his monumental pictures, drawn and painted with extraordinary conviction, precise as geometrical axioms despite the unexpectedness of their nightmarish forms. . . . Picasso's conversations with his demon in those days were remarkable indeed.
>
> The surprising appropriateness of Picasso's artistic forms to the emotions that have arisen in him enables us to judge with assurance those conversations between man and devil. Satan himself suggested to Picasso that woman is not a mechanism as Degas thought, or a doll as Renoir felt her to be, but an idol—and what an idol.[75]

Another article recognized Picasso's distance from the primitivism of Gauguin:

> When you enter the Picasso room in S. I. Shchukin's gallery, you
> are overcome by a sense of terror that relates not only to painting
> . . . but to the whole of cosmic life and its destiny. The room before
> Picasso contains a delightful Gauguin, which makes us feel that we
> for the last time tasted the joy of natural life. . . . Gauguin, the child
> of a refined and degenerate culture, had to escape to Tahiti to find
> exotic nature and exotic people. . . . From this dream we awake in
> the Picasso room, where all is cold, gloomy and terrifying. . . .
> Picasso has arrived at the Stone Age; but it is a transparent Stone
> Age. . . . Like a clairvoyant he sees through all veils . . . where he
> perceives his composite monsters. These are the demonic grimaces
> of the pent spirits of nature.[76]

Picasso's primitivism fully established the anticlassical role that "primitive" art came to play in modern art. As with the other aesthetic elements ascribed to the construct of "primitive" art, the grotesque had long functioned within the classical tradition as a peripheral expression. But the grotesque was the most radical form of nonrational expression because it represented the near opposite of the classical ideal, both in its bizarre inventions and its willful ugliness. Picasso's incorporation of the grotesque was an especially daring attack upon the classical tradition, as was his use of the idol, which functioned as the literal embodiment of irrational forces and a parody of the great tradition in classical sculpture.

In the *Demoiselles d'Avignon*, Picasso laid the framework for a stylistic language that inverted the ideals of the classical tradition more completely than ever before. Edward Fry has shown how Picasso's cubism, nascent in the *Demoiselles*, attacked the classical tradition with its own weapons, undoing it by its own means: "the special achievement of Cubism, and above all of Picasso, was to reinvent classical, mediated representation, and in that reinvention also to transform it so as to reveal its central conventions and mental processes."[77] Picasso's assimilation of the grotesque through the emulation of "primitive" art works in a similar fashion. The *Demoiselles* turns the classical ideal inside-out, installing the irrational grotesque as the governing force, while relegating rationality to the peripheral role. Picasso's cryptic claim that he found African art to be *raisonnable* becomes particularly revealing in this context, ascribing the key element of the classical

center to its most radical Other on the periphery. Just as the classical norm needed its constructed opposite to define it, to embody what it was not, Picasso's *Demoiselles* so completely inverts the classical tradition that it constructs rationality as its defining Other. The *Demoiselles d'Avignon* fully establishes primitivism as a force in modern art, but not solely by its incorporation of the "most primitive" African and Oceanic sculpture. Rather than rejecting certain elements of the classical norm, the painting constructs its direct inverse, its equally powerful Other. In doing so, Picasso strikes a death blow to academic classicism, but he simultaneously reveals the dialectic that underlay two centuries of European debate concerning "primitive" expression.

Conclusion:
Modernist Appropriations
of "Primitive" Arts

Starting with the premise that "primitive" art was a cultural construct that emerged in European discourse during the eighteenth and nineteenth centuries allows us to address not only those characteristics that Europeans ascribed to "primitivity," but the deeper presumptions concerning the visual arts that generated these criteria. The exploration of this cultural construct also raises interesting questions concerning the nature of primitivism and, on a broader level, the nature of the European avant-garde.

The most immediate of these questions regards the relationship of modernism to the classical tradition. The formalist paradigm has framed the emergence of modern art as David's victory over the Goliath of academic classicism, a formulation that has increasingly come under fire. Edward Fry's approach to cubism, taken from a strong philosophical grounding, has demonstrated that Picasso's cubist experiments functioned as a dialectic with the classical tradition. And, as we have seen here, the individual aesthetic categories that construct "primitive" art strongly suggest that the development of primitivism in modern art was not so much a total rejection

of academic classicism as a gradual inversion of it. If it was the classical tradition that framed the initial construction of "primitive" art, it follows that it was that same tradition which set the limits and defined the shape of primitivism to a large extent. Although modernist appropriations of "primitive" art have been characterized as a precocious appreciation of non-Western imagery, modern artists borrowed only those elements identified as "primitive," so that their primitivism might better be understood as the construction of an anticlassical aesthetic, the antithesis of the classical thesis.

Second, a careful examination of the development of primitivism suggests that the innovations of Gauguin and Picasso must be viewed as part of a gradual process of assimilation. We have seen that European artists incorporated elements from a series of "primitive" traditions in their attempts to address a crisis in representational art, moving further away from the classical center with each generation. The Oceanic and African imagery incorporated by Gauguin and Picasso was the most alien to European sensibilities, but both artists built upon the primitivism already established in European art, mingling African with Egyptian or Marquesan with Japanese. Reframing primitivism as a process of assimilation, heavily influenced by the classical norm, and placing Gauguin or Picasso within this continuum does not diminish their achievements by presuming either that the progression toward primitivism was predetermined or that their artistic solutions were inevitable. The development of primitivism does proceed along some recognizable patterns, but in its everyday actuality it was a fitful, experimental, and gradual process. The examples of Runge and Meryon quite emphatically demonstrate this point. Reframing their work as part of a broader assimilation process more clearly reveals the true nature of their contributions, rather than portraying them as having fallen short of the mark by measuring their efforts against the primitivism of Gauguin or Picasso. Debating the primacy of Gauguin's or Picasso's primitivism is thus relegated to a secondary position; the assimilation paradigm highlights instead that each artist coalesced very different aspects of "primitive" expression into powerful new directions in modern art.

In addition to these issues, one must address the whole narrative of aesthetic "discovery" so common to histories of primitivism. The story of modern artists discovering "primitive" art in a bistro or at the Paris *exposition universelle* does not appear quite so uncomplicated and triumphant to us now, especially when it echoes so closely the discovery motif common to voyage accounts, a motif that justified European claims of ownership and the subsequent colonization of other cultures into the European universe. While

we have discussed primitivism primarily on the level of stylistic influence, the assimilation of "primitive" art was not ideologically free. It took place during a period of spreading Western hegemony over the non-Western world. Attempting to sketch out the aesthetic frame imposed upon "primitive" art ties the phenomenon of primitivism into the broader cultural frame of colonialism imposed upon "primitive" cultures.

It is also useful to question the extent to which art history has reinforced Eurocentric conceptions of "primitive" art. There are historical explanations for this, since art history was an outgrowth of the same enterprise to chart cultural development that initially formulated the concept of "primitive" art. While academic classicism created a hybrid creature known as "primitive" art, which functioned as the inferior shadow of the classical ideal, art-historical scholarship perpetuated this representation by making "primitive" art the shadow of modernist innovations, influential yet anonymous. The growing reflexivity of the discipline has begun to make more apparent the ideas that shaped our discussions of "primitive" art and the extent to which we still depend upon them. The application of other methodologies than the one used here could further define the frame and its construction of meaning. Its outline might begin to emerge from a dialogue between scholars of Western and non-Western traditions that compared the meanings and functions of images in their original contexts: African, Romanesque, Egyptian, especially as a contrast to the anomalous fine-arts tradition of modern Europe. The viewpoints afforded by various methodologies, anthropological, semiological, or psychoanalytical, might yield further insights into the representations of "primitive" art.

Stepping back from the cultural construct of "primitive" art allows us a slightly better understanding of the motivations behind primitivism. "Primitive" art seemed to offer a return to creative possibilities. As we have seen, this involved a break away from mimesis toward alternative means of representation, but it also opened paths that skirted *ut pictura poesis* in pursuit of other means of expression. The desire to regain a "primitive" sensibility was, on a more profound level, a desire to overthrow the literary with the visual. Perhaps the key contribution of primitivism was its attempt to reembody art by returning it to pure visual means, to make it mute and physical, impassioned and poetic. Turning the classical tradition into a pedagogical formula, the art academies of the eighteenth and nineteenth centuries cut away the body and left a talking head. This is best demonstrated by the fact that those characteristics attributed by the academic frame to "primitive" expression were also those characteristics recognized

by Renaissance artists and aestheticians as the marks of artistic genius. Narrative and illusion could be learned, but only the artist of inborn genius could transform their rational structures into a truly profound work of art by virtue of his invention (*ingenia*) and his creative passion (*furia*). To be hieroglyphic was high praise, for it signaled that the artist had endowed mute, visual form with transcendent meaning. Ornament and grotesques carried similar significance as markers of inspired creation.

Primitivism seems, then, to be the effort to recover the embodied, the visual, the inspired invention by regressing to "prerational" traditions. The irony of this endeavor is that modernism further fractured the split between imagination and reason begun by academic classicism. If the academy diminished everything in the name of rational order, the growth of modernism embraced everything irrational. Primitivism did not restore the imagination to a position that transcended rational expression, but subverted the foundations of rational order in order to pursue the irrational for its own sake and toward its outermost limits. As a result, primitivism finds itself in a decidedly ambiguous position, for it is only within the larger frame of a self-defined "civilized" and "rational" culture that artists can be "primitive" and "irrational." Baudelaire's distinction between the significative and the absolute comic comes into play here. A painting such as the *Demoiselles d'Avignon* restored vitality and creative fury to the fine-arts tradition, coming very close to the purity of expression by which Baudelaire characterized the absolute comic. Nonetheless, it must be more broadly defined by the significative comic because it was a deliberate inversion of the rational hierarchies of academic painting. The *Demoiselles* takes an ironic stance to the dominant tradition, as does much of modern art (even long after the Academy lost its influence). This is the reality underlying Zola's perceptive descriptions of Manet's "elegant naïveté" and "sweet brutality." Like representations of violent natural phenomena in the sublime mode, the idols of Picasso are frightening yet pleasurable, because they, like the primitivism they embody, are framed and controlled by the broader aesthetic norms of "fine art."

Notes

Introduction

1. The scholarship informing this study comes from three key sources: art-historical studies concerned with aspects of primitivism, studies treating the classical tradition, and critical theory regarding the social construction of reality. Of those works treating the history of primitivism, Bernard Smith's landmark *European Vision and the South Pacific* (1960) deserves special mention, being the first study to address the ways in which Europeans interpreted both the cultures and the landscape of the South Pacific. Joseph Rykwert's highly original study, *On Adam's House in Paradise: The Idea of the Primitive Hut in Architectural History* (1972) and Barbara Stafford's *Symbol and Myth: Humbert de Superville's Essay on Absolute Signs in Art* (1979) describe important developments in theory and practice related to the development of a primitivist aesthetic.

Important studies of nineteenth-century movements toward primitivism include Meyer Schapiro's essay, "Courbet and Popular Imagery: An Essay on Realism and Naïvete," Aaron Sheon's discussion of "The Discovery of Graffiti," as well as the work by Gabriel Weisberg and Elisa Evett on *Japonisme*. The only two major art-historical studies that have attempted to take a comprehensive approach to the phenomenon of primitivism are Robert Goldwater's *Primitivism in Modern Painting* (1938) and the 1984 Museum of Modern Art exhibition catalogue, edited by William Rubin. The ambitious project of George Boas and Arthur O. Lovejoy to compile a broad, cultural history of primitivism did not extend beyond the publication of the first volume, *Primitivism and Related Ideas in Antiquity*, in 1935.

David Summers's extensive work on aesthetics and the structures of visual meaning has significantly advanced our understanding of the classical tradition in particular and of style in general. His discussions of ornament, *ingenia*, and the grotesque exert particular influence in this study, as do Edward Fry's analyses of *ut pictura poesis* and the relationship of modernism to the classical tradition, especially in the case of Picasso. Erwin Panofsky's 1930 essay "Das erste Blatt aus dem 'Libro' Giorgio Vasaris: Eine Studie über der Beurteilung der Gotik in der italienischen Renaissance . . ." discussed the ramifications of Vasari's defining and valorizing the "modern" (Renaissance) style by constructing its opposite, the "gothic." Panofsky's acute analysis of the means by which the classical tradition was reestablished by representing it as triumphant over the "primitive" past (a past whose characteristics mirror those later assigned to the "primitive" by many Enlightenment authors) posed questions that lie at the heart of this study. In addition, Ernst Gombrich's essay "Norm and Form," published in 1966, reveals a well-wrought analysis of the "terms of exclusion" accorded non-classical traditions.

A wide range of recent studies have addressed the "social construction of difference," that is, the visual and verbal discourses through which any group defines its Other(s). The European characterizations of the "primitive" have been taken up in this context; for indeed, the "primitive" represents one of the most compelling Others to be created by the modern,

industrialized world. Of those scholars concerned with the issue of representation, Hayden White's *Tropics of Discourse* and *Metahistory*, and Edward Said's study on Orientalism were both early and extremely influential, followed by Tzvetan Todorov's *The Conquest of America: The Question of the Other* and Gayatri Spivak's *In Other Worlds: Essays in Cultural Politics*. More recently, James Clifford demonstrated that even those representations considered the most objective—in this instance anthropological scholarship—cannot render a transparent view of any cultural reality, including their own. It was the very lack of reflexivity concerning the cultural boundedness of its own scholarly pursuits that lay at the core of the controversy concerning the MoMA exhibition. In her 1990 contribution to the discussion, *Gone Primitive: Savage Intellects, Modern Lives*, Marianna Torgovnick critiqued literary, art-historical, and anthropological attempts to write about the "primitive" and the "savage." These studies share a culturally critical and deconstructive approach to Western structures of knowledge and the works it has canonized, as does Griselda Pollock's art-historical study, *Vision and Difference* (1988), which employed Marxist and feminist theory to examine the work of art as a cultural site, as the place where cultural realities are constructed.

2. In the introductory essay to the Museum of Modern Art catalogue, *"Primitivism" in Twentieth-Century Art* (2 vols., New York, 1984), William Rubin differentiates between "archaic" and the "primitive" influences upon European artists, and also draws a distinction between "court" and "tribal" styles. He argues further that we are justified in using the term "primitive" to describe actual art traditions because these styles were admired by avant-garde artists for their primitivity. This is a circular argument, because Rubin is working within much the same cultural framework as those artists he treats.

The multiplicity of images deemed to be "primitive" is one of several themes addressed by Kirk Varnedoe in "Primitivism," in his *A Fine Disregard: What Makes Modern Art Modern* (New York, 1990), 182–215. A. A. Gerbrands provided an important and early discussion of the terminology attached to non-Western arts in his 1957 study, *Art as an Element of Culture, Especially in Negro-Africa*, trans. by G. E. van Baaren-Pape (Leiden, 1957), 9–24.

3. Friedrich von Schlegel, "Gemäldebeschreibungen aus Paris und den Niederlanden in den Jahren 1802–4," in *Sämtliche Werke*, vol. 6 (Leipzig, 1910). See especially chaps. 3 and 4.

4. P. F. H. d'Hancarville, ed., *Collection of Etruscan, Greek and Roman Antiquities from the Cabinet of the Honourable William Hamilton* (Naples, 1791–95), 1:168 and 170.

5. Cited by Hetty Joyce, "The Ancient Frescoes from the Villa Negroni and Their Influence in the Eighteenth and Nineteenth Centuries," *Art Bulletin* 65 (September 1983), 423.

6. Théophile Gautier, *L'Art moderne* (Paris, 1856), 130.

7. T. E. Bowdich, *An Essay on the Superstitions, Customs and Arts of the Ancient Egyptians, Abbysinians and Ashantees* (London, 1821).

8. Robert Goldwater, *Primitivism in Modern Painting* (New York, 1938), 252–53. As if in response to the paltry evidence, one of the principal goals of the MoMA exhibition was to uncover as many historically specific, documentable instances of "primitive" influence upon modern artists as possible. The cultural framework through which Europeans interpreted and assimilated these arts was not established. Although this project unearthed vital new information, in many respects it erred in that its zeal for historical *fact* further obscured historical (and creative) *process*.

9. "Primitive" should be distinguished from the naïve, the latter referring to the untaught or uncultivated expression in a culture that has a learned tradition. The description of a culture as "primitive" implied, as we shall see, that no such tradition existed.

10. It is more accurate to describe this as the reinvention of "primitive" art, since the desire to identify and regress to earlier forms of expression recurs in cultural history. See, for example, E. H. Gombrich's "The Debate on Primitivism in Ancient Rhetoric," *Journal of the Warburg and Courtauld Institute* 29 (1966), 24–28.

11. While recognizing that it is unwieldy, I shall set off the term "primitive" by quotation marks throughout the book to identify it as a cultural construction, and to set it off from any reference to a specific art tradition or object.

12. *The New Science of Giambattista Vico*, trans. T. G. Bergin and M. H. Fisch (Ithaca, 1968), 129–30.

13. The formalist frame was signaled perhaps most clearly in the MoMA catalogue by the three well-documented articles concerning the collection of American Indian, Oceanic, and African arts: "The Arrival of Tribal Objects in the West: From North America," by Christian Feest; "From Oceania," by Philippe Peltier; and "From Africa," by Jean-Louis Paudrat, 85–175. While these studies elaborated upon the availability of the "primitive" objects for stylistic borrowing, the ways in which these objects were understood and the impact of interpretive theory upon what was borrowed received little attention (Goldwater's second chapter does examine the anthropological interpretations of "primitive" art during the nineteenth century, especially those materialist and evolutionist theories concerned with primitive ornament; however, these theories do not carry over into his discussions of modern art). In fact, modernist historians tend to emphasize the fact that Picasso, for example, knew next to nothing about the cultural significance or provenance of various masks, being interested only in their formal invention.

14. It seems more fruitful to demonstrate that the intellectual construction of "primitive" art did indeed shape the eventual development of primitivism by examining a few, select circumstances than attempt a survey that would result in little more than a long, annotated list. If this exposition of the aesthetic structures of "primitive" art is indeed viable and convincing, then its ramifications for the work of other primitivizing artists and movements would best be taken up by scholars expert in those areas.

Chapter 1

1. This apt phrase comes from Rémy Saisselin's book, *The Rule of Reason and the Ruses of the Heart: A Philosophical Dictionary of Classical French Criticism, Critics, and Aesthetic Issues* (Cleveland, 1970).

2. Certainly these terms were not always used in the same way. While it cannot be immediately assumed that a particular term, such as "grotesque," meant exactly the same thing to each European who uttered it when confronted with a Maori carving, the meaning of a term can be reconstructed in large part because (1) it has a history of meaning whose permutations can be traced into the modern era, (2) the context in which this term was used during the eighteenth and nineteenth centuries was consistent with its established connotations, and (3) a pattern can be discerned in the types of visual expression to which the term was applied.

3. Vico, *The New Science*, 116.

4. Ibid., 313.

5. Bougainville, Comte Louis Antoine de, *Voyage autour du monde, par le frégate du Roi, La Boudeuse, en 1766–69*, trans. J. R. Förster (London, 1772), 258.

6. "L'oeil humain ne voit pas partout les couleurs de même façon . . . l'oeil japonais les voit avec infiniment moins de justesse abstraite et infiniment plus de finesse concrète que le notre. . . . Nous nous éloignons de la nature: eux s'y plongent; nous réfléchissons et ils observent." Elisa Evett, "The Late Nineteenth-Century European Critical Response to Japanese Art: Primitivist Leanings," *Art History* 6, no.1 (March 1983), 86. Evett notes that some Europeans argued from a quasi-scientific basis that Japanese artists perceived the world differently, either because of differences in the structures of Oriental and Occidental eyes or differences in light

in Europe and the Far East. She also discusses the revisions to the Romantic view of the child that were being made during the late nineteenth century (86–87).

7. "Pour le Japonais . . . la nature est un décor merveilleux qui sans cesse varie, sans cesse apportant de nouvelles délices. . . . Les moindres détails du spectacle des choses l'intéressent. . . . En même temps, les qualités supérieures de son intelligence s'affaiblissent, ou bien, faute d'usage, s'atrophient. . . . Le moindre effort de généralisation abstraite lui est interdit." Teodor de Wyzewa, *Peintres de jadis et d'aujourd'hui* (Paris, 1903), 235–36, cited in Evett, 86–87.

8. Unsigned review, in *Quarterly Review* 22 (January 1820), 286.

9. Duché de Vancy, who studied in the *Académie royale* with Joseph-Marie Vien, was undoubtedly familiar with Watteau's imagery. This drawing was one in a number sent back to Paris via another ship while Duché de Vancy continued on in a circumnavigation of the world with the Comte de La Pérouse. The sketchbooks, filled with South Pacific subjects, arrived in good order, but the La Pérouse expedition, including the artist, was lost at sea. This caused great consternation in France, despite the brewing Revolution. Search parties were sent out, but remnants of the wrecked ships were not found until 1828 by Dumont D'Urville. Reports from the natives of Vanikoro, the site of the accident, suggested that some of the crew did survive, but none lived long enough to return to France with Dumont D'Urville. See Admiral Jean-François Galaup, Comte de La Pérouse, *Voyages and Adventures of La Pérouse*, trans. J. S. Gassner from the 14th edition (Tours, 1875; reprint, Honolulu, 1969).

10. Van Wyck Brooks, ed., *Paul Gauguin's Intimate Journals* (Bloomington, 1965), 97.

11. Brooks, 41. Gauguin also claimed to have been taught the ancient beliefs of the Tahitians by a child, the thirteen-year-old girl who was for a time his mistress, when in fact he garnered the large part of this material from an ethnographic study by a Belgian scholar, A. Moerenhout, *Voyage aux îles du grand océan*, which was published in two volumes in Paris, 1837.

12. William Cohen, *The French Encounter with Africans* (Bloomington, 1980), 209. This damning assessment of the African is written by none other than the French translator of Harriet Beecher Stowe's *Uncle Tom's Cabin!* Alfred Michiels was an abolitionist but believed that the African in his native lands, apart from white influence was "the most stupid, the most perverse, the most bloodthirsty of all human races."

13. Of course, another reason for Gauguin's inclusion of negative imagery derived from his intense hatred of bourgeois values. Gauguin reveled in the aspects of Polynesian life that would be shocking to bourgeois sensibilities and routinely mentioned promiscuity and cannibalism in his writings. The paintings, of course, have none of these more lurid details.

14. Hugh Honour, *The New Golden Land: European Images of America from the Discoveries to the Present Time* (New York, 1975), 78.

15. Lafitau, *Mouers*, 91.

16. Evett, "Late Nineteenth-Century Critical Response," 83.

17. *The Journal of Eugene Delacroix*, trans. Walter Pach (New York, 1980); entry is from 15 January 1860, 651.

18. Jules Laforgue, "L'Impressionisme," trans. William Jay Smith as "Impressionism: The Eye and the Poet," *Art News* 55 (May 1956), 43.

19. Owen Jones, "Ornament of Savage Tribes," in his *The Grammar of Ornament* (London, 1856), 15–16.

20. Robert Milligan, *The Fetish Folk of West Africa* (New York, 1912; reprint, 1970, 122).

21. Vico, *The New Science*, 312.

22. *Paul Gauguin's Intimate Journals*, ed. Van Wyck Brooks (Bloomington, 1965), 245.

23. Champfleury, *L'Imagerie populaire*, xxiii, trans. in Meyer Schapiro, "Courbet and Popular Imagery: An Essay on Realism and Naïveté," in his *Modern Art: Nineteenth and Twentieth Centuries* (New York, 1979), 61.

24. Emile Zola, "Une Nouvelle manière en peinture: Edouard Manet (1867)," reprinted in *Emile Zola: Salons*, ed. F. W. J. Hemmings and Robert J. Neiss (Geneva, 1959), 85–86.

25. For all his precocity in championing early epic poetry over the accomplished styles of his peers, it must be stressed that Vico was speaking only of poetry. He did not consider the visual arts of the "primitive" equal to those of reasoning man and did not rank the "emblems" of the North American tribes with the European fine arts tradition. Nonetheless, Vico's argument was one of the first in a series that came to value the naïveté and strong passions of the "primitive." By the end of his century, Vico's admiration for "primitive" poetry would be extended by others to include the visual arts.

26. William Whewell, *The General Bearing of the Great Exhibition on the Progress of Art and Science* (London, 1851), 4–5.

27. Delaroche in Gauguin's *Avant et Après* (Paris, 1923), 35–36.

28. Lotman, B. A. Uspenskij, et al., "Theses on the Semiotic Study of Cultures (as applied to Slavic texts)," in *Structure of Texts and the Semiotics of Culture*, ed. Jan van der Eng and Mojmir Grygar (The Hague, 1973), 1–28.

29. Philippe Burty, *Memoir and Complete Descriptive Catalogue of the Works of Charles Meryon by Philip Burty*, trans. Marcus Huish (London, 1879). Meryon spent four years in the South Pacific and made numerous sketches during his voyage. His drawings strive for documentary accuracy and the etchings he later made of Oceanic subjects did not intermix or confuse particular Polynesian and Melanesian styles. Because of his attention to detail it is unlikely that Meryon skewed the model to resemble a faun. The resemblance most probably was made in Burty's mind. The subject of Meryon's model or mask (there is some confusion regarding which it was) will be taken up in more detail in Chapter 4.

30. Albert Boime has provided the most comprehensive work on the French Academy in his study, *The Academy and French Painting in the Nineteenth Century* (New York, 1971). His more recent study, *Thomas Couture and the Eclectic Vision* (New Haven, 1980), contains a wealth of material concerning the state of academic painting in mid-century. The Academy's changing role during the eighteenth century is a continuing theme in Thomas Crow's *Painters and Public Life in Eighteenth-Century Paris* (New Haven, 1985). See also Nicholas Pevsner's *Academies of Art, Past and Present* (New York, 1973).

31. See the opening argument of chap. 5, "Greuze and Official Art," in his *Painters and Public Life*, 134.

32. Boime, *Academy*, 2. This liaison was further institutionalized when the *Académie royale* was reorganized during the French Revolution, and grouped together with literature in the third class of the *Institut* (*Academy*, 5).

33. *New Science*, 306. This was, of course, Alberti's belief as well that sculpture preceded painting because it required less abstraction to give form to a shapeless mass than to create a convincing illusion of form on a two-dimensional surface.

34. Johann Joachim Winckelmann, *Geschichte der Kunst des Altertums* [1764] (Vienna, 1934), part 1, chap. 1, p. 25.

35. "L'origine de la sculpture se perd dans la nuit des temps; c'est donc un art de Caraïbes. . . . Nous voyons tous les peuples tailler fort adroitement des fétiches longtemps avant d'aborder la peinture, qui est un art de raisonnement profond, et dont la jouissance même demande une initiation particulière." Baudelaire, "Pourquoi la sculpture est ennuyeuse," *Salon de 1846, Critique d'art*, ed. Claude Pichois (Paris, 1965), 166.

36. "La sculpture se rapproche bien plus de la nature, et c'est pourquoi nos paysans eux-mêmes, que réjouit la vue d'un morceau de bois ou de pierre industrieusement tourné, restent stupides à l'aspect de la plus belle peinture."

37. William Oldfield, "On the Aborigines of Australia," *Transactions of the Ethnological Society of London* 3 (1865), 227.

38. Cited in Honour, *New Golden Land*, 28.

39. For an extensive discussion of Renaissance debates concerning *ingenium* and *ars*,

imagination and reason, see David Summers, "Contrapposto: Style and Meaning in Renaissance Art," *Art Bulletin* 59, no. 3 (September 1977), 336–61.

40. "Full of spirit, full of invention."

41. Sydney Parkinson, in B. Smith, *European Vision*, 88.

42. T. E. Bowdich, *Mission from Cape Coast Castle to Ashantee* (London, 1819; reprint, London, 1966), 306.

43. "Naïve, simple; without disguise (open), lacking finish" (*Dictionnaire*, 1776 ed.).

44. C. H. C. Wright, *French Classicism* (Cambridge, Mass., 1976), 90.

45. ". . . avoir une connaissance parfaite de la chose qu'on veut representer, de quelles parties elle doit être composée, et de quelle sorte l'on y doit procéder. Et cette connaissance que l'on acquiert, et dont l'on fait des règles, est à mon avis ce que l'on peut nommer l'Art." Félibien, preface to *Conférences de l'Académie Royale de Peinture et de Sculpture* (Paris, 1669), published in vol. 5 of Félibien's *Entretiens sur les vies et sur les ouvrages des plus excellens peintres anciens et modernes* (Trevoux, 1725), 307–8.

46. Rensselaer Lee, "*Ut pictura poesis*: The Humanistic Theory of Painting," *Art Bulletin* 22 (1940), 200.

47. Ibid., 223.

48. Ibid., 199. Lee and others have noted that *ut pictura poesis* took on a life of its own, so that the meanings that came to be attached to it were far broader than those first voiced by Horace.

49. Ibid., 201.

50. Félibien, preface to *Conférences*, 311. Félibien went on to rank the genres, relegating still life to the lowest category, then in ascending order; landscape, animal paintings, portraiture, and finally, history painting.

Interestingly, Félibien ranks the painter who can "conceal beneath the veil of fable the virtues of great men and the most exalted mysteries"—in other words, the painter of allegory— higher than the artist who presents historical narrative. This preference was reversed by many in the eighteenth century and allegory and fable described as unclear and irrational. This reflected the movement from the poetic to the increasingly prosaic and didactic in academic art, a tendency that provoked significant reaction (see Chapter 2 concerning hieroglyphics).

51. Rémy G. Saisselin, "Painting and Writing: From the Poetry of Painting to the Writing of the *Dessin Idéal*," *Eighteenth Century* 20, no. 2 (1979), 127.

52. See David Summers's discussion of the notion that Horace indeed gave the painter and poet the right to dare, in his chapter on *fantasia*, in *Michelangelo and the Language of Art*, (Princeton, 1981).

53. Lee, "*Ut pictura poesis*," 211–12.

54. J. C. Beaglehole, ed., *The Endeavor Journal of Sir Joseph Banks: 1768–1771* (Sydney, 1962), 1:407.

55. Beaglehole, *Endeavor Journal*, 2:24.

56. Ibid.

57. Wright, *French Classicism*, 163. Félibien stated the work of art begun without a clearly formed idea was the same as an infant born prematurely: not only did it cause great pain to the mother, it rarely arrived in a state of perfection (preface to *Conférences*, 5:307).

58. It was in these motivations that the differences can be located between primitivism and historicism or exoticism. Historicism and exoticism employed the trappings of particular cultures, distant in time or place, as the stage setting for traditional narrative or genre subjects painted in an established European style, whether rococo, academic classicism, or impressionism. They served in a decorative manner and exerted virtually no stylistic influence. Primitivism had reform in mind, going beyond the entertainment level of exoticism or historicism to effect stylistic change. The emulation of "primitive" styles was value-laden; rather than shoring

up the status quo, primitivism meant to subvert it. There were, of course, points where these three phenomena converged. The German Nazarenes' borrowings from both medieval subjects and medieval style conflated historicism with a tentative primitivism.

59. Friedrich Schiller, 9th Brief, *On the Aesthetic Education of Man*, ed. Elizabeth Wilkins and L. A. Willoughby (Oxford, 1967).

60. Lotman, 3.

Chapter 2

1. Runge was not the only Romantic artist to attempt a primitivizing style or subject, as Barbara Stafford has demonstrated in her study, *Symbol and Myth: Humbert de Superville's Essay on Absolute Signs in Art* (Cranbury, N.J., 1979). Stafford's study provides the most thorough overview of period interest in symbols, signs, hieroglyphics, as well as related phenomena such as phrenology and handwriting analysis. See also idem, "From 'Brilliant Ideas' to 'Fitful Thoughts': Conjecturing the Unseen in Late Eighteenth-Century Art," *Zeitschrift für Kunstgeschichte* 48 (1985), 329–63 and idem, "Characters in Stones, Marks on Paper: Enlightenment Discourse on Natural and Artificial Taches," *Art Journal* 44 (Fall 1984), 233–40.

The artist closest in time and in sensibility to Runge was William Blake, a connection particularly suggestive in Blake's *Book of Job*. William Vaughan discusses the possible connections between the two artists in *German Romanticism and English Art* (New Haven, 1979), chap. 1. For a discussion of related issues, see Aaron Sheon, "The Discovery of Graffiti," *Art Journal* 36 (Autumn 1976), 16–22.

2. Ornament was closely tied to issues of narrative and, like the hieroglyph, was identified as a component of "primitive" art. This will be taken up in the following chapter, as will the hieroglyph's overlap with the grotesque, both being hybrid, nonrational forms.

3. The best sources remain Robert Rosenblum, *Transformations in Late Eighteenth-Century Art* (Princeton, 1967), and George Levitine, *The Dawn of Bohemianism* (University Park, Pa., 1978), and Walter Friedlaender, "Eine Sekte der 'Primitiven' um 1800 in Frankreich und die Wandlung des Klassizismus bei Ingres," *Kunst und Künstler* 28 (April 1930), 281–86.

4. Honour, *New Golden Land*, 165–67.

5. J. Guibert, *Le Cabinet des Estampes de la Bibliothèque Nationale* (Paris, 1926), chap. 3, "Bérighen collection."

6. Honour, *New Golden Land*, 28.

7. Rudolf Wittkower, "Hieroglyphics in the Early Renaissance," in *Allegory and the Migration of Symbols* (London, 1977), 113–28.

8. *New Science*, 127 and 139. See also Madeleine V. David, *Le débat sur les écritures et l'hiéroglyphe aux XVIIème et XVIIIème siècle* (Paris, 1965); and Clifton Cherpack, "Warburton and Some Aspects of the Search for the Primitive in Eighteenth-Century France," *Philological Quarterly* 36 (April 1957), 221–31.

9. Lafitau, *Moeurs des sauvages*, vol. 2, plate 3.

10. *A Voyage Round the World*, trans. T. N. Longman and O. Rees (London, 1801), 345–46.

11. The literature on the *ut pictura poesis* debate is voluminous, but for a recent study of these issues, see W. J. T. Mitchell's *Iconology: Image, Text, Ideology* (Chicago, 1986). The principal discussion of *ut pictura poesis* remains Rensselaer W. Lee's "*Ut pictura poesis*: The Humanistic Theory of Painting," *Art Bulletin* 22 (1940), 197–269. Two useful articles concerning this debate are James Henry Rubin's "Allegory versus Narrative in Quatremère de Quincy," *Journal of Aesthetics and Art Criticism* (Summer 1986), 383–92; and Rémy Saisselin's "Painting and Writing: From the Poetry of Painting to the Writing of the *dessin idéal*," *Eighteenth Century* 20, no. 2 (1979), 121–26.

12. Gotthold Ephraim Lessing, *Laocoön, or On the Limits of Painting and Poetry* [1766], trans. W. A. Steel, in *German Aesthetic and Literary Criticism*, ed. H. B. Nisbet (Cambridge, 1985), 67.

13. Jean-Baptiste Du Bos, *Réflexions critiques sur la poésie et sur la peinture*, trans. Thomas Nugent, 2 vols. (London, 1748), 1:153–54.

14. Anthony Ashley Cooper, earl of Shaftesbury, "Plastics," in *Second Characters; or the Language of Forms*, ed. Benjamin Rand (Cambridge, 1914), 91.

15. George Richardson, *Iconology; or A Collection of Emblematical Figures*, ed. Stephen Orgel, 2 vols. (London, 1779).

16. Johann Joachim Winckelmann took up the subject of allegory in chap. 7 of his *Reflections* of 1755 and in his *Versuch einer Allegorie* of 1766. Although he decried the fact that the same tired narratives were painted over and over, Winckelmann was no primitivist. The classicist advocated the development of allegories that would express intangible ideals and would certainly have rejected the more concrete hieroglyphical solutions of Runge.

17. Johann Georg Hamann, *Aesthetica in Nuce* (1762), in Nisbet, ed., *German Aesthetic and Literary Criticism*, 141.

18. Liselotte Dieckmann, *Hieroglyphics: The History of a Literary Symbol* (St. Louis, Mo., 1970), 181.

19. These ideas are taken up by Lorenz Eitner in his classic article, "The Open Window and the Storm-Tossed Boat," *Art Bulletin* 37 (December 1955), 281–90. See also Ludwig Völkmann, "Die Hieroglyphen der Deutschen Romantiker," *Münchner Jahrbuch der Bildenden Kunst*, n.s. 3 (1926), 157–86; and Eva Fiesel, *Die Sprachphilosophie der Deutschen Romantik* (Tübingen, 1927).

20. Wilhelm Heinrich Wackenroder, *Herzensergiessungen eines kunstliebenden Klosterbruders* [1797] (Weimar, 1914), 74–75.

21. Although Runge's painting, known as the small version of the *Morning*, dated 1808, will be the focus of this discussion, it should be noted that Runge completed preliminary compositions for all four *Times of Day* in 1803. The collected writings of the artist, *Hinterlassene Schriften*, were published in 1840–41 in two volumes, and reproduced in facsimile (Göttingen, 1965). See especially Jörg Traeger's monograph and critical catalogue, *Philipp Otto Runge und Sein Werk: Monographie und Kritischer Katalog* (Munich, 1975), and Werner Hofmann, ed., *Runge in seiner Zeit: Kunst um 1800*, exh. cat. (Munich, 1977). Studies in English include Otto Georg von Simson, "Philipp Otto Runge and the Mythology of Landscape," *Art Bulletin* 24 (1942), 335–50; William Vaughan's chapter on Runge in his *German Romantic Painting* (New Haven, 1980); Rudolf M. Bisanz, *German Romanticism and Philipp Otto Runge: A Study in Nineteenth-Century Art Theory and Iconography* (DeKalb, Ill., 1970); and Timothy F. Mitchell, "Philipp Otto Runge and Caspar David Friedrich: A Comparison of Theory and Art," Ph.D dissertation, Indiana University, 1977.

22. "The oldest and most original form of the human imagination." Friedrich von Schlegel, *Gespräch über die Poesie* [1799–1800], in W. Rasch, ed., *Kritische Schriften* (Munich, 1938), 311. See also Karl Konrad Polheim, *Die Arabeske: Ansichten und Ideen aus Friedrich Schlegels Poetik* (Munich, 1966), esp. chap. 2, "Die Arabeske als Begriff der Malerei," 26–54; Wolfgang Kayser, *The Grotesque in Art and Literature*, trans. U. Weisstein (New York, 1968), 52; and Traeger, *Philipp Otto Runge*, chap. 6, "Imagination und Spiegelung."

23. *Hinterlassene Schriften* (hereafter *HS*), 1:6.

24. *HS*, letter to brother Daniel, 2:223.

25. Ibid.

26. Ibid. (1802), 1:5. For more on the German debates concerning medieval art, see Jane Van Nimmen, "Friedrich Schlegel's Response to Raphael in Paris," 319–33, and E. H. Gombrich, "The Values of the Byzantine Tradition: A Documentary History of Goethe's

Response to the Boisserée Collection," 291–318, both in *The Documented Image: Visions in Art History*, ed. Gabriel Weisberg and Laurinda Dixon (Syracuse, 1987). On the history of the reception of the Italian Gothic style, see Giovanni Previtali, *La Fortuna dei primitivi dal Vasari ai neoclassici* (Turin, 1964).

27. *HS*, letter to Ludwig Tieck (December 1802), 1:27.

28. For further discussion of decorative and emblematic sources for Runge, see Peter-Klaus Schuster, "Allegorien und Gelegenheitsarbeiten," in *Runge in seiner Zeit*, 104–11; and Karl Möseneder, *Philipp Otto Runge und Jacob Böhme: Über Runges "Quelle und Dichter" und den "Kleinen Morgen"* (Marburg/Lahn, 1981).

29. This arabesque, published by M. Ponce in 1789, was one of a collection drawn from Roman antiquity and from Raphael's designs. This particular volume was part of the library of Percier and Fontaine, architects to Napoleon, and is now housed in the Ryerson and Burnham Library of the Art Institute of Chicago.

30. Dieckmann, *Hieroglyphics*, 190.

31. *HS* (1807), 1:77.

32. Friedrich Schlegel, "Gemäldebeschreibungen aus Paris und den Niederlanden in den Jahren 1802–4," in *Sämtliche Werke* (Leipzig, 1910), vol. 6. Schlegel became an advocate for the medievalism of the Nazarenes, criticizing the deceased Runge for his rejection of "time-hallowed traditions."

33. See David Summers, *"Figure come fratelli*: A Transformation of Symmetry in Renaissance Painting," *Art Quarterly* 1 (Autumn 1977), 59–88, for a discussion of the meanings of symmetry as a visual structure.

34. *HS* (1806), 1:69.

35. See *HS* (1803), 2:202; Traeger, *Philipp Otto Runge*, chap. 3, 54–60; and Bisanz, chap. 3.

36. See William Vaughan's discussion of this subject in *German Romantic Painting*, 47.

Chapter 3

1. See H. R. Rookmaaker, *Gauguin and 19th-Century Art Theory* (Amsterdam, 1972), especially chaps. 5 and 8; Sven Lövgren, *The Genesis of Modernism: Seurat, Gauguin, Van Gogh, and French Symbolism* (New York, 1983); Robert Goldwater, *Symbolism* (New York, 1979), chaps. 2, 5, 6, and 7. Reinhold Heller, "Concerning Symbolism and the Structure of Surface," *Art Journal* 45 (Summer 1985), 146–53; Yvonne Thirion, "L'influence de l'estampe japonaise dans l'oeuvre de Gauguin," *Gazette des Beaux-Arts*, 6th ser. (1956), 95ff.; Lawrence Alloway, introduction to *Gauguin and the Decorative Style*, exh. cat., Guggenheim Museum of Art (New York, 1966).

2. Jones, 13. Here Jones also reveals his affinity with Semper and other mid-century theorists who believed that ornament was the first artistic impulse.

3. Sydney Parkinson, in B. Smith, *European Vision*, 88.

4. A. D. F. Hamlin, *A History of Ornament: Ancient and Medieval* (New York, 1916), 13.

5. Many eighteenth-century accounts put great emphasis upon the skill evidenced in much of "primitive" art. This attention given to this craft-related characteristic reflected, among other things, Europeans' interest in the mechanical abilities and existing technologies of these peoples and the possibilities of trade they offered.

6. J. Grasset Saint-Sauveur, *Costumes Civils: Actuels de tous les peuples connus* . . . (Paris, 1788), 4:640.

7. B. Smith, *European Vision*, 88.

8. Beaglehole, *Endeavor Journal*, 2:23.

9. A provocative discussion of the changing meanings of ornament can be found in Ananda Coomaraswamy's succinct philological essay "Ornament," *Art Bulletin* 21, no. 4 (December 1939), 375–82. The complexities of Renaissance theory concerning ornament are taken up in David Summers's essay, "Contrapposto: Style and Meaning in Renaissance Art," and in his study, *Michelangelo and the Language of Art*, particularly the chapter "L'alta fantasia."

10. *The Complete Works of Horace*, ed. C. J. Kraemer, Jr. (New York, 1936), 397.

11. Summers, "Contrapposto," 342–45.

12. Diderot, *Encyclopédie*: "un amas d'ornement confus ne peut avoir de raison apparente; une variété bizarre et sans rapport ni symetrie, comme dans l'Arabesque ou dans le goût chinois, n'annoncé aucun dessin."

13. Beaglehole, *Endeavor Journal*, 2:24.

14. Lafitau, *Moeurs*, 2:23–24.

15. This type of grotesque was often very close to the kinds of figures that Europeans called emblematic and hieroglyphic. Being hybrid forms, their conjoining of objects could move beyond fanciful play to poetic meaning. Friedrich Schlegel and John Ruskin use the terms "arabesque" and "grotesque" to describe emblematic figures, for example.

16. Harpham, *On the Grotesque*, xviii.

17. "Grotesque," *Dictionnaire de l'Académie des Beaux-arts*, printed in 1694, with subsequent editions: "la mélange fantaisiste de l'ornement et de la figure et dans l'emploi d'elements très disparates, figures humaines, animaux, vegetations étranges, caprices monstreux et contre nature."

18. R. Cotgrave, *A Dictionnairie of the French and English Tongues* (1611).

19. Johann Christoph Gottsched, *Stücke aus den ersten Gründen der gesamten Weltweisheit*, trans. Kayser, in *Grotesque*, 25. Certainly these negative opinions concerning excessive ornamentation reflected the rejection of the rococo which began in mid-century. But it is interesting that the majority of stylistic influences upon eighteenth-century art, rococo and neoclassical, were ones with a decided turn toward the grotesque: Pompeii and Herculaneum wall paintings, Chinese paintings and decorative arts, Egyptian and Archaic Greek antiquities.

20. Gerbrands, *Art as an Element of Culture, Especially in Negro-Africa*, trans. G. E. van Baaren-Pape (Leiden, 1957), 27.

21. This is contrary to Alberti's well-known hypothesis that sculpture was the first representational art because it required no abstraction into an illusion (*On Painting and on Sculpture*, ed. C. Grayson [London, 1972]). Baudelaire repeated this same claim, calling sculpture a "carib" art, the art first mastered by "primitive" man.

22. For example, the discovery of prehistoric cave paintings at Altamira late in the nineteenth century provoked a furor since their sophisticated representations conflicted with their supposed early position in the evolutionary time line.

23. See Joseph Rykwert, *On Adam's House in Paradise: The Idea of the Primitive Hut in Architectural History* (Cambridge, Mass., 1981), 29–33; Goldwater, *Symbolism*, 18–19; and Harry Francis Mallgrave, "Gottfried Semper: London Lectures," *RES* 6, 9, and 11. This discussion is especially indebted to the arguments of Michael Podro in his book, *The Critical Historians of Art* (New Haven, 1982), chaps. 4 and 5. In his study, *The Sense of Order: A Study in the Psychology of Decorative Art* (Ithaca, 1979), Ernst Gombrich discusses both Semper and Riegl. For a study of nineteenth-century anthropology, with special emphasis upon the latter half of the century, see George W. Stocking, Jr., *Victorian Anthropology* (New York, 1987).

24. Gottfried Semper, *Wissenschaft, Industrie und Kunst* [1852], ed. H. M. Wingler (Mainz, 1966), 35. This treatise, subtitled "Proposals for the Development of a National Taste in Art at the Closing of the London Industrial Exhibition," was presented just weeks after the Crystal Palace closed.

25. The discussion of ornament and argument here is very much indebted to the incisive

essay by Margaret Olin, "Self-Representation: Resemblance and Convention in Two Nineteenth-Century Theories of Architecture and the Decorative Arts," *Zeitschrift für Kunstgeschichte* 49, no. 3 (1986), 376–97. See also Olin's study, *Forms of Representation: Alois Riegl's Theory of Art* (University Park, Pa., 1992), and dissertation, "Alois Riegl and the Crisis of Representation in Art Theory, 1880–1905 (University of Chicago, 1982); Margaret Iversen, "Style as Structure: Alois Riegl's Historiography," *Art History* 2, no. 1 (March 1979), 62–72; and Michael Podro's discussion of Riegl in *Critical Historians*.

26. Interestingly, the progression of Riegl's theory, particularly his concept of the *Kunstwollen*, seems to have led him back toward this more expressive aspect of form.

27. On Arts and Crafts, see Gombrich, *Sense of Order*, 33–62; Gillian Naylor, *The Arts and Crafts Movement: A Study of Its Sources, Ideals and Influence on Design Theory* (Cambridge, Mass., 1971). See also Nicholas Penny, "Ruskin's Ideas on Growth in Architecture and Ornament," *British Journal of Aesthetics* 13, no. 3 (Summer 1973), 276–86.

28. E. E. Viollet-le-Duc, *Discourses on Architecture* (London, 1959), 2:200.

29. Joseph Masheck, "The Carpet Paradigm: Critical Prolegomena to a Theory of Flatness," *Arts Magazine* 51, no. 1 (September 1976), 82–109.

30. J. K. Colling, in Leighton, *Suggestions in Design* (London, 1880), 15. The preface for this volume points out that the "nucleus" of the *Suggestions* was published by Leighton in 1852–53 and claims that it "was the first of its kind in which all the styles of ornament were displayed." The 1880 edition doubled the number of illustrative plates and added the commentary of J. K. Colling, "a well-known writer on ornamental art," to the more objective descriptions of the plates published in Leighton's earlier edition.

31. Gauguin's aesthetic preferences lay primarily with the ornamental, though he occasionally referred to his art as Papuan in order to contrast its "savagery" with the effete efforts of his European contemporaries. For example, Gauguin declined to participate in an exhibition of younger symbolist artists, writing to Maurice Denis: "My Papuan art has no reason to appear alongside . . . symbolists and the rest"; quoted in Maurice Malingue, ed., *Lettres de Gauguin à sa femme et à ses amis* (Paris, 1946). Gauguin seems to be reacting to that element of symbolism that could be generally described as "decadent," characterized by preciousness and perversity.

32. Achille Delaroche, in Gauguin's *Avant et Après*, 37: "Il conviendrait donc de laisser à la porte les préjugés de nos Académies avec leurs lignes convenues, leurs décors clichés, leur rhétorique de torses."

33. Gauguin's reply to André Fontainas's review, dated March 1899, in his *Letters to Ambroise Vollard and André Fontainas*, ed. John Rewald (San Francisco, 1943), 21–24.

34. Gauguin made numerous comparisons between his decorative style and music; see esp. his *Notes synthétiques* (1885) and *Diverses choses* (1897).

35. Gauguin in Gauss, *Aesthetic Theories*, 56.

36. John Ruskin, *Modern Painters* (London, 1843–60), 3:98–99.

37. *Noa Noa* (1957), 23.

38. Letter from Gauguin to Vincent van Gogh, in Françoise Cachin, "Gauguin Portrayed by Himself and Others," in *The Art of Paul Gauguin*, ed. Brettel et al., National Gallery of Art (Washington, D.C., 1988), xx.

39. Denis, *Théories, 1890–1910* (Paris, 1913), 27.

40. G.-Albert Aurier, "Le Symbolisme en peinture: Paul Gauguin," *Mercure de France* (1891), trans. H. Chipp and H. R. Rookmaaker in H. Chipp, *Theories of Modern Art* (Berkeley and Los Angeles, 1968), 89–93.

41. André Fontainas, review of Vollard exhibition, *Mercure de France* (1899), cited in Gauguin's *Letters to Ambroise Vollard and André Fontainas*, ed. John Rewald (San Francisco, 1943), 18–21.

42. Achille Delaroche, in Gauguin's *Avant et Après*, 37.

43. Kirk Varnedoe suggests that the pictographs could represent Tehemana's many godparents and "by extension . . . the complex origins of her race" (189–90) in "Gauguin," in *Primitivism in Twentieth-Century Art*, 1:179–210. For Gauguin's knowledge of Polynesian symbolism and myth, see Jehanne Teilhet-Fisk, *Paradise Reviewed: An Interpretation of Gauguin's Polynesian Symbolism* (Ann Arbor, 1983).

Chapter 4

1. For more on idols and fetishes, see William Pietz's series on the fetish: "The Problem of the Fetish" (I, II, IIIa, and IIIb), in *RES*, vols. 9, 13, 16, and 17, respectively. Pietz demonstrates that Europeans did make a distinction between the idol and the fetish, but in general discussions of "primitive" imagery it is common to see the two terms used without differentiation. Of particular interest to this study is Pietz's analysis of the Enlightenment *philosophes'* use of the idol as a means to denounce religious "superstition" of all sorts. See also Joseph Masheck, "Raw Art: 'Primitive' Authenticity and German Expressionism," *RES* 4 (Autumn 1982), 93–117. Chapter 4 of my dissertation, "The Origins and Development of Primitivism in Eighteenth and Nineteenth-Century European Art and Aesthetics" (University of Pittsburgh, 1987), takes up these issues.

2. Archibald Campbell, *A Voyage Round the World from 1806–1812* (Edinburgh, 1816; reprint, New York, 1969), 193.

3. A good example of the negative interpretation of sculpture can be taken from T. E. Bowdich's *Mission from Cape Coast Castle to Ashantee* (London, 1819). Bowdich was unusually positive in his assessment of these African people and their arts, but his chapter entitled, "Architecture, Arts and Manufactures" contained no mention of sculpture. "Fetishes" were briefly mentioned only in a chapter on "Superstitions."

4. For an excellent discussion of the conception of the idol and the nature of idolatry in Western culture, see Michael Camille's *The Gothic Idol: Ideology and Image-Making in Medieval Art* (Cambridge, 1989).

5. Alfred Burdon Ellis, *The Land of Fetish* (London, 1883; reprint, Westport, Conn., 1970), 46–48.

6. Noel Baudin, *Fetichism and Fetich Worshippers* (English trans.; London, 1885), 5.

7. Paul du Chaillu, *A Journey to Ashango-Land and Further Penetration into Equatorial Africa* (New York ed., 1867), 99, 264, and 313.

8. John Williams, speaking of Rarotonga, Hervey Islands, in *A Narrative of Missionary Enterprises* (London, 1837), 117.

9. Page du Pratz, *Histoire de la Louisiane*, 3 vols. (Paris, 1758).

10. Mrs. Anna M. Scott, *Day Dawn in Africa: or, Progress of the Protestant Episcopalian Mission* (New York, 1858), 289–90.

11. André Thévet, *Cosmographie universelle*, in Cohen, *French Encounter*, 15–16.

12. J. C. Beaglehole, *The Journals of Captain James Cook on His Voyages of Discovery*, 1:199–200 and 224. Cook was speaking here of the Isle of Amsterdam.

13. The Reverend Herbert Probert, *Life and Scenes in Congo*, published by the American Baptist Society, Philadelphia, 1889, 52, 58.

14. Chaillu, *Ashango-Land*, 35.

15. This is true, with the one exception of the Easter Island monuments, which were known to be ancient and which were anomalous to the kinds of sculpture in those regions. These were represented during the Romantic period, and might in fact be compared to the paintings of Stonehenge that emerged in that era.

16. Gauguin in a letter to Fontainas, reprinted in Chipp, *Theories*, 75.

17. *Paul Gauguin's Intimate Journals*, ed. Brooks, 97.

18. Gauguin's letter in reply to André Fontainas's review of his work, 1899, in Gauguin, *Letters to Ambroise Vollard and André Fontainas*, ed. John Rewald (San Francisco, 1943), 21–24.

19. *The Complete Works of Horace*, ed. C. J. Kraemer, Jr. (New York, 1936), 397.

20. *An Account of the Sandwich Islands: The Hawaiian Journal of John B. Whitman, 1813–15*, ed. J. D. Holt (Peabody Museum of Salem, Mass., 1979), 24.

21. Victor Hugo, *Préface to 'Cromwell'* (1827): "Le Grotesque . . . est partout; d'une part il crée le difforme et horrible; de l'autre le comique et le bouffon," ed. Pierre Grosclaude (Paris, 1949), 27.

22. Ellis, *The Land of Fetish*, 46–48.

23. (New York, 1968), 2.

24. *Hawaiian Journal of John B. Whitman*, 24.

25. Montaigne, *Essais* (Paris, 1603), 1:89. Montaigne is describing the nature of his own essays, when brought together in a collection, as a grotesque and monstrous body, "rappiecez de divers members, sans certaine figure, n'ayants ordre ny proportion."

26. Winckelmann, "Generality," in his *History of Ancient Art* (1764); cited in Eitner, *Neoclassicism*, 1:16.

27. Gotthold Ephraim Lessing, *Laocoön: On the Limits of Painting and Poetry* [1766], in *German Aesthetic and Literary Criticism*, ed. Nisbet, 65.

28. Alexander Cozens, *Principles of Beauty Relative to the Human Head* (London, 1778), 2–3.

29. Enlightened observers of "primitive" peoples emphasized those arts that framed these people as existing on an early, childlike level of universal development. As discussed in the two previous chapters, the more rationalist interests were in hieroglyphics, ornament, and the arabesque, with emphases upon ingenuity and skill.

30. See a discussion of this in Rüdiger Joppien and Bernard Smith, *The Art of Captain Cook's Voyages* (New Haven, 1985–88), 2:74–77.

31. See Bernard Smith, *European Vision*, 71–72, and Isabel Stuebe, "The Life and Work of William Hodges" (diss., New York University, Institute of Fine Arts, 1978), 98–101.

32. Another related association for Hodges's painting was the growing taste for the sublime, subjects that were presented so as to inspire awe, simultaneously wonderful and terrifying. But this leads us in the wrong direction because the Easter Island figures were an anomaly in Oceanic art. Their sheer size and mysterious origins separated them from other Pacific sculpture. The depiction of the Hawaiian figures illustrated above (Fig. 27) was far more characteristic, showing "primitive" sculpture as disgustingly repulsive or ridiculous, with no hint of the awe-inspiring power associated with the sublime.

33. For discussions of Romanticism and the grotesque, see Wolfgang Kayser, *The Grotesque in Art and Literature*, chaps. 3 and 4; Athanassoglou-Kallmyer, *Eugène Delacroix: Prints, Politics and Satire, 1814–1822* (New Haven, 1991), esp. the final chapter; Werner Hofmann, "Comic Art . . . ," *Encyclopedia of World Art*; and Ronald Paulson, "The Grotesque, Gillray, and Political Caricature," in his *Representations of Revolution (1789–1820)* (New Haven, 1983), 168–213. On the nature of the grotesque itself, see C.-P. Warncke, *Die ornamentale Groteske in Deutschland (1500–1650)*, 2 vols. (Berlin, 1979), and Barbara Stafford, "From 'Brilliant Ideas' to 'Fitful Thoughts': Conjecturing the Unseen in Late Eighteenth-Century Art," *Zeitschrift für Kunstgeschichte* 48 (1985), 329–63.

34. Charles Baudelaire, *De l'essence du rire et généralement du comique dans les arts plastiques* [1855]; in *Salon de 1846, Critique d'Art*, ed. Claude Pichois (Paris, 1965), 211–32.

35. Ibid., 216: "une civilisation perspicace et ennuyée."

36. Ibid., 231: "un des signes trés-particuliers du comique absolu est de s'ignorer lui-même."

37. Most art-historical accounts of Meryon's work have concentrated on the etchings and neglected the Oceanic drawings. The catalogues of his work by Burty, Wedmore, Delteil and Wright, and most recently, Schneiderman, concentrate on the etchings. In June 1961 the *Gazette des Beaux-Arts* published Jean Vallery-Radot's "Quand Meryon était Marin. Ses dessins inédits de la campagne de la Corvette *Le Rhin* (1842–46) conservés au Cabinet des Estampes" (359–68). More recently, R. D. J. Collins, of the University of Otago, New Zealand, has published a series of important articles related to Meryon's Pacific voyage. Three of these are listed in subsequent notes, but his essay, "Auguste Delâtre, Interprète de Charles Meryon," published in the November 1983 *Gazette des Beaux-Arts* (169–77), should be mentioned here for its illustration of fourteen of Meryon's Oceanic drawings (as reproduced by Delâtre). The most comprehensive source on Meryon's Pacific voyage and these artifacts is Jean Ducros's *Charles Meryon, officier de marine, peintre-graveur, 1821–68*, an exhibition catalogue published by the Musée de la Marine (Paris, 1968). Nonetheless, barely one-fourth of Meryon's extant sketches have been published. I would like to express my appreciation to M. Ducros, Professor Philippe Verdier, Dr. James Burke, and Dr. Collins for their willingness to discuss various aspects of Meryon's work with me.

38. Meryon seems to have continued his interest in Oceanic sculpture upon his return to Paris. In addition to the New Caledonian subjects, he sketched a carved Maori chest (with figures on each end) in the Musée de la Marine and in 1866, drew a Maori *hei-tiki* figure, possibly from the collection of the Musée des Antiquités Nationales. Ducros, no.851.

39. Burty's essay, published in *La Nouvelle Revue* 2 (1880), 115–38, describes "un moulage d'un 'sauvage grotesque' " (118), while Marcus Huish's translation, published one year earlier in London, cites "the mould of a mask of a 'grotesque savage' " (4). If it was a portrait bust of some sort, it clearly turned away from the classicizing, "noble savage" representations of Oceanic peoples, enough so that Burty compared the face to a classical "monster." The English translation by Huish suggests that this might have been a mask of some sort, possibly inspired by New Caledonian examples? Burty actually saw the mask, but his description, as discussed in Chapter 1, relies upon classical terminology. The actual sculpture has been lost.

40. His choice of subject matter early in his career showed an interest in other "primitive" themes, including medieval and prehistoric. R. D. J. Collins examines in detail these early efforts in an article entitled, "The Landscape and Historical Paintings of Charles Meryon," *Turnbull Library Record* (Wellington, New Zealand), 8, no. 2 (October 1975), 4–16. Collins, in his "Les 'Projets' de Charles Méryon," *Nouvelles de l'estampe*, no. 110 (May–June 1990), 5–12, points out that in a list of future projects (written in a small, hand-sewn booklet, dated approximately 1847–48), Meryon included several more Pacific subjects, such as the shipwreck of La Pérouse at Vanikoro, as well as a medieval theme, *Joan of Arc Surrounded by her Executioners*.

41. This letter is in the Bibliothèque nationale, Cabinet des Estampes, Res. Yb3 1673. Earlier in the same year (14 January) Meryon wrote to Foleÿ regarding the latter's plans to develop his collection of Oceanic artifacts into a "joli cabinet de curiosités."

42. See Collins, "Landscape," 7–8 and 11–12. Meryon also suffered a form of color-blindness, which would not necessarily have prevented him from painting, but might have figured in his decision to become a graphic artist.

43. Eugène Viollet-le-Duc, "Sculpture," *Dictionnaire raisonné de l'architecture française du XIème au XVIème siècle*, 8:244.

44. "J'ai considéré avec bonheur le portail de la cathédrale, qui est si vieux et si déchiqueté qu'il ressemble à ces roches corrodées par les eaux de mer, semblables à celles qu'on remarquait à l'entrée d'Akaroa." Bibliothèque nationale, Res. Yb3 1673.

45. Ducros, no.612. No Oceanic artifacts are directly incorporated into the *Eaux-fortes sur Paris* suite. In his *History of Caricature* (1968) Thomas Wright noted the similarity between the grotesque figures found in the South Pacific and on medieval cathedrals. He pointed to the grotesque face with a huge, lolling tongue, such as the one etched by Meryon in *Le Stryge*, and stated that this figure personified lust.

46. James D. Burke, ed., *Charles Meryon: Prints and Drawings*, Yale University Art Gallery, 1974, 35.

47. Frederick Wedmore, *Meryon and Meryon's Paris, with a Descriptive Catalogue of the Artist's Work* (London, 1879), 44–45.

48. Aglaus Bouvenne, *Notes et souvenirs sur Charles Meryon* (Paris, 1883), 42. These lines are from the poem which the artist inscribed beneath an early state of the etching. For a discussion of this print, see Adele Holcomb, "*Le Stryge de Notre-Dame*: Some Aspects of Meryon's Symbolism," *Art Journal* 31 (Winter 1971–72), 150–57. Also see Aaron Sheon, "Charles Meryon in Paris," *Burlington Magazine* 110 (December 1968), 721–22.

49. Meryon died in the hospital of Saint-Maurice in 1868 (Dr. Collins has found that Meryon was actually treated in the hospital of Saint-Maurice, which originally had been conjoined with Charenton asylum. The two institutions were split apart sometime in the late 1850s), and his personal effects, including nearly two hundred drawings, were sent to his father in London, and later donated to the British Museum. Eighty-five drawings of Oceanic subjects are held in the Bibliothèque nationale, and smaller groupings are scattered in collections around the world.

50. My thanks to Adrienne Kaeppler of the Museum of Natural History, Smithsonian Institution, for identifying these patterns. Meryon's representations of Oceania seem to reflect the emphasis of his naval training upon scientific illustration. His drawings exhibit an unusual accuracy, a trait commonly sacrificed in most representations of "primitive" or exotic cultures. For example, the frontispiece for the suite, *La Nouvelle Zélande*, echoes the manner in which "curiosities" were displayed in ethnographic museums or *expositions universelles*. But while these bazaar-like, decorative displays typically blurred distinctions between cultures and styles, Meryon's composition features only Maori artifacts.

51. See R. D. J. Collins's excellent argument concerning one of these prints, "Charles Meryon's *Ministère de la Marine*," *New Zealand Journal of French Studies* 9, no. 1 (1988), 41–51. Meryon also used the New Caledonian mask on a figure on horseback in his small, strange etching, *Le Petit Prince Dito* (1864).

52. A particular irony here is that the gargoyle featured by Meryon was a reconstruction, part of the restoration of the cathedral by Viollet-le-Duc.

53. Of course, detractors of realist and impressionist artists sometimes described their imagery as grotesque, meaning, in the simplest sense of the word, that they were ugly and unidealized.

54. The appreciation for and emulation of popular, folk, and children's art has been explored in several excellent articles. In chronological order, Meyer Schapiro's "Courbet and Popular Imagery"; Stanley Meltzoff, "The Revival of the LeNains," *Art Bulletin* 24 (September 1942), 259–86; Aaron Sheon, "The Discovery of Graffiti," *Art Journal* 36, no. 1 (Autumn 1976), 16–22; Anne Coffin Hanson, "Popular Imagery and the Work of Edouard Manet," in *French Nineteenth-Century Painting and Literature*, ed. U. Fincke (Manchester, 1972).

55. See the chapter on "The Experiment of Caricature," by E. H. Gombrich in his *Art and Illusion* (Princeton, 1972), 331–58. See also Schapiro's discussion of Töpffer's ideas in his "Courbet and Popular Imagery."

56. On this particular issue, I do not agree with Yve-Alain Bois's seconding of Kahnweiler's assertion that *Les Demoiselles* works within the parameters established by Gauguin's primitivism; see his "Kahnweiler's Lesson," *Representations* 18 (Spring 1987), 33–68; reprinted in his

Painting as Model (Cambridge, Mass., 1990), 65–97. Kahnweiler's statement that "the 'savage' quality of those pictures [those paintings from 1907 to 1909 influenced by *Les Demoiselles*] can be fully explained by the influence of Gauguin's paintings and—above all—of his sculptures" (38–39), radically diminishes the primitivism of Gauguin, which (as discussed in the two previous chapters) incorporates both hieroglyphic and ornamental *structures*. Also, it is quite difficult to accept the argument that Gauguin's sculptures, however crude, rival the explosive power and aggression of the *Demoiselles*. I would argue that the difference between Gauguin and Picasso is as fundamental as that between *Les Demoiselles* and the *Guitare* of 1912.

57. Oceanic sculpture was confused or conflated with African during the early modern period, and as Rubin points out, many different tribal and island traditions were lumped together as *l'art nègre*.

58. W. Rubin states that "Picasso's primitivism marked a broadening of the Western language of art, erasing the distinctions between 'high' and 'low' " ("Picasso," in *Primitivism in Twentieth-Century Art*, 1:242). This is generally true, but I have tried to demonstrate that this process of assimilating the "low" to the "high" (or in a less value-laden manner of speaking, bringing the peripheral into the center) began much earlier. Picasso continued this process, but was far more radical in his borrowings and more transformative in his innovations.

59. W. Rubin, "Picasso," 242. On Picasso's attraction to the magical in "primitive" sculpture, see Lydia Gasman, "Mystery, Magic and Love in Picasso, 1925–1938" (Ph.D. dissertation, Columbia University, 1981).

60. Leo Steinberg wrote the essential essay concerning the central role of invention in Picasso's art; see "The Algerian Women and Picasso at Large," in his *Other Criteria* (London, 1972), 125–234.

61. W. Rubin remarks in note 52 to his "Picasso" essay that Picasso made several comments to him concerning the inventiveness of African and Oceanic art.

62. Bois makes a strong and thought-provoking argument ("Kahnweiler's Lesson") supporting Kahnweiler's contention that the profound influence of African sculpture emerged in Picasso's *Guitare* of 1912, five years after *Les Demoiselles*. I think that it is fundamentally true that the lesson learned from African and Oceanic sculpture emerged later, and was structural (to use Bois's term) in its nature. But the beginnings of this morphological shift can be discerned in the *Demoiselles*, specifically in the repainted, Africanized figures. The argument presented below is that this painting incorporates the grotesque quality of "primitive" art, in both its monstrous/expressive form and its arabesque/structural form.

63. Leo Steinberg states this in his "The Philosophical Brothel," *Art News* 71, part 1 (September 1972), 20–29; part 2 (October 1972), 38–47. Statement is from part 1, 21.

64. See W. Rubin, "La genèse des *Desmoiselles d'Avignon*," in *Les Demoiselles*, ed. Hélène Seckel, exh. cat. (Musée Picasso, Paris, 1987), 483, 487. Varnedoe also discusses this transformation in his essay "Primitivism."

65. The spatial grotesque is the one example that possibly can be explained as an extension of Cézanne, unlike the figurative inversions and metamorphoses, which have no precedent outside of those African and Oceanic images Picasso knew at this time.

66. In "High and Low: Caricature, Primitivism, and the Cubist Portrait," Adam Gopnik argued that Picasso assimilated "the vocabulary of primitive and archaic art to the grammar of caricature" (375) in order to develop a schematized and condensed, nonmimetic form of likeness. I would add, however, that Picasso's assimilation of African and Oceanic motives was more complex, involving more than the one filter of caricature, and that he assimilated them *through* the grammar of caricature. Caricature was of particular interest to several post-impressionist artists, particularly the Nabis, who were heavily influenced by Gauguin, and Toulouse-Lautrec. Picasso's youthful paintings of the café scene in Barcelona and Paris show the influence of Toulouse-Lautrec and incorporate these exaggerated physiognomies. And, as

Gopnik demonstrates, Picasso combined African elements with those of caricature to create a likeness in his cubist portraits. But Picasso's overtly primitivizing works, including the *Demoiselles* and those paintings, such as the *Portrait of Gertrude Stein* (1906), which characterized his archaic period, featured impassive, masklike faces, not the grimacing expression and exaggerated quirks that indicate personality. With the incorporation of *l'art nègre*, the entire figure and its surrounding space are deformed.

67. G. Burgess, "The Wild Men of Paris," *Architectural Record* 27 (May 1910), 401–14.

68. Leo Steinberg's "Philosophical Brothel" first focused scholarly attention on the themes of sexuality, femininity, and "negritude" at the heart of the painting and its evolution. W. Rubin enlarges upon these ideas in his essay "Picasso," in his *Primitivism*. Patricia Leighten's most recent article, "The White Peril and L'Art nègre: Picasso, Primitivism and Anticolonialism" *Art Bulletin* (December 1990), 609–30, brings out the connection in the European mind between the grotesque and things African, and explores the debates and scandals regarding the African colonies that were contemporaneous with *Les Demoiselles*. In a June 1988 article in *Art in America* (131–41, 172–73), "Painting as Trauma," Bois suggested a more overtly psychoanalytical reading of the sexual anxiety conveyed by the painting.

69. See related discussions of the *Demoiselles* by Ronald Johnson, "*The Demoiselles d'Avignon* and Dionysian Destruction," *Arts* 15 (October 1980), 94–101, and W. Rubin, "Picasso," *Primitivism*.

70. Salmon, *Le jeune peinture française* (Paris, 1912), trans. in Edward Fry, *Cubism* (New York, 1966), 81–83.

71. "When I went to the old Trocadéro, it was disgusting. The Flea Market. The smell. I was all alone. I wanted to get away. . . . The masks weren't just like any other pieces of sculpture. Not at all. They were magic things. The Negro pieces were *intercesseurs*, mediators. . . . I understood why I was a painter. All alone in that awful museum, with masks, dolls made by the redskins, dusty manikins. *Les Demoiselles d'Avignon* must have come to me that very day, but not at all because of the forms; because it was my first exorcism-painting—yes absolutely!" This account was given to André Malraux in 1940 and published after Picasso's death in *La tête obsidienne*, 10–11. As is well known, Picasso's statements concerning his artistic intentions were often intentionally misleading. W. Rubin offers that Picasso expressed similar sentiments concerning African art to him personally (in "Picasso," pp. 254–55 and notes 50–52). In addition, this commentary seems quite consistent with the African influence upon Picasso's art.

72. Leighten, *Re-Ordering the Universe*, 89–91.

73. Kahnweiler, *Mes galeries et mes peintres* (Paris, 1961), 45.

74. Salmon, trans. in Fry, *Cubism* (New York, 1966), 81–84.

75. Georgy Chulkov, "Demons and Modern Life," *Apollon*, nos. 1–2 (St. Petersburg, 1914), repr. in Marilyn McCully, ed., *A Picasso Anthology: Documents, Criticism, Reminiscences* (Princeton, 1982), 104–5.

76. Nikolay Berdyaev, "Picasso," *Sofya* 8 (Moscow, 1914), repr. in McCully, 110–11.

77. Edward Fry, "Picasso, Cubism, and Reflexivity," *Art Journal* 47, no. 4 (Winter 1988), 296.

Selected Bibliography

Adams, H. P. *The Life and Writings of Vico*. London, 1935.

Adanson, Michel. *A Voyage to Senegal*. London, 1759.

Alberti, Leon Battista. *On Painting and on Sculpture*. Edited by C. Grayson. London, 1972.

Alloway, Lawrence, ed. *Gauguin and the Decorative Style*. Exhibition catalogue. Guggenheim Museum of Art, New York, 1966.

Andrews, K. *The Nazarenes, A Brotherhood of German Painters in Rome*. Oxford, 1964.

Arnoldi, Mary Jo. "A Distorted Mirror: The Exhibition of the Herbert Ward Collection of Africana." In *Museums and Communities: The Politics of Public Culture*. Edited by Ivan Karp, Christine M. Kreamer, and Steven D. Lavine. Washington, D.C., 1992, 428–57.

The Art of Paul Gauguin. Edited by R. Brettel, F. Cachin, C. Frèches-Thory, and C. Stuckey. Exhibition catalogue. National Gallery of Art, Washington, D.C., 1988.

Athanassoglou-Kallmyer, Nina M. *Eugène Delacroix: Prints, Politics and Satire, 1814–1822*. New Haven, 1991.

Aurier, G.-Albert. *Oeuvres posthumes de G.-Albert Aurier*. Paris, 1893.

———. "Les Symbolisme en peinture: Paul Gauguin (1891)." Translated by H. Chipp and H. R. Rookmaaker in H. Chipp, *Theories in Modern Art*. Berkeley and Los Angeles, 1968, 89–93.

Barrère, Jean-Bertrand. "Victor Hugo's Interest in the Grotesque in His Poetry and Drawings." In *French Nineteenth-Century Painting and Literature*, edited by Ulrich Finke. New York, 1972, 258–79.

Baudelaire, Charles. *Baudelaire: Art in Paris, 1845–62*. Edited and translated by Jonathan Mayne. London, 1965; Ithaca, 1981.

———. "De l'essence du rire et généralement du comique dans les arts plastiques" (1855). In *Salon de 1846, Critiques d'Art*, edited by Claude Pichois. 2 vols. Paris, 1965, 1:211–32.

———. "Pourquoi la sculpture est ennuyeuse." In *Salon de 1846. Critiques d'Art*, edited by Claude Pichois. 2 vols. Paris, 1965, 1:168–69.

———. *Baudelaire: The Painter of Modern Life and Other Essays*. Edited and translated by Jonathan Mayne. London, 1964.

Baudet, Henri. *Paradise on Earth: Some Thoughts on European Images of Non-European Man*. Translated by Elizabeth Wentholt. New Haven, 1965.

Baudin, Noel. *Fetiches and Fetich Worshippers*. English translation, London, 1885.

Beaglehole, J. C. *The Endeavor Journal of Joseph Banks: 1768–1771*. 2 vols. Sydney, 1962.

―――. *The Exploration of the Pacific*. London, 1934.

―――. *The Journals of Captain James Cook on His Voyages of Discovery*. 3 vols. Cambridge, 1955–67.

―――. *The Life of Captain James Cook*. London, 1975.

Beetem, Robert N. "George Catlin in France: His Relationship to Delacroix and Baudelaire." *Art Quarterly* 24 (1961): 129–44.

Benjamin, Walter. "The Work of Art in the Age of Mechanical Reproduction." In *Illuminations*, edited by Hannah Arendt. New York, 1955, 219–54.

Berdyaev, Nikolay. "Picasso." *Sofya* 8 (Moscow, 1914). Reprinted in *A Picasso Anthology: Documents, Criticism, Reminiscences*, edited by Marilyn Mc-Cully. Princeton, 1982, 110–12.

Berger, Klaus. *Japonisme in Western Painting from Whistler to Matisse*. Translated by David Britt. Cambridge, 1992.

Berlin, Isaiah. *Vico and Herder: Two Studies in the History of Ideas*. New York, 1976.

Bernard, Émile. "De l'art naïf et de l'art savant." *Mercure de France* (April 1895): 86–91.

Bisanz, Rudolf. *German Romanticism and Philipp Otto Runge: A Study in Nineteenth-Century Art Theory and Iconography*. DeKalb, Ill., 1970.

Bissell, B. *The American Indian in English Literature of the Eighteenth Century*. New Haven, 1925.

Blondel, Auguste. *Rodolphe Töpffer: L'Ecrivain, l'artiste, et l'homme*. Geneva, 1976.

Blunt, Anthony. *Artistic Theory in Italy, 1450–1600*. London, 1940.

Boas, George, and Arthur Lovejoy. *Primitivism and Related Ideas in Antiquity*. Vol. 1, *A Documentary History of Primitivism and Related Ideas*. Baltimore, 1935.

Boas, George. *The Cult of Childhood*. London, 1966.

Bogner, Dieter. "Alois Riegl et l'École Viennoise d'histoire de l'art." *Cahiers du Musée nationale d'art moderne* 14 (March 1985): 44–55.

Boime, Albert. *The Academy and French Painting in the Nineteenth Century*. New York, 1971.

―――. *Thomas Couture and the Eclectic Vision*. New Haven, 1980.

Bois, Yve-Alain. "Kahnweiler's Lesson." *Representations* 18 (Spring 1987): 33–68.

―――. *Painting as Model*. Cambridge, Mass., 1990.

―――. "Painting as Trauma." *Art in America* 6 (June 1988): 131–41, 172–73.

Börsch-Supan, Helmut. *Deutsche Romantiker*. Munich, 1972.

Bougainville, Comte Louis Antoine de. *Voyage autour du monde, par la frégate du Roi, La Boudeuse, en 1766–69*. Paris, 1771. Translated by J. R. Förster. London, 1772.

Bourdier, Franck. *Préhistoire de France*. Paris, 1967.

Bouvenne, Aglaus. *Notes et souvenirs sur Charles Meryon*. Paris, 1883.

Bowdich, T. E. *An Essay on the Superstitions, Customs and Arts of the Ancient Egyptians, Abbysinians and Ashantees*. London, 1821.

―――. *Mission from Cape Coast Castle to Ashantee*. London, 1819. Reprint, London, 1966.

Boydell, John. *The Origin of Painting*. London, 1774.

Braunholtz, H. J. *Sir Hans Soane and British Ethnography*. Edited by William Fagg. London, 1970.

Brooks, Van Wyck, ed. *Paul Gauguin's Intimate Journals*. Bloomington, Ind., 1965.

Burgess, G. "The Wild Men of Paris." *Architectural Record* 27 (May 1910): 401–14.

Burke, James D., ed. *Charles Meryon: Prints and Drawings.* Yale University Art Gallery, 1974.

Burty, Philippe. *Memoir and Complete Descriptive Catalogue of the Works of Charles Meryon by Philip Burty.* Translated by Marcus Huish. London, 1879.

Cachin, Françoise. "Gauguin Portrayed by Himself and Others." In *The Art of Paul Gauguin,* edited by R. Brettel, F. Cachin, C. Frèches-Thory, and C. Stuckey. National Gallery of Art, Washington, D.C., 1988, xiv–xxvii.

Campbell, Archibald. *A Voyage Round the World from 1806–1812.* Edinburgh, 1816. Reprint, New York, 1969.

Camille, Michael. *The Gothic Idol: Ideology and Image-making in Medieval Art.* Cambridge, 1989.

Caponigri, A. *Time and Idea: The Theory of History in Giambattista Vico.* Chicago, 1953.

Carrot, Richard. *The Egyptian Revival; Its Sources, Monuments and Meaning, 1808–1858.* New York, 1978.

Cassell's Illustrated Family Paper Exhibitor. London, 1851 and 1862.

Caylus, Comte Anne Claude Philippe. *Recueil d'antiquités égyptiennes, grecques, et romaines.* Paris, 1752–67.

Chaillu, Paul du. *A Journey to Ashango-Land and Further Penetration into Equatorial Africa.* New York ed., 1867.

Chambers, Sir William. *Primitive Buildings.* London, 1759.

Champfleury (Jules Fleury). *Histoire de la caricature.* 5 vols. Paris, 1865–80.

———. *Histoire de l'imagerie populaire.* Paris, 1869.

Cherpak, Clifton. "Warburton and Some Aspects of the Search for the Primitive in Eighteenth-Century France." *Philological Quarterly* 36 (April 1957): 221–31.

Chesneau, Ernest. *L'Art japonais.* Paris, 1869.

Chinard, Gilbert. *L'Amérique et le rêve exotique dans la littérature française au XVIIème et XVIIIème siècles.* Paris, 1913.

———. *L'exotisme américain dans l'oeuvre de Chateaubriand.* Paris, 1918.

Chipp, Herschel. *Theories of Modern Art.* Berkeley and Los Angeles, 1968.

Choris, Louis. *Voyages pittoresque autour du monde, avec des portraits des sauvages.* Paris, 1822.

Christoffel, Ulrich. *Malerei und Poesie: Die symbolistische Kunst des 19. Jahrhunderts,* Vienna, 1948.

Chulkov, Georgy. "Demons and Modern Life." *Apollon,* nos. 1–2 (St. Petersburg, 1914). Reprinted in *A Picasso Anthology: Documents, Criticism, Reminiscences,* ed. Marilyn McCully. Princeton, 1982, 104–6.

Clement, N. H. *Romanticism in France.* New York, 1939.

Clifford, James. *The Predicament of Culture: Twentieth-Century Ethnography, Literature, and Art.* Cambridge, Mass., 1988.

Cohen, William. *The French Encounter with Africans.* Bloomington, 1980.

Coleman, Francis X. J. *The Aesthetic Thought of the French Enlightenment.* Pittsburgh, 1971.

Collins, R. D. J. "Another Eden, Demi-Paradise: Charles Meryon in the Pacific." *Art New Zealand,* no. 47 (Winter 1988): 104–7.

———. "Auguste Delatre, Interprète de Charles Meryon." *Gazette des Beaux-Arts* (November 1983): 169–77.

———. "Charles Meryon's *Ministère de la Marine." New Zealand Journal of French Studies,* 9, no. 1 (1988): 41–51.

————. "The Landscape and Historical Paintings of Charles Meryon." *Turnbull Library Record* (Wellington, New Zealand), 8, no. 2 (October 1975): 4–16.

————. "Les 'Projets' de Charles Meryon." *Nouvelles de l'estampe*, no. 110 (May–June 1990): 5–12.

————, comp. *Charles Meryon: A Bibliography*. Dunedin, New Zealand: University of Otago Press, 1984.

————. *Charles Meryon: A Preliminary Checklist*. Dunedin, New Zealand: University of Otago Press, 1976.

Condillac, E. B. de. *Essai sur l'origine des connaissances humaine*. Amsterdam, 1746.

Condorcet, Marie Jean de. *Esquisse d'un tableau historique des progrés de l'esprit humain*. Paris, 1795.

Connelly, Frances. "The Oceanic Sketches of Charles Meryon: A Precocious Primitivism?" *The Print Collector's Newsletter* 24, no. 2 (April–May 1993): 44–49.

————. "The Origins and Development of Primitivism in Eighteenth- and Nineteenth-Century European Art and Aesthetics." Ph.D. diss., University of Pittsburgh, 1987.

————. "Poetic Monsters and Nature Hieroglyphics: The Precocious Primitivism of Philipp Otto Runge." *Art Journal* 52, no. 2 (Summer 1993): 31–39.

Cook, Captain James. *A Voyage to the Pacific Ocean . . . in the Years 1776, 1777, 1778, 1779 and 1780*. London, 1784.

————. *A Voyage Towards the South Pole and Round the World . . . in the Years 1772, 1773, 1774 and 1775*. London, 1776.

Coomaraswamy, Ananda K. "Ornament." *Art Bulletin* 21, no. 4 (December 1939): 375–82.

Cooper, Anthony Ashley, earl of Shaftesbury. "Plastics." In *Second Characters; or the Language of Forms*, edited by Benjamin Rand. Cambridge, 1914, 89–178.

Cotgrave, R. *A Dictionnairie of the French and English Tongues*. London, 1611.

Court de Gébelin, Antoine. *Le monde primitif analysé et comparé avec le monde moderne*. 9 vols. Paris, 1775–84.

Cozens, Alexander. *Principles of Beauty Relative to the Human Head*. London, 1778.

Crane, Walter. *The Claims of Decorative Art*. Boston, 1892.

Croce, Benedetto. *The Philosophy of Giambattista Vico*. Translated by R. G. Collingwood. London, 1913.

Crow, Thomas. *Painters and Public Life in Eighteenth-Century Paris*. New Haven, 1955.

Curtin, Philip. *The Image of Africa: British Ideas and Action, 1780–1850*. 2 vols. Madison, Wis., 1964.

Curtis, Melinda, ed. *The Search for Innocence: Primitive and Primitivistic Art of the Nineteenth Century*. College Park, Md., 1975.

David, Madéleine. *Le Débat sur les écritures et l'hiéroglyphe au XVIIème et XVIIIème siècles*. Paris, 1965.

Les Demoiselles d'Avignon. Edited by Hélène Seckel. Exhibition catalogue. 2 vols. Musée Picasso, Paris, 1987.

Degérando, Joseph Marie. *The Observation of Savage Peoples*. Translated by F. T. Moore. Berkeley and Los Angeles, 1969.

Delacroix, Eugène. *The Journal of Eugène Delacroix*. Translated by Walter Pach. New York, 1980.

Delisles de Sales. *Histoire philosophique du monde primitif*. Paris, 1795–96.

Denis, Maurice. "L'époque du symbolisme." *Gazette des Beaux-Arts* (March 1934).
———. *Théories, 1890–1910.* Paris, 1913.
d'Hancarville, P. F. H., ed. *Collection of Etruscan, Greek, and Roman Antiquities from the Cabinet of the Honourable William Hamilton.* 3 vols. Naples, 1791–95.
Dictionnaire de l'académie des beaux-arts. Paris, 1694, with subsequent editions.
Diderot, Denis. "Afrique." *Encyclopédie*, Suppl. 1. Amsterdam, 1780.
———. *Salons.* Edited by Jean Seznec and Jean Adhemar. 4 vols. Oxford, 1963–67.
———. "Sénégal." *Encyclopédie*, vol. 15.
Dieckmann, Liselotte. *Hieroglyphics: The History of a Literary Symbol.* St. Louis, Mo., 1970.
Donnell, C. A. "Representation versus Expressionism in the Art of Gauguin." *Art International* 19, part 3 (March 1975): 56–60.
Dorival, Bernard. "Sources of the Art of Gauguin from Java, Egypt, and Ancient Greece." *Burlington Magazine* 93, no. 577 (April 1951): 118–22.
Du Bos, Jean-Baptiste. *Réflexions critiques sur le poésie et sur le peinture.* 2 vols. Paris, 1719. Translated by Thos. Nugent. London, 1748.
Duchartre, Pierre, and René Saulnier. *L'Imagerie Populaire.* Paris, 1925.
Duchet, Michele. *Anthropologie et histoire au siècle des lumières.* Paris, 1971.
Ducros, Jean. *Charles Meryon, officier de marine, peintre-graveur, 1821–68.* Exhibition catalogue. Paris, Musée de la Marine, 1968.
Dudley, Edward, and Max Novak, eds. *The Wild Man Within: An Image in Western Thought from the Renaissance to Romanticism.* Pittsburgh, 1972.
Du Pratz, Page. *Histoire de la Louisiane.* Paris, 1758.
D'Urville, Dumont. *Voyage pittoresque autour de monde.* Paris, 1834.
Einstein, Carl. *Negerplastik.* Leipzig, 1915.
Eitner, Lorenz. *Neoclassicism and Romanticism, 1750–1850.* 2 vols. Englewood Cliffs, N.J., 1970.
———. "The Open Window and the Storm-Tossed Boat. An Essay in the Iconography of Romanticism." *Art Bulletin* 37 (December 1955): 281–90.
Ellis, Alfred Burdon. *The Land of Fetish.* London, 1883. Reprint, Westport, Conn., 1970.
Evett, Elisa. *The Critical Reception of Japanese Art in Late Nineteenth-Century Europe.* Ann Arbor, 1982.
———. "The Late Nineteenth-Century European Critical Response to Japanese Art: Primitivist Leanings." *Art History* 6, no. 1 (March 1983): 82–106.
Feest, Christian. "The Arrival of Tribal Objects in the West: From Native America." In *Primitivism in Twentieth-Century Art.* New York, 1984, 1: 85–98.
Félibien, André. *Conférences de l'Académie Royale de Peinture et de Sculpture* (Paris, 1669). Published in vol. 5 of his *Entretiens sur les vies et sur les ouvrages des plus excellens peintres anciens et modernes.* Trévoux, 1725.
———. *Entretiens sur les vies et sur les ouvrages des plus excellens peintres anciens et modernes.* 5 vols. Trévoux, 1725.
Ferguson, Adam. *Essay in the History of Civil Society.* London, 1767.
Fiesel, Eva. *Die Sprachphilosophie der Deutschen Romantik.* Tübingen, 1927.
Finke, U., ed. *French Nineteenth-Century Painting and Literature, with Special Reference to the Relevance of Literary Subject-Matter to French Painting.* Manchester, 1972.
Foçillon, Henri. *Vie des formes.* Paris, 1934. Translated by C. B. Hogan and G. Kubler. New York, 1948.

Force, Maryanne, and Roland Force. *Art and Artifacts of the Eighteenth Century: Objects in the Leverian Museum as Painted by Sarah Stone.* Honolulu, 1968.

Foster, Hal. *Recodings: Art, Spectacle, Cultural Politics.* Port Townsend, Wash., 1985.

Fraser, Douglas. "The Discovery of Primitive Art." *Arts Yearbook* 1 (1957): 119–33.

Friedlaender, Walter. "Eine Sekte der 'Primitiven' um 1800 in Frankreich und die Wandlung des Klassizismus bei Ingres." *Kunst und Künstler* 28 (April 1930): 281–86.

Frobenius, Leo. *Die Masken und Geheimbunde.* Halle, 1898.

Fry, Edward. *Cubism.* New York, 1966.

———. "Picasso, Cubism, and Reflexivity." *Art Journal* 47, no. 4 (Winter 1988): 296–310.

Galaup, Jean-François, comte de la Pérouse. *Voyages and Adventures of La Perouse.* Translated by J. S. Gassner from the 14th edition. Tours, 1875. Reprint, Honolulu, 1969.

Gasman, Lydia. "Mystery, Magic and Love in Picasso, 1925–1938." Ph.D. dissertation, Columbia University Press, 1981.

Gauguin, Paul. *Avant et Après.* Paris, 1923.

———. *Diverses choses, 1896–97.* Manuscript in the Louvre Museum, Department of Graphic Arts. Excerpts published in Daniel Guérin, *The Writings of a Savage, The Journals of Paul Gauguin.* New York, 1978.

———. *Letters to Ambroise Vollard and André Fontainas.* Edited by John Rewald. San Francisco, 1943.

———. *Noa Noa.* New York, 1957.

———. *Notes synthétiques.* 1885 essay reprinted in Raymond Cogniat and John Rewald. *Paul Gauguin, A Sketchbook,* facs. ed. Paris and New York, 1962.

———. *Paul Gauguin's Intimate Journals.* Edited by Van Wyck Brooks. Bloomington, Ind., 1965.

———. *The Writings of a Savage, The Journals of Paul Gauguin.* Edited by Daniel Guérin. New York, 1978.

Gauss, C. E. *Aesthetic Theories of French Artists.* Baltimore, 1949.

Gautier, Théophile. *L'Art moderne.* Paris, 1856.

Gay, Peter. *The Enlightenment: An Interpretation.* New York, 1966.

Gerbi, Antonelli. *The Dispute of the New World: The History of a Polemic, 1750–1900.* Translated by Jeremy Moyle. Pittsburgh, 1973.

Gerbrands, A. A. *Art as an Element of Culture, Especially in Negro-Africa.* Translated by G. E. van Baaren-Pape. Leiden, 1957.

Germann, Georg. *The Gothic Revival in Europe and Britain: Sources, Influences and Ideas.* Translated by Gerald Onn. Cambridge, Mass., 1973.

Gibbs, William, author and publisher. *The Decorator's Assistant* (periodical published in London, c. 1848).

Gobineau, Arthur de. *Essai sur l'inégalite des races humaines.* Paris, 1853–55.

Goldwater, Robert. *Paul Gauguin.* New York, 1957.

———. *Primitivism in Modern Painting.* New York, 1938.

———. *Symbolism.* New York, 1979.

Gombrich, E. H. *Art and Illusion: A Study in the Psychology of Pictorial Representation.* Princeton, 1972.

———. "The Debate on Primitivism in Ancient Rhetoric." *Journal of the Warburg and Courtauld Institute* 29 (1966): 24–28.

———. "The Experiment of Caricature." In his *Art and Illusion.* Princeton, 1972, 331–58.

———. "Imagery and Art in the Romantic Period." *Burlington Magazine* (June 1949); reprinted in his *Meditations on a Hobby-Horse*, London, 1963.

———. "Norm and Form: The Stylistic Categories of Art History and Their Origins in Renaissance Ideals." In his *Norm and Form: Studies in the Art of the Renaissance*. London, 1966, 81–98.

———. *The Sense of Order. A Study in the Psychology of Decorative Art*. Ithaca, 1979.

———. "The Values of the Byzantine Tradition: A Documentary History of Goethe's Response to the Boisserée Collection." In *The Documented Image: Visions in Art History*, edited by Gabriel Weisberg and Laurinda Dixon. Syracuse, 1987, 291–318.

Gonse, Louis. *L'Art japonais*. Paris, 1883.

———. "L'Art japonais et son influence sur le goût européen." In *Revue des arts decoratifs* 8 (1898): 97–116.

Gopnik, Adam. "High and Low: Caricature, Primitivism, and the Cubist Portrait." *Art Journal* 43 (Winter 1983): 371–76.

Grandpierre, Dralse de. *Relation de divers voyages faits dans l'Afrique, dans l'Amérique, et aux Indes occidentales*. Paris, 1718.

Gray, Christopher. *Sculpture and Ceramics of Paul Gauguin*. Baltimore, 1963.

Greenblatt, Stephen. *Marvelous Possessions: The Wonder of the New World*. Chicago, 1991.

Greene, Richard. *A Catalogue of the Curiosities, Natural and Artificial, in the Litchfield Museum*. 3d ed. London, 1786.

Guibert, J. *Le Cabinet des Estampes de la Bibliothèque Nationale*. Paris, 1926.

Guide de la section de l'État indépendant du Congo à l'Exposition de Bruxelles-Tervueren en 1897. Brussels, 1897.

Haddon, A. C. *Evolution in Art as Illustrated by the Life-Histories of Designs*. London, 1895.

Hamann, Johann Georg. *Aesthetica in Nuce* (1762). In *German Aesthetic and Literary Criticism: Winckelmann, Lessing, Hamann, Herder, Schiller, Goethe*, edited by H. B. Nisbet. Cambridge, 1985, 135–50.

Hamlin, A. D. F. *A History of Ornament: Ancient and Medieval*. New York, 1916.

Hannoosh, Michele. *Baudelaire and Caricature: From the Comic to an Art of Modernity*. University Park, Pa., 1992.

Hanson, Anne Coffin. "Popular Imagery and the Work of Edouard Manet." In *French Nineteenth-Century Painting and Literature, with Special Reference to the Relevance of Literary Subject-Matter to French Painting*, edited by U. Finke. Manchester, 1972, 133–63.

Harbison, Robert. *Deliberate Regression*. New York, 1980.

Harpham, Geoffrey. *On the Grotesque*. Princeton, 1982.

Haskell, Francis. *Rediscoveries in Art: Some Aspects of Taste, Fashion and Collecting in England and France*. Ithaca, 1976.

Hawkesworth, John, ed. *An Account of the Voyages undertaken by the Order of His Present Majesty for making Discoveries in the Southern Hemisphere*. London, 1773.

Heller, Erich. *The Artist's Journey into the Interior*. New York, 1965.

———. *The Disinherited Mind: Essays in Modern German Literature and Thought*. New York, 1975.

Heller, Reinhold. "Concerning Symbolism and the Structure of Surface." *Art Journal* 45 (Summer 1985): 146–53.

Hiller, Susan, ed. *The Myth of Primitivism: Perspectives on Art.* London, 1991.

Hipple, W. J. *The Beautiful, the Sublime and the Picturesque in Eighteenth-Century British Aesthetic Theory.* Carbondale, Ill., 1957.

Hofmann, Werner, ed. *Runge in seiner Zeit: Kunst um 1800.* Exhibition catalogue. Hamburg Kunsthalle, Munich, 1977.

Holcomb, Adele. "Le Stryge de Notre-Dame: Some Aspects of Meryon's Symbolism." *Art Journal* 31 (Winter 1971–72): 150–57.

Holt, J. D., ed. *An Account of the Sandwich Islands: The Hawaiian Journal of John B. Whitman, 1813–15.* Peabody Museum, Salem, Mass., 1979.

Honour, Hugh. *Chinoiserie; The Vision of Cathay.* New York, 1973.

———. *The New Golden Land: European Images of America from the Discoveries to the Present Time.* New York, 1975.

———. *Romanticism.* New York, 1972.

Horace. *Ars Poetica.* In *The Complete Works of Horace,* edited by C. J. Kraemer, Jr. New York, 1936, 395–412.

Hugo, Victor. *Preface to 'Cromwell'* (1827). Edited by Pierre Grosclaude. Paris, 1949.

Impey, Oliver. *Chinoiserie: The Impact of Oriental Styles on Western Art and Decoration.* New York, 1977.

Iversen, Margaret. *Alois Riegl: Art History and Theory.* Cambridge, Mass., 1993.

———. "Alois Riegl's Historiography." Ph.D. dissertation, University of Essex, 1980.

———. "Style as Structure: Alois Riegl's Historiography." *Art History* 2, no. 1 (March 1979): 62–72.

Johnson, Ronald. "*The Demoiselles d'Avignon* and Dionysian Destruction." *Arts* 55 (October 1980): 94–101.

Jones, Owen. *The Grammar of Ornament.* London, 1856.

Joppien, Rüdiger, and Bernard Smith. *The Art of Captain Cook's Voyages.* 2 vols. New Haven, 1985–88.

Joyce, Hetty. "The Ancient Frescoes from the Villa Negroni and Their Influence in the Eighteenth and Nineteenth Centuries." *Art Bulletin* 65 (September 1983): 423ff.

Kaeppler, Adrienne. *Artificial Curiosities: An Exposition of Native Manufactures Collected on the Three Pacific Voyages of Captain Cook.* Honolulu, 1978.

Kahnweiler, D. H. *Mes galeries et mes peintres: Entretiens avec Francis Crémieux.* Paris, 1961.

Karp, Ivan, and Steven D. Lavine. *Exhibiting Cultures: The Poetics and Politics of Museum Display.* Washington, D.C., 1991.

Karp, Ivan, Christine M. Kreamer, and Steven D. Lavine. *Museums and Communities: The Politics of Public Culture.* Washington, D.C., 1992.

Kayser, Wolfgang. *The Grotesque in Art and Literature.* Translated by U. Weisstein. New York, 1968.

Klenze, C. von. "The Growth of Interest in the Early Italian Masters." *Modern Philology* 4 (1906): 207–68.

Klemm, Gustav. *Allgemeine Cultur-Geschichte der Menschheit.* 10 vols. Leipzig, 1843–52.

———. *Handbuch der germanischen Alterthums-kunde.* Dresden, 1836.

Knaak, P. *Über den Gebrauch des Wortes "Grotesque."* Dissertation, Greifswald, 1913.

Knight, William. *The Philosophy of the Beautiful—Being Outlines of the History of Aesthetics.* 2 vols. London, 1891.

Kris, Ernst, and E. H. Gombrich. *Caricature*. Harmondsworth, 1940.

Kuhn, Herbert. *Die Kunst der Primitiven*. Munich, 1923.

Kunzle, David. *History of the Comic Strip*. 2 vols. Berkeley, 1973–90.

Labat, Père. *Nouvelle relation de l'afrique occidentale*. 5 vols. Paris, 1728.

Lafitau, Père J. F. *Moeurs des sauvages américains comparées aux moeurs des premiers temps*. Paris, 1724. English translation by W. Fenton and E. Moore. Toronto, 1974.

Laforgue, Jules. "L'Impressionisme." Translated by William Jay Smith as "Impressionism: The Eye and the Poet." *Art News* 55 (May 1956): 43–45.

Lahontan, Louis A., Baron de. *New Voyages to North America*. Edited by R. G. Thwaites. 2 vols. Chicago, 1905. 1st ed., The Hague, 1703.

Laude, Jean. *La Peinture française et l'art nègre*. 2 vols. Paris, 1968.

Laude, Jean, and G. Picon. *Arts primitifs dans les ateliers d'artistes*. Paris, Musée de l'Homme, 1967.

Lee, Rensselaer W. "*Ut pictura poesis:* The Humanistic Theory of Painting." *Art Bulletin* 22 (1940): 197–269.

Leighten, Patricia. *Re-Ordering the Universe: Picasso and Anarchism, 1897–1914*. Princeton, 1989.

———. "The White Peril and *L'art nègre*: Picasso, Primitivism, and Anticolonialism." *Art Bulletin* 72 (December 1990): 609–30.

Leighton, John. *Suggestions in Design*. London, 1880.

Lenoir, Alexandre. *Museum of French Monuments*. Translated by J. Griffith. Paris, 1803.

Lessing, Gotthold Ephraim. *Laocoön: or On the Limits of Painting and Poetry* (1766). Translated by W. A. Steel in *German Aesthetic and Literary Criticism: Winckelmann, Lessing, Hamann, Herder, Schiller, Goethe*, edited by H. B. Nisbet. Cambridge, 1985, 55–134.

Levitine, George. *The Dawn of Bohemianism: The Barbu Rebellion and Primitivism in Neoclassical France*. University Park, Pa., 1978.

———. "The Primitifs and Their Critics in the Year 1800." *Studies in Romanticism* 1 (Summer 1962): 209ff.

Le livre des Expositions universelles, 1851–1979. Union Centrale des Arts Decoratifs, Paris, 1983.

Lotman, Yury. *Analysis of the Poetic Text*. Edited and translated by D. B. Johnson. Ann Arbor, 1976.

Lotman, Yury, B. A. Uspenskij, et al. "Theses on the Semiotic Study of Cultures (as applied to Slavic Texts)." In *Structure of Texts and the Semiotics of Culture*, edited by Jan van der Eng and Mojmir Grygar. The Hague, 1973, 1–28.

Loutfi, Martine A. *Littérature et colonialisme: L'Expansione coloniale vue dans la littérature romanesque française, 1871–1914*. Paris, 1971.

Lövgren, Sven. *The Genesis of Modernism: Seurat, Gauguin, Van Gogh, and French Symbolism*. New York, 1983.

Lubbock, Sir John. *Origins of Civilisation*. London, 1870.

MacLeod, Malcolm. "T. E. Bowdich—An Early Collector in West Africa." *British Museum Year Book* 2 (1977): 79–104.

Malingue, Maurice, ed. *Lettres de Gauguin à sa femme et à ses amis*. Paris, 1946.

Mallgrave, Harry Francis. "Gustav Klemm and Gottfried Semper: The Meeting of Ethnological and Architectural Theory." *RES* (1985): 68–79.

———, ed. "Gottfried Semper: London Lecture of December 1853: 'On the Origin of Some Architectural Styles.' " *RES* 9 (Spring 1985): 53–60.

————, ed. "Gottfried Semper: London Lecture of November 18, 1853, 'The Development of the Wall.' " *RES* 11 (Spring 1986): 33–41.

————, ed. "Gottfried Semper: London Lecture of November 29, 1854: 'On the Relations of Architectural Systems with the General Cultural Conditions.' " *RES* 11 (Spring 1986): 42–53.

————, ed. "London Lecture of Autumn 1854: 'On Architectural Symbols.' " *RES* 9 (Spring 1985): 61–67.

————, ed. "London Lecture of November 11, 1853: Gottfried Semper." *RES* 6 (Fall 1983): 5–31.

Malraux, Andre. *La Tête d'obsidienne.* Paris, 1974.

Marchand, Etienne. *A Voyage Round the World.* Translated by T. N. Longman and O. Rees. London, 1801.

Marcus, George E., and Michael M. J. Fischer. *Anthropology as Cultural Critique: An Experimental Moment in the Human Sciences.* Chicago, 1986.

Masheck, Joseph. "The Carpet Paradigm: Critical Prolegomena to a Theory of Flatness." *Arts Magazine* 51, no. 1 (September 1976): 82–109.

————. *Modernities: Art-Matters in the Present.* University Park, Pa., 1992.

————. "Raw Art: 'Primitive' Authenticity and German Expressionism." *RES* 4 (Autumn 1982): 93–117.

Mathews, Patricia Townley. *Aurier's Symbolist Art Criticism and Theory.* Ann Arbor, 1986.

Maubert, Andre. *L'éxotisme dans la peinture française du XVIIIème siècle.* Ph.D. dissertation, University of Paris, 1943.

McCully, Marilyn, ed. *A Picasso Anthology: Documents, Criticism, Reminiscences.* Princeton, 1982.

Meltzoff, Stanley. "The Revival of the LeNains." *Art Bulletin* 24 (September 1942): 259–86.

Mercier, Roger. *L'Afrique noire dans la littérature française: Les premières images (XVIIème et XVIIIème siècles).* Dakar, 1962.

————. "Les Débuts de l'exotisme africain en France." *Revue de littérature comparée* 36 (1962): 191–209.

————. "L'Image de l'autre et l'image de soi-même dans le discours ethnologique du XVIIIème siècle." *Studies on Voltaire and the Eighteenth Century* 154 (1976): 1417–35.

Miller, Christopher L. *Blank Darkness: Africanist Discourse in French.* Chicago, 1985.

Milligan, Robert. *The Fetish Folk of West Africa.* New York, 1912; reprint, 1970.

Mitchell, Timothy F. "Philipp Otto Runge and Caspar David Friedrich: A Comparison of Theory and Art." Ph.D. dissertation, Indiana University, 1977.

Mitchell, W. J. T. *Iconology: Image, Text, Ideology.* Chicago, 1986.

Mitter, Partha. *Much Maligned Monsters: History of European Reaction to Indian Art.* Oxford, 1977.

Moerenhout, A. *Voyage aux îles du grand océan.* 2 vols. Paris, 1837.

Monk, Samuel. *The Sublime: A Study of Critical Theories in XVII-Century England.* Ann Arbor, 1960.

Montaigne, Michel de. *Essais.* 3 vols. Paris, 1603.

Moorhead, Alan. *Fatal Impact; An Account of the Invasion of the South Pacific, 1767–1840.* New York, 1966.

Möseneder, Karl. *Philipp Otto Runge and Jacob Böhme: Über Runges "Quelle und Dichter" und den "Kleinen Morgen."* Marburg/Lahn, 1981.

Munro, Thomas. *Evolution in the Arts and Other Theories of Cultural History.* Cleveland, 1963.

Naylor, Gillian. *The Arts and Crafts Movement: A Study of Its Sources, Ideals and Influence on Design Theory.* Cambridge, Mass., 1971.

Nisbet, H. B., ed. *German Aesthetic and Literary Criticism: Winckelmann, Lessing, Hamann, Herder, Schiller, Goethe.* Cambridge, 1985.

Nochlin, Linda. *Realism and Tradition in Art, 1848–1900.* Englewood Cliffs, N.J., 1966.

——. *Impressionism and Post-Impressionism, 1874–1904.* Englewood Cliffs, N.J., 1966.

Oldfield, William. "On the Aborigines of Australia." *Transactions of the Ethnological Society of London* 3 (1865).

Olin, Margaret. "Alois Riegl and the Crisis of Representation in Art Theory, 1880–1905." Ph.D. dissertation, University of Chicago, 1982.

——. *Forms of Representation: Alois Riegl's Theory of Art.* University Park, Pa., 1992.

——. "Self-Representation: Resemblance and Convention in Two Nineteenth-Century Theories of Architecture and the Decorative Arts." *Zeitschrift für Kunstgeschichte* 49, no. 3 (1986): 376–97.

Panofsky, Erwin. "The First Page of Giorgio Vasari's 'Libro': A Study on the Gothic Style in the Judgment of the Italian Renaissance." In *Meaning in the Visual Arts*, Garden City, N.Y., 1955. First published as "Das erste Blatt aus dem 'Libro' Giorgio Vasaris; eine Studie über der Beurteilung der Gotik in der italienischen Renaissance." In *Städel-Jahrbuch*, VI, 1930, 25–72.

Parkinson, Sydney. *Journal of a Voyage to the South Seas.* London, 1773.

Paudret, Jean-Louis. "The Arrival of Tribal Objects in the West: From Africa." In *Primitivism in Twentieth-Century Art*, ed. W. Rubin. New York, 1984, 1:125–78.

Paulson, Ronald. "The Grotesque, Gillray, and Political Caricature." In his *Representations of Revolution (1789–1820)*. New Haven, 1983, 168–213.

——. *Representations of Revolution (1789–1820)*. New Haven, 1983.

Pauw, Cornelius de. *Recherches philosophiques sur les Amériquains, ou mémoires intéressants pour servir a l'histoire de l'espèce humaine.* Berlin, 1768.

Peltier, R. "The Arrival of Tribal Objects in the West: From Oceania." In *Primitivism in Twentieth-Century Art*, ed. W. Rubin. New York, 1984, 1:99–124.

Penny, Nicholas. "Ruskin's Ideas on Growth in Architecture and Ornament." *British Journal of Aesthetics* 13, no. 3 (Summer 1973): 276–86.

Perucchi-Petri, Ursula. *Die Nabis und Japan: Das Frühwerk von Bonnard, Vuillard und Denis.* Munich, 1976.

Pevsner, N. *Academies of Art, Past and Present.* New York, 1973.

Picart, Bernard, and Bruzen de la Martinière. *Cérémonies et coutumes religièuses de tous les peuples du monde.* 11 vols. Amsterdam, 1723.

Pietz, William. "The Problem of the Fetish." *RES* 9 (Spring 1985): 5–17; *RES* 13 (Spring 1987): 23–45; *RES* 16 (Autumn 1988): 105–23; *RES* 17 (Spring 1989): 21–42.

Piles, Roger de. *Cours de peinture par principes.* Paris, 1708.

Podro, Michael. *The Critical Historians of Art.* New Haven, 1982.

Poirier, Maurice G. "Studies on the Concepts of *Disegno, Invenzione,* and *Colore* in Sixteenth- and Seventeenth-Century Art Theory." Ph.D. dissertation, New York University, 1976.

Polheim, Karl Konrad. *Die Arabeske: Ansichten und Ideen aus Friedrich Schlegels Poetik.* Munich, 1966.

Poliakov, Leon. *The Aryan Myth: A History of Racist and Nationalist Ideas in Europe.* Translated by E. Howard. London, 1974.

———, ed. *Hommes et bêtes: Entretiens sur le racisme.* Paris, 1975.

Pollock, Griselda. *Avant-Garde Gambits, 1888–1893: Gender and the Color of Art History.* London, 1992.

———. *Vision and Difference: Femininity, Feminism and the Histories of Art.* London, 1988.

Pollock, Griselda, and Fred Orton. "Les Données Bretonnantes: La Prairie de Représentation." *Art History* 3, no. 3 (1980): 314–44.

Pratz, Page du. *Histoire de la Louisiane.* 3 vols. Paris, 1758.

Prelinger, Elizabeth. "The Art of the Nabis: From Symbolism to Modernism." In *The Nabis and the Parisian Avant-Garde.* Rutgers, 1988.

———. *The Nabis and the Parisian Avant-Garde.* Rutgers, 1988.

Previtali, Giovanni. *La Fortuna dei primitivi dal Vasari ai neoclassici.* Turin, 1964.

Prévost, Abbé A. F. *Histoire générale des voyages.* 20 vols. Paris, 1746–59.

Probert, Herbert. *Life and Scenes in Congo.* Philadelphia, 1889.

Racinet, A. *L'Ornement polychrome.* 2 vols. Paris, 1869.

Rand, Benjamin, ed. *Shaftesbury: Second Characters, or The Language of Forms.* Cambridge, 1914.

Rasch, W., ed. *Friedrich von Schlegel: Kritische Schriften.* Munich, 1938.

Ratzel, F. *Völkerkunde.* Leipzig, 1885–88.

Richardson, George. *Iconology; or A Collection of Emblematical Figures.* With Introductory Notes by Stephan Orgel. 2 vols. London, 1779.

Riegl, Alois. *Problems of Style: Foundations for a History of Ornament* (1893). Translated by Evelyn Kain with annotations and introduction by David Castriota. Princeton, N.J., 1992.

———. *Spätrömische Kunstindustrie.* Vienna, 1901.

———. *Stilfragen.* Berlin, 1893.

Rogers, Mark, Jr. "Carved Work." *The Society of Arts: Artisan Reports on the Paris Universal Exhibition of 1878.* London, 1879.

Rogers, Woodes. *A Cruising Voyage Round the World.* London, 1712.

Rookmaaker, H. R. *Gauguin and 19th-Century Art Theory.* Amsterdam, 1972.

———. *Synthetist Art Theories: Genesis and Nature of the Ideas on Art of Gauguin and His Circle.* Amsterdam, 1959.

Rosenblum, Robert. "The Origin of Painting: A Problem in the Iconography of Romantic Classicism." *Art Bulletin* 39 (December 1957): 279–90.

———. *Transformations in Late Eighteenth-Century Art.* Princeton, 1967.

Rubin, James Henry. "Allegory versus Narrative in Quatremère de Quincy." *Journal of Aesthetics and Art Criticism* (Summer 1986): 383–92.

Rubin, William. "From Narrative to 'Iconic' in Picasso: The Buried Allegory in *Bread and Fruit Dish on a Table* and the Role of *Les Demoiselles d'Avignon.*" *Art Bulletin* 65 (December 1983): 615–48.

———. "La genèse des Demoiselles d'Avignon." In *Les Demoiselles d'Avignon,* edited by Hélène Seckel. Exhibition catalogue. 2 vols. Musée Picasso, Paris, 1987, 2:367–487.

———, ed. *Pablo Picasso: A Retrospective.* Exhibition catalogue. Museum of Modern Art, New York, 1980.

———. "Picasso." In *Primitivism in Twentieth-Century Art: Affinity of the Tribal*

and the Modern. Exhibition catalogue, 2 vols. Museum of Modern Art, New York, 1:240–343.

————, ed. *"Primitivism" in Twentieth-Century Art: Affinity of the Tribal and the Modern.* Exhibition catalogue. 2 vols. Museum of Modern Art, New York, 1984.

Runge in seiner Zeit: Kunst um 1800. Exhibition catalogue. Edited by Werner Hofmann, Hamburg Kunsthalle, Munich, 1977.

Runge, Edith A. *Primitivism and Related Ideas in Sturm und Drang Literature.* Baltimore, 1946.

Runge, Philipp Otto. *Hinterlassene Schriften von Philipp Otto Runge Mahler.* 2 vols. Hamburg, 1840–41. Facs. reprint, Göttingen, 1965.

Ruskin, John. *Modern Painters.* 5 vols. London, 1843–60.

————. *The Stones of Venice.* 3 vols. New York, 1887.

Ryden, Stig. *The Banks Collection: An Episode in Eighteenth-Century Anglo-Swedish Relations.* Stockholm, 1963.

Rykwert, Joseph. *On Adam's House in Paradise: The Idea of the Primitive Hut in Architectural History.* Cambridge, Mass., 1981.

Saint-Sauveur, J. Grasset. *Costumes Civils: Actuels de tous les peuples connus. . . .* 4 vols. Paris, 1788.

————. *Encyclopédie des voyages.* Paris, 1796.

Said, Edward. *Orientalism.* New York, 1978.

Saisselin, Rémy. "Painting and Writing: From the Poetry of Painting to the Writing of the *dessin idéal.*" *Eighteenth Century: Theory and Interpretation* 20, no. 2 (1979): 121–26.

————. *The Rule of Reason and the Ruses of the Heart: A Philosophical Dictionary of Classical French Criticism, Critics, and Aesthetic Issues.* Cleveland, 1970.

Salerno, Luigi. "Primitivism." *Encyclopedia of World Art.* New York, vol. 11, cols. 706–9. 1959–87.

Salmon, André. *La jeune peinture française.* Paris, 1912. Translated in Edward Fry, *Cubism.* New York, 1966.

Schapiro, Meyer. "Courbet and Popular Imagery: An Essay on Realism and Naïveté." *Journal of the Warburg and Courtauld Institutes* 4 (1941): 164–91. As reprinted in his *Modern Art: 19th and 20th Centuries.* New York, 1982, 47–85.

Schiller, Friedrich. *On Naïve and Sentimental Poetry* (1795–96). Translated by Julius A. Elias. In *German Aesthetic and Literary Criticism: Winckelmann, Lessing, Hamann, Herder, Schiller, Goethe,* edited by H. B. Nisbet. Cambridge, 1985, 180–232.

————. *On the Aesthetic Education of Man.* Edited by Elizabeth Wilkins and L. A. Willoughby. Oxford, 1967.

Schlegel, Friedrich von. "Gemäldebeschreibungen aus Paris und den Niederlanden in den Jahren 1802–4." In his *Sämtliche Werke,* 6 vols. Leipzig, 1910, vol. 6: chaps. 3–4.

————. *Gespräch über die Poesie* (1799–1800). In *Kritische Schriften,* edited by W. Rasch. Munich, 1938, 283–339.

Schlosser, Julius von. *Die Kunst und Wunderkammern der Spätrenaissance.* Leipzig, 1908.

Schneiderman, Richard, with F. W. Raysor II. *The Catalogue Raisonné of the Prints of Charles Meryon.* London, 1990.

Schuster, Peter-Klaus. "Allegorien und Gelegenheitsarbeiten." In *Runge in seiner*

Zeit: Kunst um 1800, edited by Werner Hofman. Exhibition catalogue. Hamburg Kunsthalle, Munich, 1977, 104–11.

Schweinfurth, G. *Artes Africanae*. Leipzig, 1875.

Schweitzer, N. *The Ut Pictura Poesis Controversy in Eighteenth-Century England and Germany*. Bern, 1972.

Scott, Anna M. *Day Dawn in Africa; or, Progress of the Protestant Episcopalian Mission*. New York, 1858.

Seckel, Hélène, ed. *Les Demoiselles d'Avignon*. Exhibition catalogue. 2 vols. Musée Picasso, Paris, 1987.

Semper, Gottfried. *Der Stil in den technischen und tektonischen Kunsten oder praktische Aesthetik*. Frankfort, 1861–63.

———. *Die Palau-Inseln im Stillen Ocean*. Leipzig, 1873.

———. *Über die formelle Gesetzmassigkeit des Schmuckes und dessen Bedeutung als Kunstsymbol*. Zürich, 1856.

———. *Wissenschaft, Industrie und Kunst*. Edited by H. M. Wingler. Mainz, 1966.

Seroux d'Agincourt, J. B. *Histoire de l'art par les monuments depuis sa décadence au IVème siècle jusqu'a son renouvellement au XVIème*. 6 vols. Paris, 1811–23.

Serusier, Paul. *ABC de la peinture*. Paris, 1942.

Seznec, J., and J. Adhémar. *Diderot: Salons*. Oxford, 1957.

Sheon, Aaron. "Caricature and the Physiognomy of the Insane." *Gazette des Beaux-Arts* 88 (October 1976): 145–50.

———. "Charles Meryon in Paris." *Burlington Magazine* 110 (December 1968): 721–22.

———. "Courbet, French Realism and the Discovery of the Unconscious." *Arts Magazine* (February 1981): 273–315.

———. "The Discovery of Graffiti." *Art Journal* 36, no. 1 (Autumn 1976): 16–22.

Shukman, Ann. *Literature and Semiotics: A Study of the Writings of Yu. M. Lotman*. Amsterdam, 1977.

Simson, Otto Georg von. "Philipp Otto Runge and the Mythology of Landscape." *Art Bulletin* 24 (1942): 335–50.

Sinclair, Andrew. *The Savage: A History of Misunderstanding*. London, 1977.

Solomon-Godeau, Abigail. "Going Native." *Art in America* (July 1989): 119–28, 161.

Spivak, Gayatri Chakravorty. *In Other Worlds: Essays in Cultural Politics*. New York, 1988.

Smith, Bernard. "Captain Cook's Artists and the Portrayal of Pacific Peoples." *Art History* 7 (1984): 295–313.

———. *European Vision and the South Pacific, 1768–1850*. Oxford, 1960.

———. *Imagining the Pacific: In the Wake of the Cook Voyages*. New Haven, 1992.

Smith, William. *Collection choisie des voyages autour du monde et dans les contrees les plus curieuses du globe*. Paris, n.d.

Stafford, Barbara M. *Body Criticism: Imaging the Unseen in Enlightenment Art and Medicine*. Cambridge, Mass., 1991.

———. "Characters in Stones, Marks on Paper: Enlightenment Discourse on Natural and Artificial Taches." *Art Journal* 44 (Fall 1984): 233–40.

———. "From 'Brilliant Ideas' to 'Fitful Thoughts': Conjecturing the Unseen in Late Eighteenth-Century Art." *Zeitschrift für Kunstgeschichte* 48 (1985): 329–63.

———. "'Peculiar Marks': Lavater and the Countenance of Blemished Thought." *Art Journal* 46 (Fall 1987): 185–92.

———. "The State of Research: The Eighteenth Century: Towards an Interdisciplinary Model." *Art Bulletin* (March 1988): 6–24.

————. *Symbol and Myth: Humbert de Superville's Essay on Absolute Signs in Art.* Cranbury, N.J., 1979.

————. "Toward Romantic Landscape Perception: Illustrated Travel Accounts and the Rise of 'Singularity' as an Aesthetic Category." *Art Quarterly*, n.s. 1 (Autumn 1977): 89–124.

————. *Voyage into Substance: Art, Science, Nature and the Illustrated Travel Account, 1760–1840.* Cambridge, Mass., 1984.

Steinberg, Leo. "The Algerian Women and Picasso at Large." In his *Other Criteria*. London, 1972, 125–234.

————. *Other Criteria.* London, 1972.

————. "The Philosophical Brothel." *Art News* 71, part 1 (September 1972): 20–29; part 2 (October 1972): 38–47.

Stephen-Chauvet. *L'Île de Pâques et ses mystères: La première étude réunissant tous les documents connus sur cette île mystérieuse.* Paris, 1935.

Steube, Isabel. "The Life and Work of William Hodges." Dissertation, New York University, Institute of Fine Arts, 1978.

Stocking, George W., Jr., "French Anthropology in 1800." *Isis* 55 (August 1964): 146ff.

————. *Museums and Material Culture.* History of Anthropology 3. Madison, Wis., 1985.

————. *Victorian Anthropology.* New York, 1987.

Summers, David. "Contrapposto: Style and Meaning in Renaissance Art." *Art Bulletin* 59, no. 3 (1977): 336–61.

————. "*Figure come fratelli*: A Transformation of Symmetry in Renaissance Painting." *Art Quarterly* 1 (Autumn 1977): 59–88.

————. " 'Form,' Nineteenth-Century Metaphysics and the Problem of Art Historical Description." *Critical Inquiry* 15 (1989): 372–406.

————. *The Judgment of Sense: Renaissance Naturalism and the Rise of Aesthetics.* Cambridge, 1987.

————. "*Maniera* and Movement: The *Figura Serpentinata.*" *Art Quarterly* 35 (1972): 269–301.

————. *Michelangelo and the Language of Art.* Princeton, 1981.

————. "Real Metaphor: Towards a Redefinition of the 'Conceptual' Image." In *Visual Theory: Painting and Interpretation*, edited by N. Bryson, M. Holly, and K. Moxey. New York, 1991, 231–59.

Taillemite, Etienne. *Bougainville et ses compagnons autour du monde.* 2 vols. Paris, 1977.

Tagliacozzo, Giorgio, and Hayden White, eds. *Giambattista Vico: An International Symposium.* Baltimore, 1969.

Teggart, Frederick. *The Idea of Progress: A Collection of Readings.* Berkeley and Los Angeles, 1960.

Teilhet-Fisk, Jehanne. *Paradise Reviewed: An Interpretation of Gauguin's Polynesian Symbolism.* Ann Arbor, 1983.

Thévet, André. *Cosmographie universelle.* Paris, 1575.

Thirion, Yvonne. "L'Influence de l'estampe japonaise dans l'oeuvre de Gauguin." *Gazette des Beaux-Arts*, 6th ser. (1956): 95ff.

————. "L'Influence de l'estampe japonaise sur la peinture française dans la seconde moitié du XIXème siècle." Ph.D. dissertation, L'École du Louvre, 1947–48.

Todd, Ruthven. "The Imaginary Indian in Europe." *Art in America* 60 (1972): 40–47.

Todorov, Tzvetan. *The Conquest of America: The Question of the Other.* Translated by Richard Howard. New York, 1984.

Töpffer, Rodolphe. *Oeuvres complètes.* Edited by Pierre Cailler and H. Giller. Geneva, 1945.

―――. *Réflexions et menus propos d'un peintre genevois.* Paris, 1848. Reprint, 1853 and 1865.

Torgovnick, Marianna. *Gone Primitive: Savage Intellects, Modern Lives.* Chicago, 1990.

Traeger, Jörg. *Philipp Otto Runge und Sein Werk: Monographie und Kritischer Katalog.* Munich, 1975.

Tylor, Edward. *Primitive Culture.* London, 1871.

Vallery-Radot, Jean. "Quand Meryon etait marin. Ses dessins inedits de la campagne de la Corvette, 'Le Rhin' (1842–46) conservés au Cabinet des Estampes." *Gazette des Beaux-Arts* (June 1961): 359–68.

Van Nimmen, Jane. "Friedrich Schlegel's Response to Raphael in Paris." In *The Documented Image: Visions in Art History,* edited by Gabriel Weisberg and Laurinda Dixon. Syracuse, 1987, 319–33.

Varnedoe, Kirk. "Primitivism." In *A Fine Disregard: What Makes Modern Art Modern.* New York, 1990, 182–215.

―――. "Gauguin." In *Primitivism in Twentieth-Century Art,* edited by W. Rubin. New York, 1984, 179–210.

Vaughan, William. *German Romantic Painting.* New Haven, 1980.

―――. *German Romanticism and English Art.* New Haven, 1979.

Verene, Donald Phillip. *Vico's Science of Imagination.* Ithaca, 1981.

Vico, Giambattista. *The New Science of Giambattista Vico.* Translated by T. G. Bergin and M. H. Fisch. Ithaca, 1968.

Views of the South Seas, containing plates by John Webber and others. London, 1808.

Viollet-le-Duc, E. E. *Discourses on Architecture.* 2 vols. London, 1959.

―――. "Sculpture." *Dictionnaire raisonné de l'architecture française du XIème au XVIème siècle.* 10 vols. Paris, 1868, 8:244.

Vischer, F. T. *Aesthetik.* Reutlingen, 1846–57.

Völkmann, Ludwig. "Die Hieroglyphen der Deutschen Romantiker." *Münchner Jahrbuch der Bildenden Kunst,* n.s. 3 (1926): 157–86.

Wackenroder, Wilhelm Heinrich. *Herzensergiessungen eines kunstliebenden Klosterbruders* (1797). Weimar, 1914.

―――. *Werke und Briefe von Heinrich Wackenroder.* Edited by Lambert Schneider. Heidelberg, 1967.

Wadström, C. B. *Observations on the Slave Trade.* London, 1789.

Warburton, William. *The Divine Legation of Moses Demonstrated.* 4 vols. 1741. Reprint, New York, 1978.

Warncke, C.-P. *Die ornamentale Groteske in Deutschland (1500–1650).* 2 vols. Berlin, 1979.

Wedmore, Frederick. *Meryon and Meryon's Paris, with a Descriptive Catalogue of the Artist's Work.* London, 1879.

Weisberg, Gabriel, ed. *Japonisme—Japanese Influence on French Art, 1854–1910.* Exhibition catalogue. Cleveland Museum, 1975.

Weisberg, Gabriel, and Laurinda Dixon, eds. *The Documented Image: Visions in Art History.* Syracuse, 1987.

Whewell, William. *The General Bearing of the Great Exhibition on the Progress of Art and Science.* London, 1851.

White, Hayden. *Metahistory: The Historical Imagination in Nineteenth-Century Europe*. Baltimore, 1973.

———. *Tropics of Discourse: Essays in Cultural Criticism*. Baltimore, 1978.

Whitman, John B. *An Account of the Sandwich Islands: The Hawaiian Journal of John B. Whitman, 1813–15*. Edited by J. D. Holt, Peabody Museum, Salem, Mass., 1979.

Whitney, Lois. *Primitivism and the Idea of Progress*. Baltimore, 1934.

Wichmann, S. *World Cultures and Modern Art*. Munich, 1972.

Wiedmann, August. *Romantic Roots in Modern Art: Romanticism, and Expressionism: A Study in Comparative Aesthetics*. Old Woking, Surrey, 1979.

Williams, John. *A Narrative of Missionary Enterprises*. London, 1837.

Winckelmann, Johann Joachim. *Geschichte der Kunst des Altertums* (1764). Vienna, 1934.

———. *Reflections on the Painting and Sculpture of the Greeks* (1755). Translated by Henry Fuseli. London, 1765.

———. *Versuch einer Allegorie*. Leipzig, 1766.

Winckelmanns Briefe. Edited by W. Rehm and H. Diepolder. Berlin, 1952–57.

Wittkower, Rudolf. "Hieroglyphics in the Early Renaissance." In his *Allegory and the Migration of Symbols*. London, 1977, 113–28.

Wright, C. H. C. *French Classicism*. Cambridge, Mass., 1976.

Wright, Thomas. *A History of Caricature and the Grotesque in Art*. New York, 1968.

Zola, Emile. "Une Nouvelle manière en peinture: Edouard Manet (1867)." Reprinted in *Emile Zola: Salons*, edited by F. W. J. Hemmings and Robert J. Neiss. Geneva, 1959, 85–86.

Index